ANDREW WYETH

AUTOBIOGRAPHY

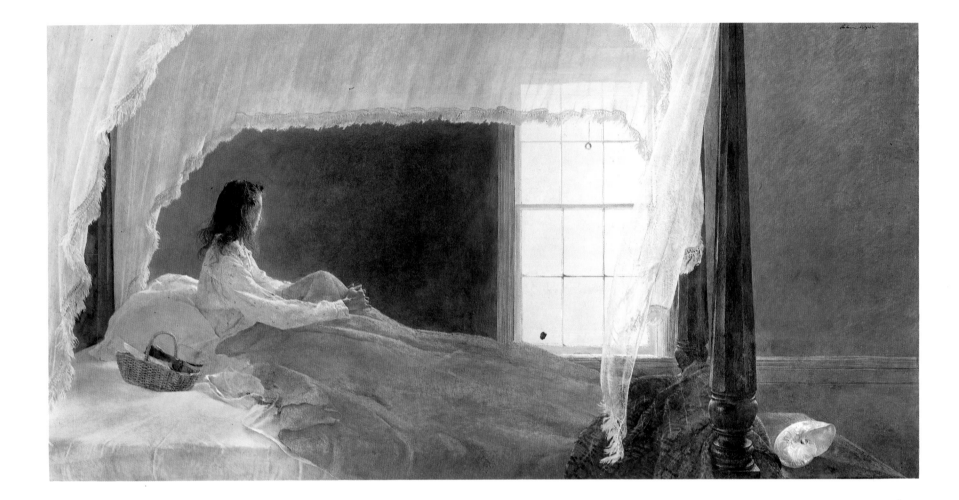

ANDREW WYETH

AUTOBIOGRAPHY

Introduction by Thomas Hoving

With commentaries by Andrew Wyeth as told to Thomas Hoving

KONECKY & KONECKY

Konecky & Konecky
72 Ayers Point Rd.
Old Saybrook, CT 06475

ISBN: 1-56852-654-7
13 digit ISBN: 978-1-56852-654-6

This edition published by arrangement with Bullfinch Press,
an imprint of Little, Brown and Company,
a division of Hachette Book Group USA, Inc. New York, NY.
All rights reserved. It was first published on the occasion of the retrospective exhibition
Andrew Wyeth: Autobiography at The Nelson-Atkins Museum of Art, Kansas City, Missouri.

Credits and commentaries for the following paintings appear on page 153:

page 2: *Chambered Nautilus*, 1956
page 8: *Battleground*, 1981

Painting whose titles are marked with an asterisk did not appear in the Nelson-Atkins exhibition.

Printed and bound in India

Contents

Foreword

This book and the accompanying retrospective exhibition in Kansas City give us the rare opportunity to consider the six-decade career of a signal American artist in light of as many years of thorny critical debate. As Thomas Hoving reminds us in his thoughtful introductory essay, Andrew Wyeth and his work are extremely complex. Neither submits comfortably to the categorizations into which much critical writing has tried to cast them. There has been the tendency to superimpose on the art preconceived critical positions limited by parochial boundaries rather than to try to understand the means Wyeth exploits to reveal our times and our psyche with such compelling force. At once alluring and unsettling, the work strikes the very heart of our emotional being, reminding us that art is ultimately about truth and the human condition.

We are extremely grateful to R. Crosby Kemper, without whose good offices the exhibition in Kansas City would not have occurred. His pivotal role in bringing the only American showing of the exhibition to The Nelson-Atkins Museum of Art and his financial support through UMB Banks and the Enid and Crosby Kemper Foundation demonstrate once again his liberal and generous patronage.

This book and the exhibition are the result of a long and fruitful relationship between Andrew Wyeth and Thomas Hoving, to both of whom we extend our thanks. Our gratitude extends to all the individuals acknowledged by Mr. Hoving, especially to our friends at the *Chunichi Shimbun*. Special recognition should go to Margaret C. Conrads, Samuel Sosland Curator of American Art at the Nelson-Atkins, for coordinating all aspects of the exhibition and its related programs in Kansas City.

Marc F. Wilson, Director
The Nelson-Atkins Museum of Art

Acknowledgments

This retrospective of the works of Andrew Wyeth could never have been mounted without the dedication of a host of people who strived ceaselessly to carry out the large and the small tasks and overcame all the obstacles that always accompany a major exhibition. Our sincerest thanks go to the following:

Andrew Wyeth, for his matchless creativity and for allowing himself to be subjected to hour after hour of interviews over many years—every one carried out with grace and humor.

Betsy Wyeth, for her gifted sense of organization and her unique and precious insights into every phase of the artist's life and creativity.

Mary Landa, Deb Snedden, Dolly Bruni Havard, and Peter Ray of the Wyeth "team," who were there when we needed them—always a step ahead.

Peter Marcelle, whose idea it was to form a retrospective.

The *Chunichi Shimbun,* that exceptional Japanese newspaper and its Cultural Division under the able direction of Norimichi Aiba, which dreamed about, supported, and funded the show. To Aiba and his aides Kosuke Nakagawa and Yoko Iida who solved every problem—major and minor—with dispatch. This is their show in many ways and they have made a significant contribution to world culture.

Shin Doi, the United States Liaison Officer, who provided such fine diplomacy.

Shuji Takahashi, Curator of the Aichi Prefectural Museum in Nagoya, who organized the Japanese loans (often in miraculous manner) for his own institution and the Bunkamura Museum in Tokyo and the Fukushima Prefectural Museum of Art in Fukushima and who came forward with the most fascinating insights into the work of the artist.

At The Nelson-Atkins Museum of Art in Kansas City we thank director Marc Wilson for his forthright handling of the show, Margi Conrads for her sensitive curatorship, and Crosby Kemper for his unflagging leadership. To UMB Banks and the Enid and Crosby Kemper Foundation for their generous support of the exhibition in Kansas City.

Nicholas Wyeth deserves the highest praise for his diplomatic and problem-solving talents.

Frank Fowler was crucial for the formation of the exhibition and for continual, perfect advice.

All the collectors, both public and private, who contributed to this unique assembly of fine works of art and who are the true guardians of the artist's heritage.

Janet Swan Bush and her alert cadre of editors at Bulfinch Press/Little, Brown and designer Bruce Campbell—how easy professionals can make travail seem.

Nancy Hoving and Marianne Lyden in my office, whose untiring attention to the facts laid the foundations for the retrospective.

Thomas Hoving

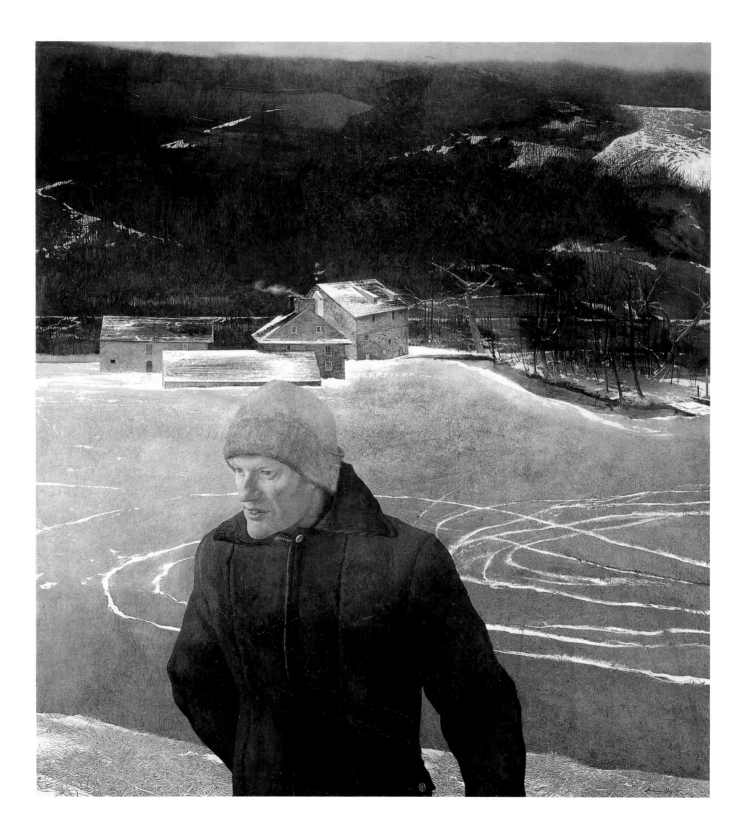

Introduction

THOMAS HOVING

It takes a very long time to get to know Andrew Wyeth as a man and even longer to know him as an artist. He's a cover-up kind of guy in life and in art. But the key to understanding both human being and creator is to know that he is a staunch independent.

He's been independent all his life—from the time he was taken out of school and tutored (sometimes being treated like Little Lord Fauntleroy) and from the moment his famous illustrator-father took him into the studio and started his formal artistic education. His fierce independence has continued right up to the present day.

He has almost always gone against the grain, except for the early watercolors in Maine, which he tends to dismiss as being part of his "blue sky" period. As a realist in an epoch of art history devoted to the abstract and the visually obtuse, Wyeth has been swimming upstream all his career. It has not been easy, although it may look it. Wyeth has struggled with his art. There is nothing facile about it.

From the start Wyeth was free and undisciplined. He either resented opinion or ignored it. Early on he stopped showing anyone his works in the first stages for fear that a discouraging phrase might cause him to abandon the project. He learned how to fight and finish a picture, for himself, beyond anything. In art, as well as in life, the artist can become ornery. And he can be maddeningly secretive—so much so that, at times, he becomes the sole worshiper in his own cult.

Wyeth, in essence, has always painted for himself. He harbors private, sometimes bizarre reasons for initiating a work, reasons that occasionally surface in an interview, such as those comments that accompany the paintings chosen for this retrospective.

It would have been impossible for anyone to have imagined that the impulse to produce the brilliant *Garret Room* (see page 61), showing the sleeping old black man Tom Clark, would have been the four-year-old Wyeth feeling both anticipation and trepidation in the middle of the night at the Christmas stocking on his bed with the skinny doll stuck in its neck. And it's hard to imagine that when he began to conceive of the complete *Night Sleeper* (see page 119)—that mesmerizing image of his sleeping dog and the views of his farm through mysterious night windows—he was recalling the old overnight train that whisked him to Maine as a child. In other pictures we all can guess the symbolism:

the dry leaf that reaches out like a hand or the dried corn that stands out there alone, solitary and isolated like a personal friend or alter ego of the artist. Like Caspar David Friedrich, he is an original who only on occasion chooses to share with the world the underlying emotional and spiritual impulses that goaded him into creation.

For Wyeth the free, dreamlike, often romantic associations are a vital part of his creative process and lie at the heart of the independent spirit that has supported him for five decades. The romantic nature of his realism is what has sustained him throughout his career and will guarantee that in the years to come his works will be remembered, perhaps not always with fondness, but no doubt indelibly.

That does not make Wyeth a romantic. He couldn't be further from one, and despite the fact that he brings his emotions to bear in creating a work of art, it's accurate to describe him as dispassionate, even cruelly detached from his subjects.

He moves things that he sees around in his pictures, he swoops up into the air to have a "helicopter look" or burrows down on the ground to investigate from an ant's point of view something that has struck his gaze, but he never romanticizes or sweetens a subject. He relishes letters he has received praising him for having painted the "beautiful picture of that gorgeous young girl Christina" crawling in her front yard in *Christina's World*. As he says, somewhat triumphantly, "Of course, she's an old cripple, for Pete's sake!"

Unlike most artists of the second half of the twentieth century, Wyeth has never been confused about the direction his work should take, nor has he experienced dramatic transformations of style. That is not to say that he has not changed. Early in his career he was a proud protagonist of technique and a keen observer of and philosopher about the materials of painting. Today he argues convincingly that he doesn't "give a damn" about technique and sometimes tries to lay waste to it.

This is all the more surprising since, in the past, he has been virtually poetic about the various media he uses.

About drawing: "To me, pencil drawing is a very emotional, very quick, very abrupt medium. . . . I will perhaps put in a terrific black and press down on the pencil so strongly that the lead will break, in order to emphasize my emotional impact with the object. . . . Pencil is sort of like fencing or shooting. Yet sometimes my hand, almost my fingertips, begins to shiver when I start."

On watercolor: "The only virtue to it is to put down an idea quickly without thought about what you feel at the moment. It's one's free side. Watercolor shouldn't behave."

On drybrush: "I work in drybrush when my emotion gets deep enough into a subject. I paint with a smaller brush, dip it into color, splay out the brush and bristles, squeeze out a good deal of the

moisture and color with my fingers so that there's only a very small amount of paint left. It's a weaving process—one applies layers of drybrush over and within the broad washes of watercolor. And I sometimes throw in pencil and Higgins' ink."

On tempera: "It's a dry pigment mixed with distilled water and yoke of egg. I love the quality of the colors: the earths, the terra verde, the ochers, the Indian reds, and the blue-reds. They aren't artificial. I like to pick the colors up and hold them in my fingers. Tempera is something with which I build—like building in great layers the way the earth was itself built. Tempera is not the medium for swiftness."

These days the artist seldom speaks about technique. Today he stresses light, the emotional impact of his story, the feeling of the atmosphere. The once-revered, almost mystical tools of painting are now just tools.

Subject matter has always been of paramount importance to Wyeth, especially when it comes to him unexpectedly, or, as he likes to put it, "through the back door." He may start a scene and then see something days or weeks later that will make him completely change the first impression and, of course, the picture. He thoroughly believes, like one of his favorites, John Constable, the English painter of the eighteenth-nineteenth century, that you never have to add life to a scene. If you quietly sit and wait long enough, patiently enough, life will come—"sort of an accident in the right spot."

These "accidents" are the foundations on which the bulk of Wyeth's best visions are based and are relatively unknown—for good reason, since he has not bothered to talk about them until fairly recently. For the most part only the pictures' titles offer any clues to the vivid experiences behind an inspiration.

One "accident" occurred while he was finding it impossible to resolve one of his most impressive images, *Distant Thunder* (see page 57). He had wanted to paint his wife picking blueberries and couldn't get it right. Finally he had hidden in the hope that he would be surprised by something. He was. There she was sleeping, and he made a quick drawing. He heard thunder in the distance, and suddenly the dog's head popped up in alarm. That action became the spark that ignited his imagination. He then realized that there was too much of his wife's face in the picture, and he painted in the nonexistent hat.

Chance, the odd happenstance, the abrupt appearance of life where before there was stillness or death is of critical importance to Wyeth the painter. Several times in his lifetime of painting the unplanned discovery of something young and fresh and different on the very day or even moment when a favorite model was dying or had just died has transformed his life. On his way to the funeral of Christina Olson in Maine, he happened to drive by the house of the Finn, George Erickson, leading him to think about Erickson's young daughter, Siri, who would become the model of some of Wyeth's

best nudes in the 1970s. Wyeth remembers going by the young girl's house as he was following the hearse on his way to Christina Olson's funeral and thinking of her as at once the end and the continuation of Olsons—a subject emerging from Christina yet antithetical to her, one that was invigorating, zestful, and powerful.

When his friend Karl Kuerner was dying, Wyeth was painting one of his most brooding and poetic works, a large watercolor of the Kuerner house, with one light in the window where his friend lay on his sickbed. The time of year was that between-moment of winter and spring, and that is where Wyeth first met Helga, "carrying a vacuum cleaner." And, of course, on Karl's death, Helga, his nurse, became the symbol of life out of ashes and the real—and furtive—spring that exists to a certain degree in all our yearnings.

The more mature Wyeth becomes, the more he hopes for the spark of chance that will add mystery and incongruity to a scene. Objects washed up on the shores of Maine intrigue him. The sudden burst of bright color from a Sunday newspaper advertising supplement blown into the road seizes his fancy. And the paintings already started will alter radically.

When he finds a subject that he describes as "almost perfect for me," he is likely, these days, to walk away from it. It is not that he needs a contrived charge to move a jaded eye; it's more that at seventy-six years of age, he is still maturing creatively, willing to take even more risks than at any time in his career.

There was hardly a time in his creative life when he didn't take risks and revel in them. When in his formative years, urged by his father to paint colorful pictures, he rebelled after finding a dead crow in a field one day. He felt impelled to get down on the ground and to observe the bird and nature from inches away, preserving her dour, harsh colors. As he says, "This crow in one of Karl's fields symbolized the nature and intimacy of the Pennsylvania landscape. The blue-black of the feathers helped me break free of 'impressionism.' Without seeing this crow I would never have done *Christina's World*, which has an emphasis on grasses and the landscape very close-up—what lurks close down at the surface."

This intense, close-up examination of nature was the inspiration for the gripping self-portrait titled *Trodden Weed* (see page 32), in which Wyeth sees himself, nature, and the presence of death from a height of six inches off the ground. With any naturalist other than Wyeth this view of old boots and the dried-out beige grasses of winter would be contrived, even false. But with Wyeth the scene is a faithful depiction of nature plus an accurate evocation of a dream.

Yet for Wyeth the dream, the all-but-hidden personal association, is not always necessary for a picture to succeed brilliantly. For observation, an almost obsessed and driven observation of a subject, can

be the force behind a work, as long as that observation does not fully take command. Nowhere is this more evident than in the penetrating study of the side of the Olson house, *Weatherside* (see page 67). For this painting, Wyeth found himself actually counting every piece of clapboard, every nail, all the peeling strips of paint, the panes of glass, the shards of the broken panes, rags, clothes, and detritus that lent character to the deteriorating, old structure. Carried away to the point where his fascination with the details began to impinge upon art, the artist was able to take hold of himself, calm down, and create something deeper and more universal than a mere inventory of intriguing forms. He wanted to paint "a true portrait of the house—not a picturesque portrait, but one I'd be satisfied to carry around in my wallet." He succeeded.

It's hard sometimes to keep track of Wyeth's impulses in individual works—and, of course, he revels in creating a certain confusion on the part of the observer. He can be surgically observant in a picture like *Weatherside*, then go "out of his mind" with the emotion of a scene, as he did in the extraordinary watercolor *Wolf Moon* (see page 105). The latter is a fanciful view of the Kuerner farmhouse, seen as if the artist had been elevated into the air, and, at the same time, a depiction of sounds and the feeling of a human being—Anna Kuerner—walking from room to room in the cold house in the middle of the night turning on and off lights as she makes her way to her upstairs bedroom. Nothing about this still image is without movement, sound, or emotion. In time it will probably be mistaken as surreal.

The real danger with Andrew Wyeth is that in the future he may be interpreted incorrectly as an artist who imagined all his subjects. It might be difficult in a generation or two to believe that Wyeth's wife, Betsy, really existed as she did in *Maga's Daughter* (see page 84), wearing an old Quaker hat and looking so hot under the collar. Or that the striking portrait of the Kuerners in which Karl seems to be deliberately pointing a rifle at his weird-looking spouse was an actual moment of fact and that the non-factual element of the picture—a rack of elk—was sandpapered out of the large watercolor to accommodate the reality of the event.

Of all the watershed paintings in Wyeth's life, perhaps *Barracoon* (see page 108), painted in 1976, is the most significant. For not only is this the nude that implies—or is—Helga, but it is a painting from which the artist eliminated all references to the specific place in which it was created in order to achieve a timelessness and spacelessness. After this one senses in Wyeth's works a gradual lessening of the bonds of having to be so specific, having, as a duty, to observe every board, piece of glass, or rusted metal hook. The stunning painting is in a real sense the halfway point in Wyeth's creative life—about thirty years from *Christina's World* and twenty years from the strong works of the 1990s. It's quite possible that this nude will turn out to be the single most successful and moving painting of his entire oeuvre.

13

From the late seventies and early eighties on, there has been another subtle change in Wyeth's viewpoint about his worlds and their occupants and properties. He discovered the light and atmosphere of the out-of-doors—what the French would describe as "plein air." Of course, Wyeth had painted out-of-doors from his earliest landscapes and figural scenes and was fascinated by the shifting moods of light, so it's not as if he suddenly discovered a new world outside the studio. But until paintings like *Night Sleeper* (see page 119), *Ravens Grove*, and *Pentecost* (see page 143), he used the light as "moods of light" rather than as totally accurate and perceived light. And that is not quite the same as plein air, which is a combination of perception and exuberance. In the early eighties it may be that Wyeth finally came to grips and made a proper compromise with the "impressionism" of his youthful years (if not with the garish colors of his "blue sky" period of the forties) and acquired an interest in light as color and tangible substance. In works such as *Flood Plain* (see page 140) and the recent *Whale Rib* (see page 152), a startlingly powerful image of a small island in Maine, the light is at the same time illumination, color, atmosphere, structure, and emotion.

Whale Rib, painted in the late summer of 1993, is an uncannily observed picture and a profoundly emotional and dramatic one—possessing a host of delicious, "false" surrealistic touches. It echoes his first desire to get down on the ground, for he painted this watercolor literally lying on his side in a fierce storm. The painting, done on Bennes Island, is a portrait of Maine as a state of physical reality and a state of mind—a place in which things are constantly in danger of being blown off the face of the earth. And the painting is also almost a scientific tract, an official inventory of the flora and fauna that can exist only on this specific and single tiny island, an environment that is, in reality, utterly different from Allen Island a stone's throw away. In the same stroke, *Whale Rib* is broad and universal, specific in almost a picky way and emotionally powerful, no less than a nature walk and the reminder of the inevitable end of all things human, natural, even cosmic.

Only a true artistic independent like Andrew Wyeth could have created something of such pure simplicity and maddening complexity, something so obvious yet so satisfyingly clandestine.

ANDREW WYETH

AUTOBIOGRAPHY

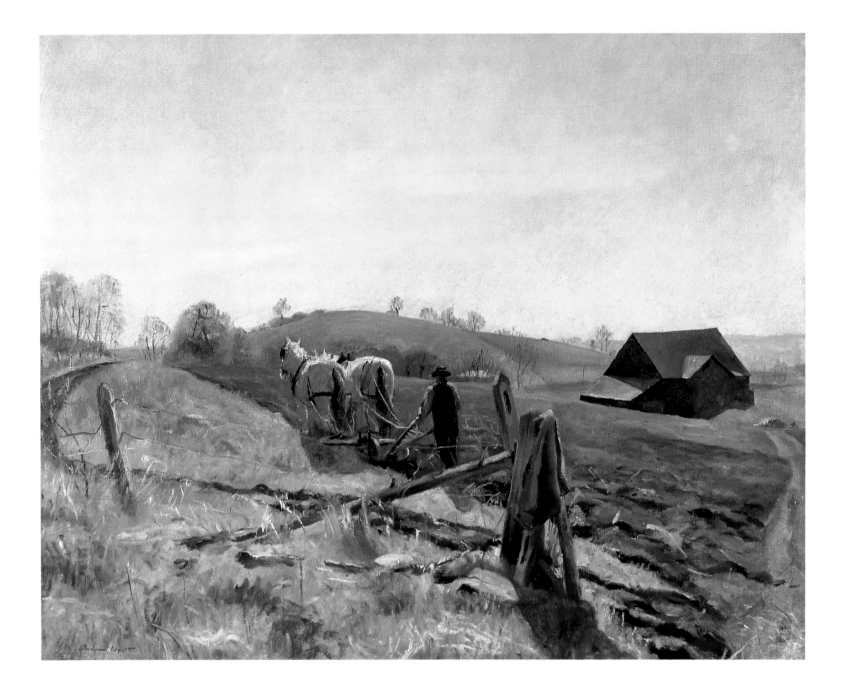

SPRING LANDSCAPE AT KUERNERS, 1933
Oil
32 × 40 inches (81.3 × 101.6 cm)
Naigai Trading Co., Ltd., Japan

I painted this—in oil—when I was sixteen years of age. I gave it to Karl, and years later he asked if he could sell it. He needed a tractor, and I said, "Sure, but be sure to let me know before you do." I wanted to tell him about what price to ask for. He didn't tell me and sold it to some guy for twelve thousand dollars, who sold it to a collector for sixty-five. Karl *was* independent.

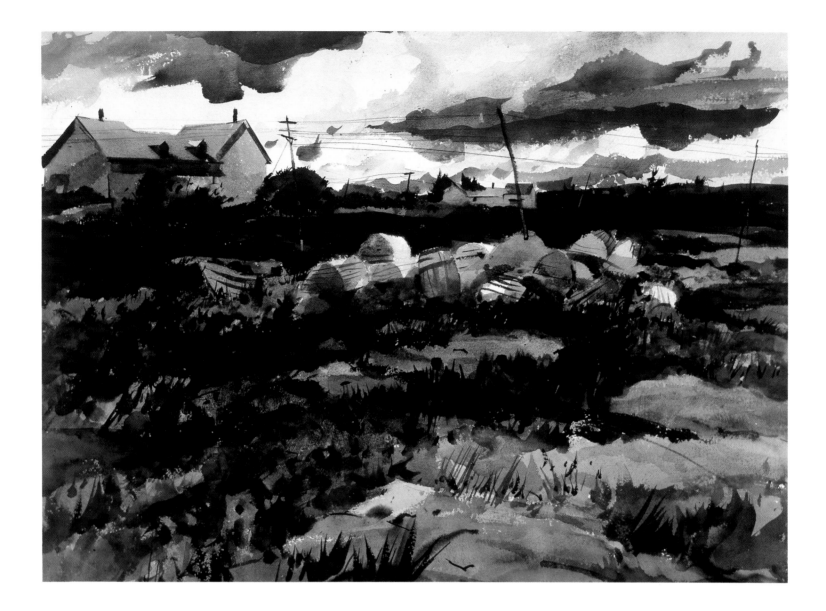

LOBSTER TRAPS, 1939
Watercolor
21 × 29¼ inches (53.3 × 74.3 cm)
Collection of Mr. and Mrs. Andrew Wyeth

I was twenty, and this was my "blue sky" period of brash watercolors with deep, almost exaggerated tones—using pure blues, purples, and browns out of the tube. I did these at Martinsville, Maine, for my second show at the Macbeth Gallery in New York City. In the first show my colors were bright but light. Now there's a deepness.

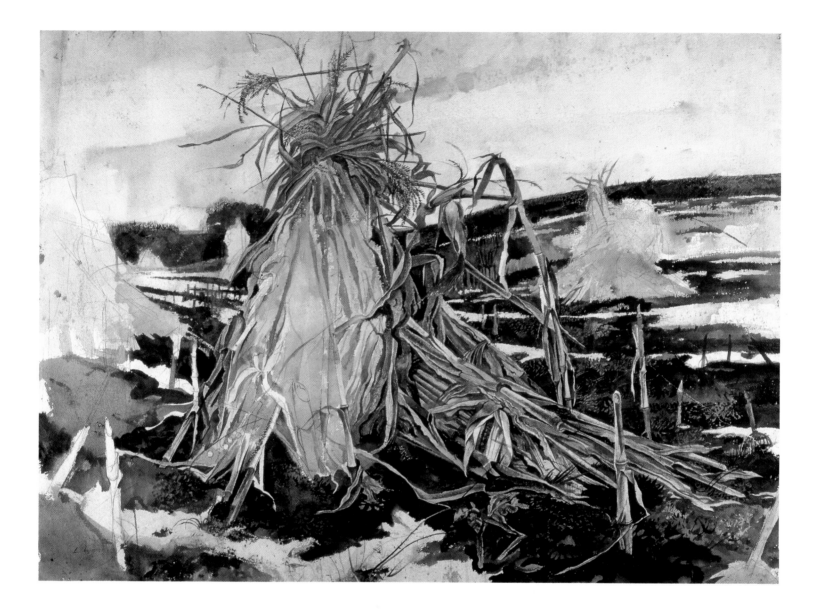

WINTER CORN FIELDS, STUDY, 1942
Drybrush and watercolor
28 × 40½ inches (71 × 102.9 cm)
Collection of Mr. and Mrs. Andrew Wyeth

When I was a kid and the rest were going to school, I was getting educated wandering through cornfields and the woods. I look upon this as a picture of a friend.

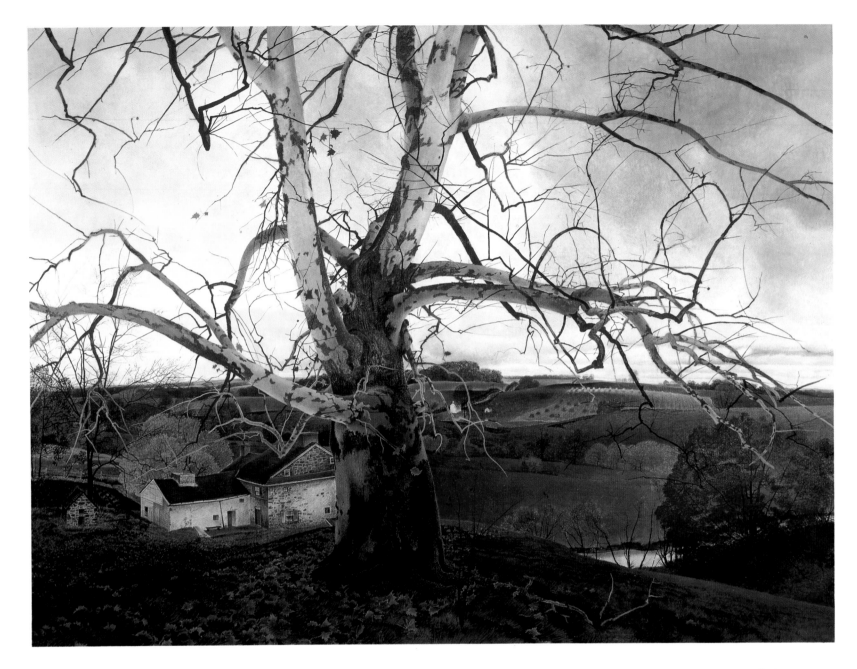

PENNSYLVANIA LANDSCAPE, 1942

Tempera on panel

35¼ × 47⅛ inches (89.5 × 119.7 cm)

Collection of the Brandywine River Museum, Chadds Ford, Pa.

Bequest of Helen Remsen Yerkes

I think of it as the whole Pennsylvania landscape in one picture—with that marvelous buttonwood tree in the middle. I was thinking about doing the landscape to put over a mantelpiece. I'm almost suspended, looking down. Of course, it's a composite view. I never stand in one spot when I paint a landscape. I float. I move. It's impossible for me to be photographic. I wanted to capture the movement of the scene. The majesty of that nearly five-hundred-year-old tree. You know, it's an odd picture—almost prosaic. I wanted to get it all down, maybe out of my system. I wanted to be able to say, Everything's possible—if you believe and can get excited.

BEFORE PICKING, 1942
Drybrush and watercolor
21 × 29¾ inches (53.3 × 75.6 cm)
Collection of Mr. and Mrs. Andrew Wyeth

The trees are in my father's orchard. I actually counted the apples when I did these. They're "smokehouse" apples. I think these drawings are a story with a mysterious beginning and an end. Prophetic.

AFTER PICKING, 1942
Drybrush and watercolor
22½ × 30⅝ inches (57.2 × 77.8 cm)
Collection of Mr. and Mrs. Andrew Wyeth

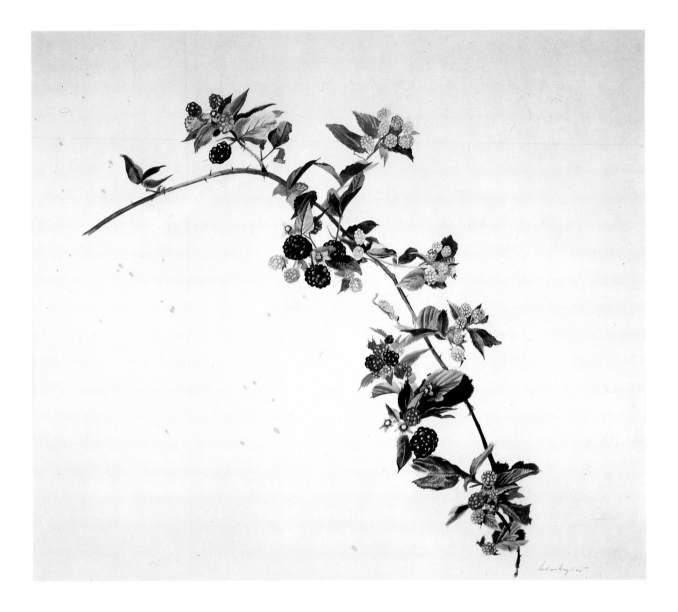

BLACKBERRY BRANCH, 1943
Study for BLACKBERRY PICKER, drybrush
22 × 26⅞ inches (55.9 × 68.3 cm)
Collection of Mr. and Mrs. Andrew Wyeth

I had a helluva good time with this—a study for the tempera called the *Blackberry Picker*—because as I finished each berry I'd eat it!

SPRING BEAUTY, 1943
Drybrush
20 × 30 inches (50.1 × 76.2 cm)
Sheldon Memorial Art Gallery, University of Nebraska, Lincoln
F. M. Hall Collection, 1944

This is important for the development of my way of seeing reality. Here is a time I used pencil and Higgins' ink, too, to make the silver gray of the bark, for the texture of that bark was fascinating to me. Now this is far from the colorful "impressionism" of my earlier works. Here I'm slowly changing. I'm seeing things in a clearer way.

ROAD CUT, 1940
Tempera on panel
15⅝ × 34¼ inches (39.7 × 87 cm)
The Joan Whitney Payson Collection at the Portland Museum of Art,
Portland, Me. Lent by John Whitney Payson

This road is the gateway to the little valley in Chadds Ford [Pennsylvania], where I've painted so many pictures. When Betsy came to Chadds for the first time—before we were married—I showed her this small tempera, and she liked it and observed that it said a lot about me and my aspirations. That building is Mother—or Sister—Archie's church. She was the Negro preacher who took that octagonal building and made it into a church. When my father came to Chadds in 1903, she was preaching there. When I was a kid, that road was dirt. I used to ski down it and toboggan—fast! It shows up throughout my life in my work. It's the same place as in the tempera *Ring Road* (see page 136), and in that you can see the remains of the old structure. It's the entrance to my valley.

CHRISTMAS MORNING, 1944
Tempera on panel
23¾ × 38¾ inches (60.3 × 98.4 cm)
The Regis Collection, Minneapolis, Minn.

My first link with death. A woman I knew had died. I painted this purely from memory. It's a strange picture. I was striving for an overall schematic of dawn colors—silvery hues.

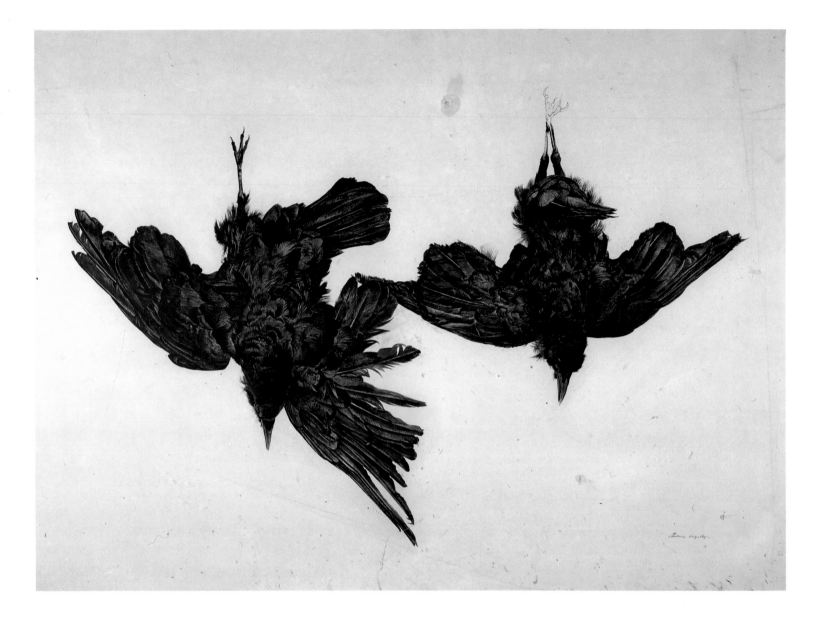

CROWS, 1944
Study for WOODSHED, drybrush and pencil
35 × 48 inches (103.9 × 121.9 cm)
Lyman Allyn Art Museum, New London, Conn.

I saw these crows hanging on the fence. Karl Kuerner's son had shot them. Sad, but farmers do shoot these marvelous birds. It was a March day, and they were there with their black feathers blowing. Later I did some drawings and a tempera painting called *The Woodshed*, which I exhibited in New York at the Macbeth Gallery.

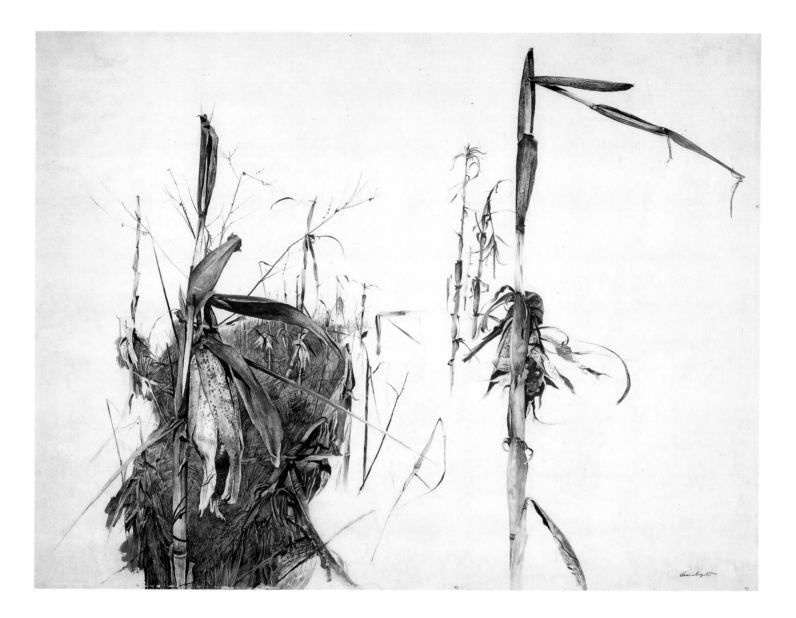

WINTER CORN, 1948
Drybrush
29 × 38¾ inches (73.7 × 98.4 cm)
Private Collection

There was a lonely cornfield near Lafayette's headquarters in Chadds Ford where I loved to go and sit alone in the quietness. The corn was abandoned; it had been allowed just to go to seed and stood there like the lances held by a line of medieval knights. This is the best painting of corn I ever did, I think. Sere, dry, very much in the spirit of Albrecht Dürer. Funny, I looked upon the two ears almost as portraits—one of a toothless person and the other with every tooth in his mouth.

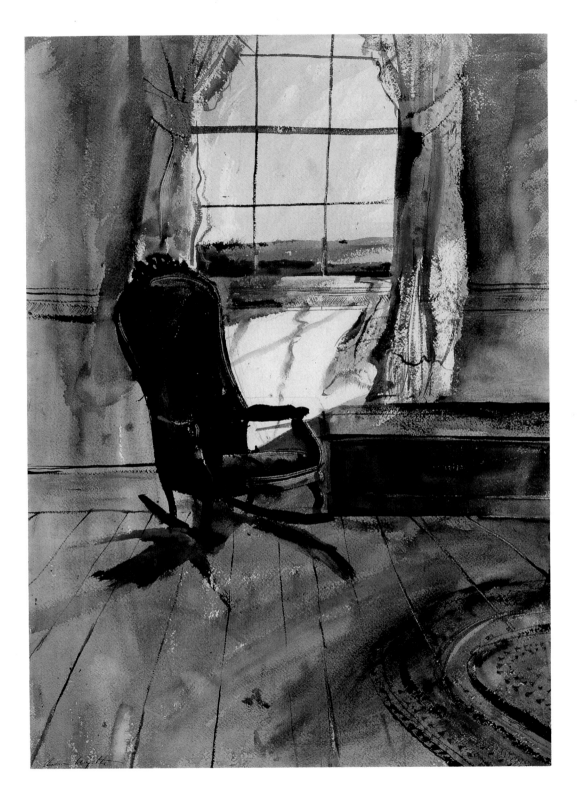

FRONT ROOM, 1946
Watercolor
28¾ × 21¼ inches (73 × 54 cm)
Private Collection

I was in Betsy's family's house one day—the same place where I painted *Chambered Nautilus* (see page 2). What caught my attention in that front room was that Victorian chair and the tension and imbalance between its stolid shape and the rockers. It's one of the most freely brushed pictures I've ever done—very spontaneous. There's an appealingly strange pink glow about it.

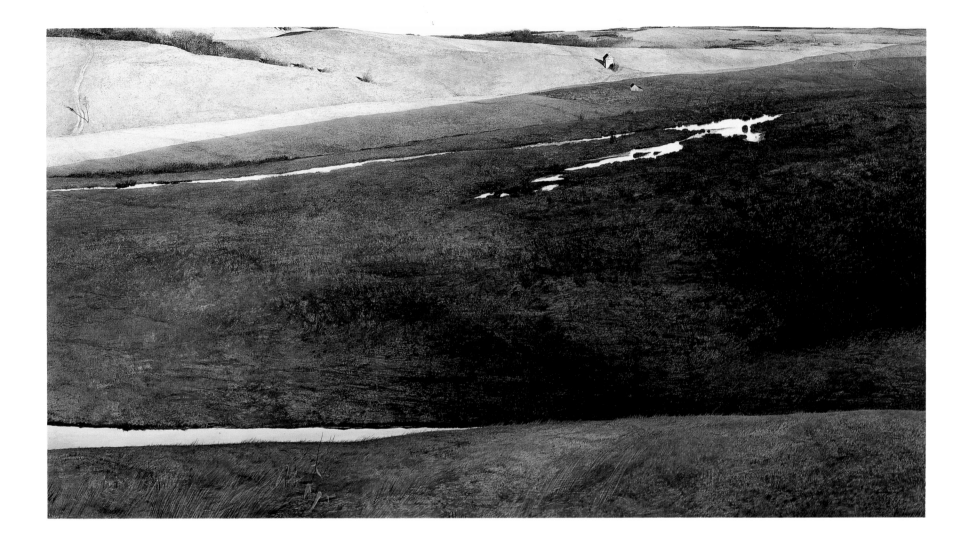

HOFFMAN'S SLOUGH, 1947
Tempera on panel
30 × 55 inches (76.2 × 139.7 cm)
Everson Museum of Art, Syracuse, N.Y.
Bequest of Jane R. Mayer

The idea began with a drawing I'd worked on one whole winter and left when I went up to Maine. When I saw it again, I was struck by its abstract shapes. It's not often that I will come back to Chadds Ford and finish something. That dark swamp intrigued me, sitting up there on that ridge like an eyelid shutting down. It's pure gold at the top, and the rest is deep browns and ochers but for the glints. The one dried leaf in the foreground is important, as is the little building in the far distance, both of which give the picture its sense of space.

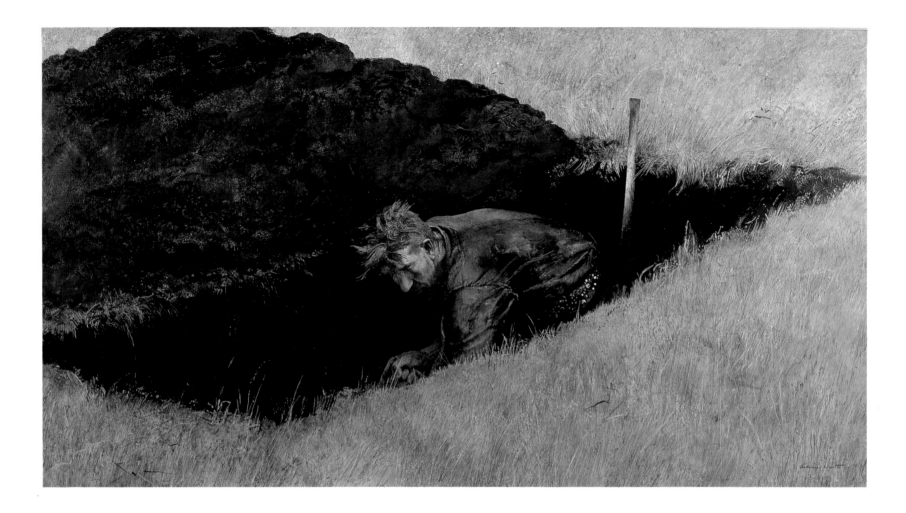

THE SEXTON, 1950
Tempera on panel
21 × 38 inches (53.3 × 96.5 cm)
Peter Howle Brady

An old lady had died—this was in Maine—and I went over to the graveyard, the same one where my wife Betsy's mother is buried. I heard this sound of a pickax hitting the dirt, and there was Waino Mattson, the Finn who worked in the quarries and also dug the graves. There he was at work, swigging on a bottle of beer. The shape of the grave in the rocky soil impressed me, and that amazing man down there digging away. He's the sexton, of course. I changed the title. Didn't like the first one—*She Didn't Winter Well*.

TOLL ROPE, 1951

Tempera on panel
28¾ × 11¼ inches (73 × 28.6 cm)
Delaware Art Museum, Wilmington, Del.
Gift of Mr. and Mrs. William Worth

This is inside the church at Wylie's Cor-
ner in Maine. I liked going up in the
belfry. The dry quality of that church
steeple, the dried flowers, and the sea an-
chor wrapped in black crepe from the
seamen's funerals made a strong impres-
sion on me—totally New England.

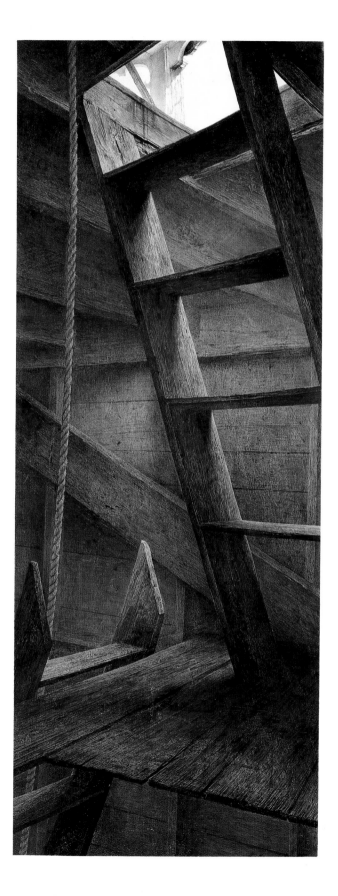

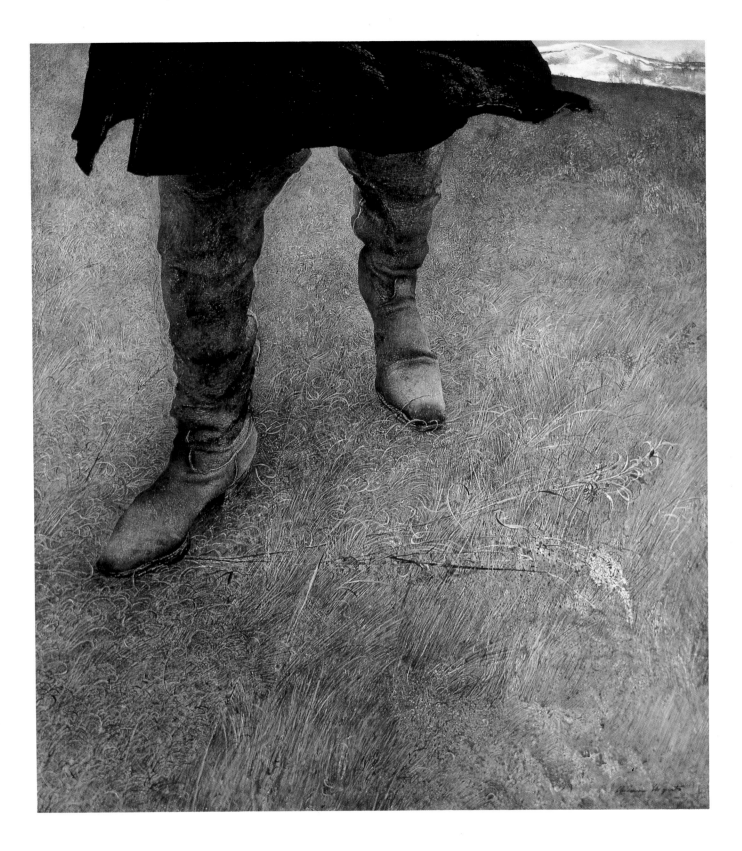

32

JAMES LOPER, 1952

Tempera on panel
43½ × 21 inches (110.5 × 53.3 cm)
Collection of the Brandywine River Museum,
Chadds Ford, Pa.
Gift of Harry G. Haskell, Jr.

He's one of the people I grew up with in
Chadds Ford. His belt was a horse's harness,
and his shoes were cut out to get air. Here
he is with that scythe, staring off into the
distance looking like the silent film star
John Gilbert.

◀ TRODDEN WEED, 1951

Tempera on panel
20 × 18¼ inches (50 × 46.4 cm)
Private Collection

A self-portrait. It was after a dangerous eight-hour oper-
ation on my lung. Afterward I walked and walked the
country around Chadds, getting my strength back, wear-
ing these French cavalier's boots which belonged to the
painter Howard Pyle. As I walked, I had to watch my
feet because I was so unsteady. And I suddenly got the
idea that we all stupidly crush things underfoot and ruin
them—without thinking. Like the weed here getting
crushed. That black line is not merely a compositional
device—it's the presence of death. Before my operation I
had been looking at Albrecht Dürer's works. During the
operation they say my heart stopped once. At that mo-
ment I could see Dürer standing there in black, and he
started coming at me across the tile floor. When my
heart started, he, Dürer—death—receded. So this paint-
ing is highly emotional—dangerous and looming. I
like it.

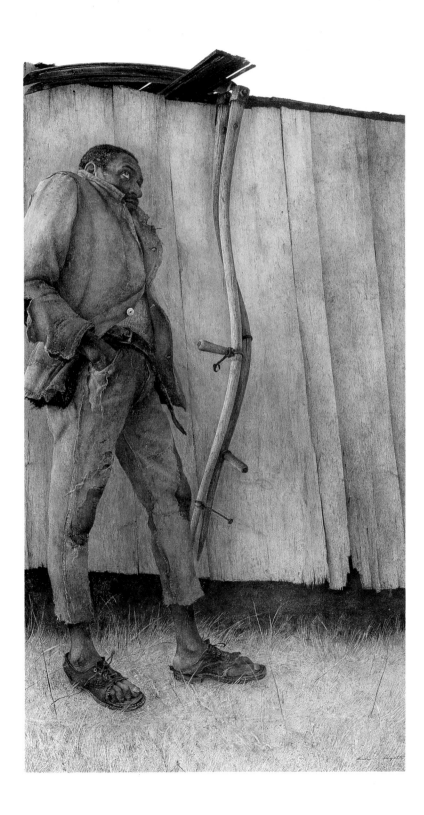

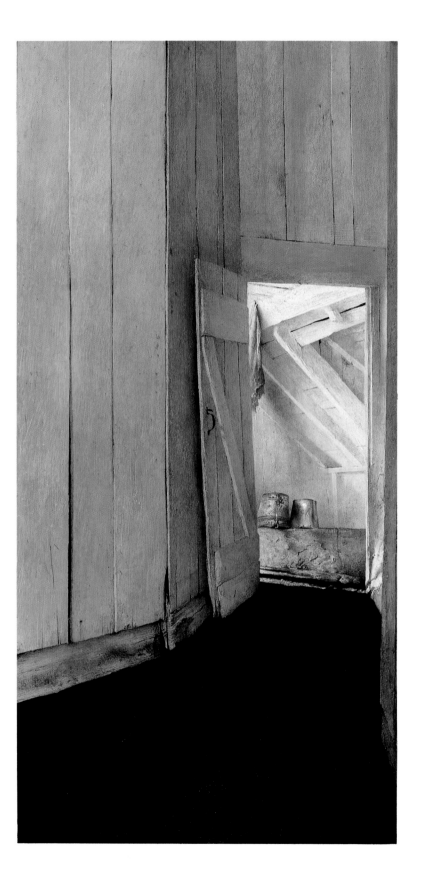

COOLING SHED, 1953*
Tempera on panel
24¾ × 12⅜ inches (62.9 × 31.4 cm)
Private Collection

Imagine this! As a kid I was always building houses of cards. In this tempera I wanted a feeling of a stacked card house. I was moved by those cardlike whitewashed walls twisting through the luminous shed. I was taken by that piece of chamois and especially those gleaming buckets, like the helmets of medieval knights. And I was taken by the sounds— sounds are so important in my work. Here I wanted to portray that hollow tin sound when the buckets would be filled. This is far from just a bucolic or farm scene. I was thrilled to find such abstraction in the every day.

BLUE DOOR, 1952
Watercolor
29 × 21 inches (73.7 × 53.3 cm)
Delaware Art Museum, Wilmington, Del.
Special Purchase Fund

Christina Olson's. I was trying to capture
the afternoon light and the ragged feeling
of that house. It was a foggy day, and I
loved the defused light hitting all those
ragged things and how the peculiar
shadows were cast from those strange
buckets.

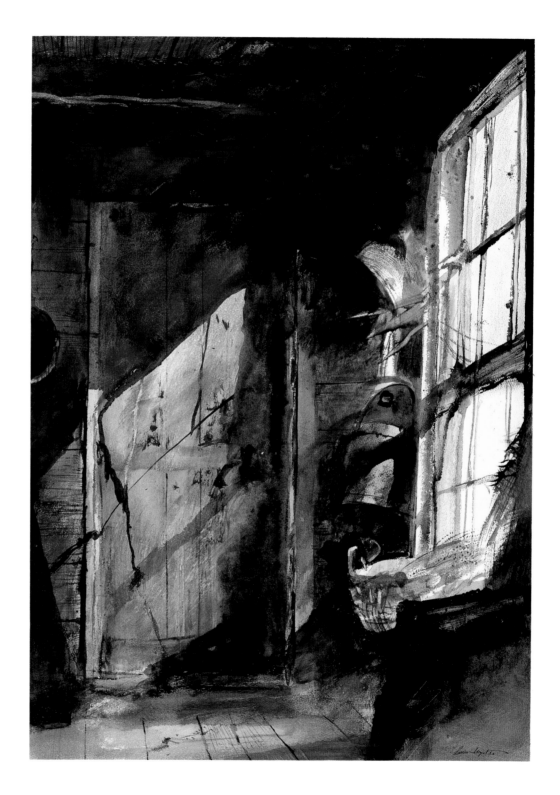

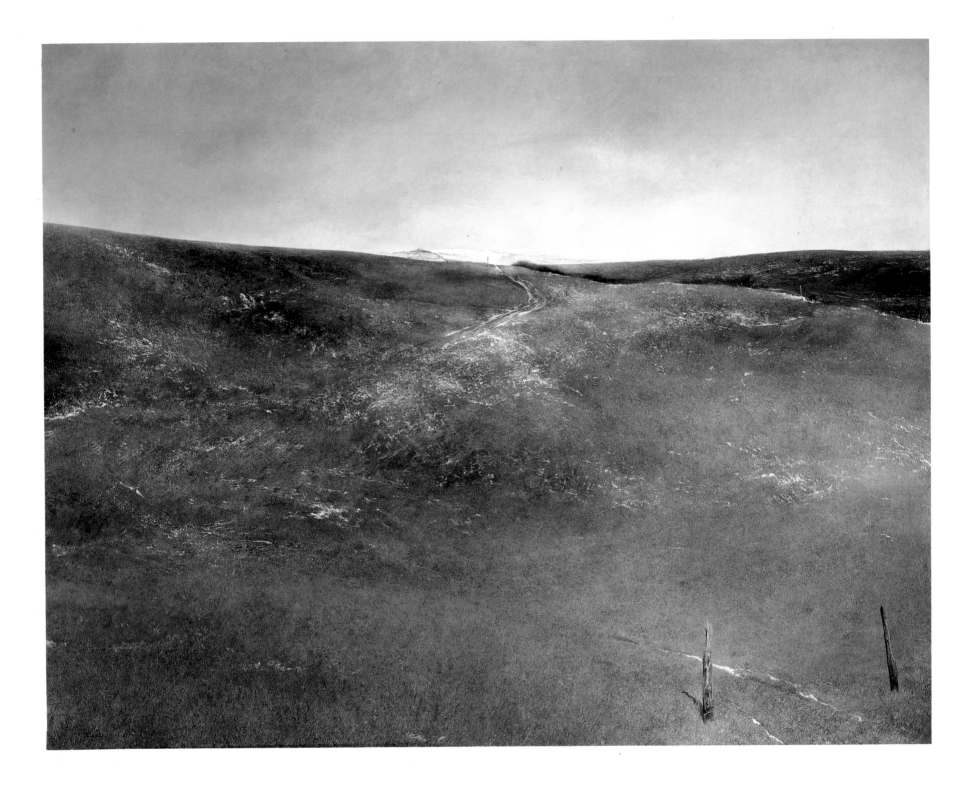

◀ SNOW FLURRIES, 1953
Tempera on panel
34¼ × 48 inches (87 × 121.9 cm)
National Gallery of Art, Washington, D.C.
Gift of Dr. Margaret I. Handy

I spent almost a year on this tempera because I was fascinated by the motion of those cloud shadows on that hill near Kuerner's farm and by what that hill meant to me. I've walked that hill a hundred times, a thousand times, ever since I was a small child, so it was deathless as far as I was concerned. I could probably just paint a hill for the rest of my life. Actually . . . Margaret Handy, who owned *Snow Flurries,* said that the one thing that bothered her about the painting was the presence of the fence posts. But by taking out the fence posts I think I would have gone too far. I think you can overdo it in simplification. You can be too Homeric, too life-eternal. I don't like that either. It's a very fine boundary.

FLOCK OF CROWS, 1953
Study for SNOW FLURRIES, drybrush
9¾ × 19¼ inches (24.8 × 48.9 cm)
Collection of Mr. and Mrs. Andrew Wyeth

For *Snow Flurries,* but these crows never made it into the tempera. They are actually what got me going on the picture. Strange what does. It's usually infinitesimal—half an inch of a vital idea. You cling to it for a while and then maybe destroy it.

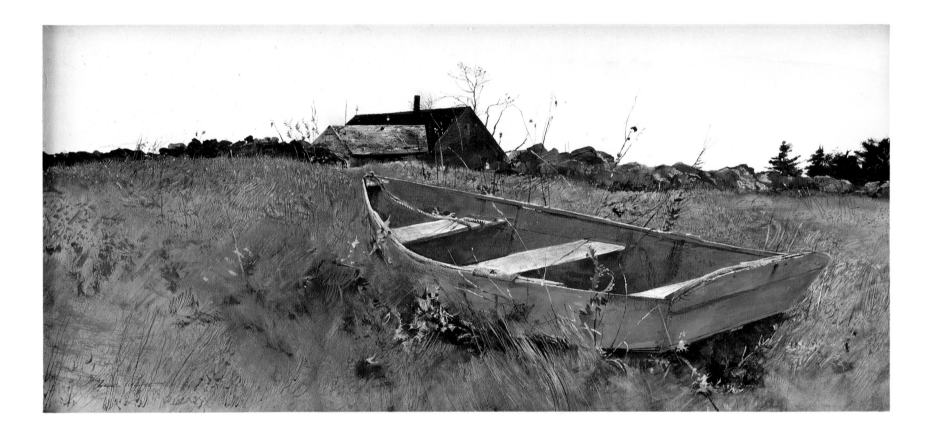

TEEL'S ISLAND, 1954
Watercolor and drybrush
10 × 23 inches (25.4 × 58.4 cm)
Gallet Co., Ltd., Japan

Henry Teel had a punt, and one day he hauled it up on the bank and went to the mainland and died. I was struck by the ephemeral nature of life when I saw the boat there just quietly going to pieces. The actor Bob Montgomery had this painting and one day asked me if I minded if he traded it for a certain Winslow Homer. I said okay, though I was aghast, for the Homer looked not so good. The dealer who had the Homer asked me on the side if I thought *Teel's Island* was any good, and I replied that it was one of my best. So the trade was made, and the dealer sold this to Joe Levine for a large amount. Montgomery wouldn't speak to me for the rest of his life. He thought I'd concocted the deal.

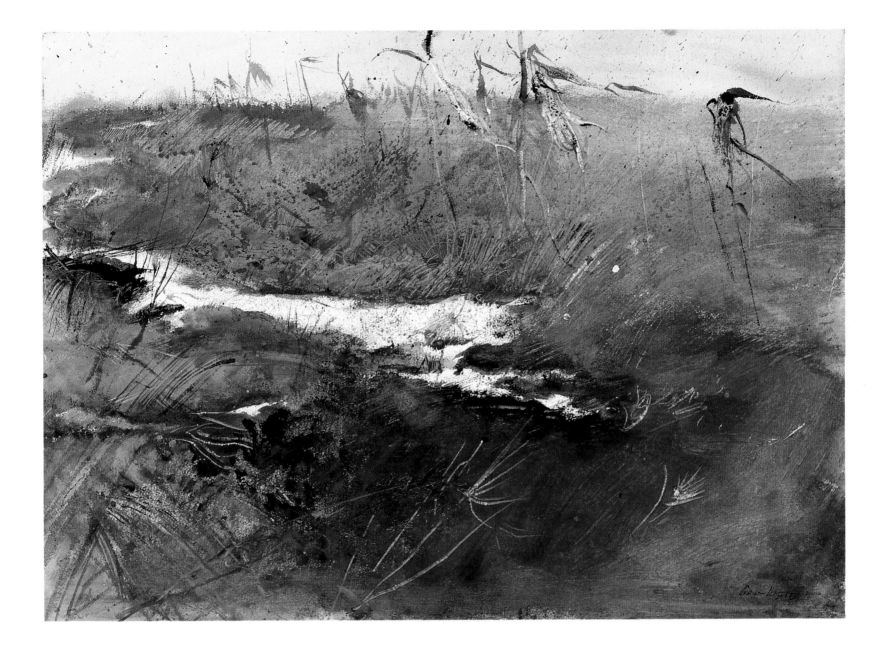

EDGE OF THE FIELD, 1955
Watercolor
19½ × 26½ inches (49.5 × 67.3 cm)
Colby College Museum of Art, Waterville, Me.
Gift of Miss Adeline F. and Miss Caroline R. Wing

Talk about a bleak painting! Just before my father died, he told me that he was worried about my future because of my lack of color. But the art critic Aline Saarinen told him, rightly, that the somber feeling was my strength. It's a marvelous stalk of corn with the few ears and the snowdrift and the feeling of things skidding over the snow. Come to think of it, it is rather astounding that I've been able to sell this kind of picture. But this kind of thing *is* life in the country.

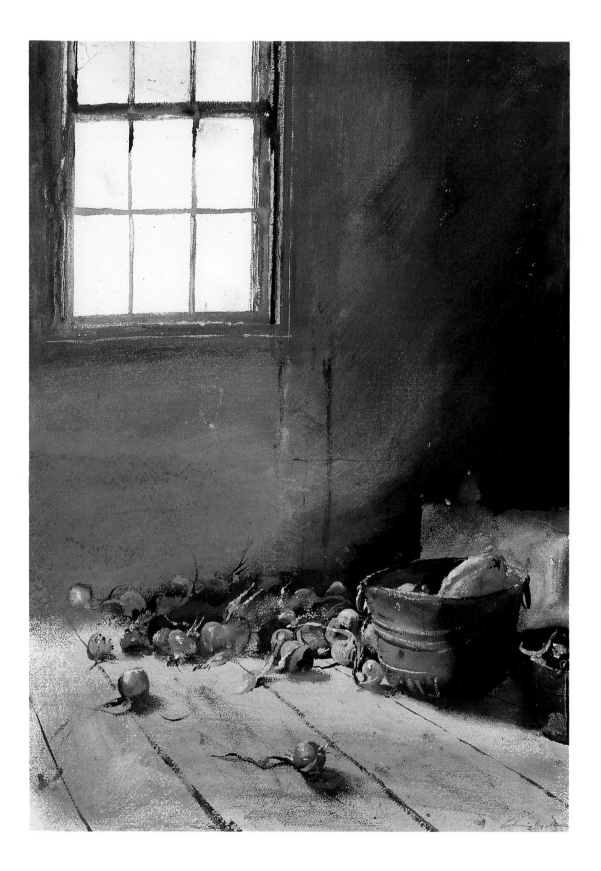

ONIONS, 1955
Watercolor
27 × 19½ inches (68.5 × 49.5 cm)
Yamaso Art Gallery, Japan

Funny things get to me. Here it was that
odd, slightly reddish cast of those Ber-
muda onions on the dry, brown barn
floor that caught my attention, and I felt I
had to capture the feeling. Strange feel-
ing, too.

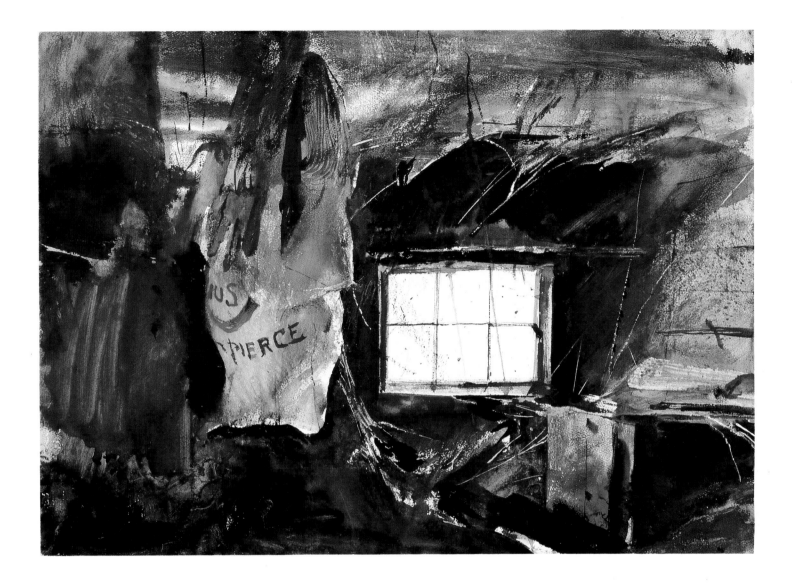

BLUE BOX, 1956
Watercolor
21 × 29 inches (53.5 × 73.7 cm)
Private Collection

This is a watercolor inside the barn at Olson's in Maine. There's hay hanging down and a bag with some lettering, and that's a blueberry machine. The little window is the one that shows up in *Christina's World*. I was interested in the shadows on the chimney made by the swifts. I liked all the drabness of the barn, the dung of the animals—

a real New England barn with the light hitting the cobalt blue of that machine, which was like the color of blueberries themselves, which is why I painted it. I feel very strongly about one note of bright color in a picture. I like to play up one color. That's where I'm a little oriental. When I play that color, it can't be too much, not too obvious, just the right balance. And it can't be contrived. It's just got to happen. It was around the time I was painting *Hay Ledge* (see page 48). I was working night and day at Olson's, much of the time in the barn. I got completely wrapped up in the Olsons. I had a studio at the time, but this, too, was a kind of studio.

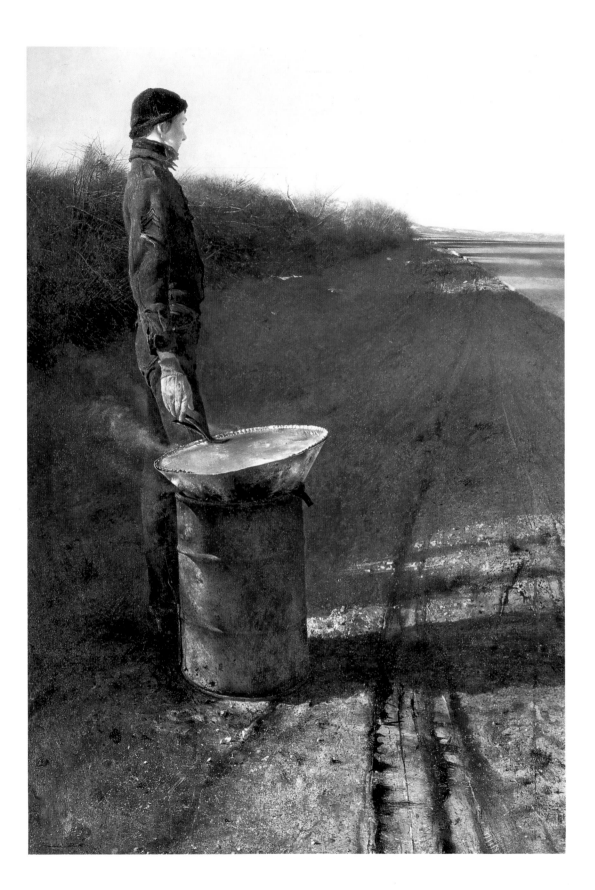

ROASTED CHESTNUTS, 1956
Tempera on panel
48 × 33 inches (121.9 × 83.8 cm)
Collection of the Brandywine River Museum,
Chadds Ford, Pa.
Gift of Harry G. Haskell

The boy is Allen Messersmith, and I saw
him standing there on Highway 202 near
West Chester down in Pennsylvania. The
tracks seemed to me almost like those made
by ancient Roman chariots. There's a sort of
ancient feeling about this picture and the
young man. He's wearing an Eisenhower
jacket. Funny, Ike had this painting on loan
in the White House for half a year. He liked
it very much. I sent Ike some roasted
chestnuts, and he enjoyed them, too.

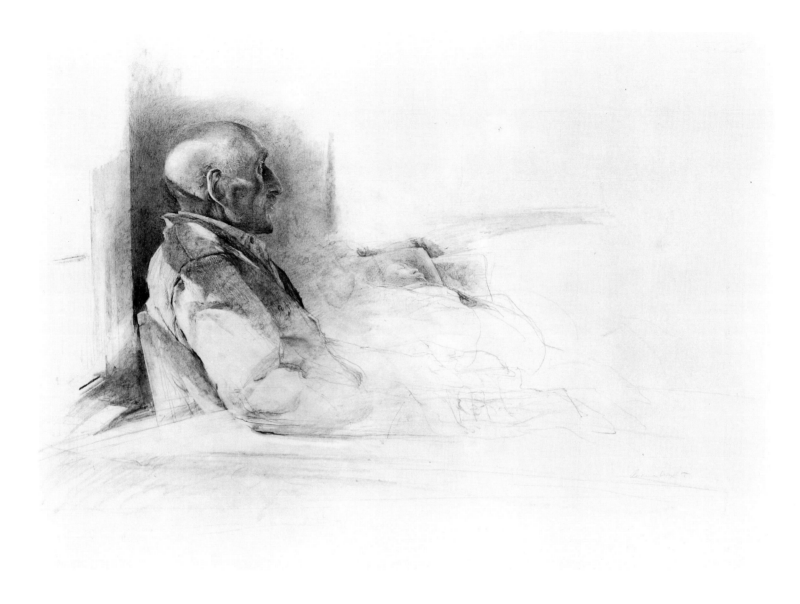

TOM AND HIS DAUGHTER, 1959
Pencil
15⅞ × 22 inches (40.3 × 55.9 cm)
Collection of Mr. and Mrs. Andrew Wyeth

She'd had a date the night before and was still groggy from the alcohol and the sex, I suppose. There he is so dignified, and she's almost disappearing, or maybe coming to life. His gesture is almost a creative one, making her come alive.

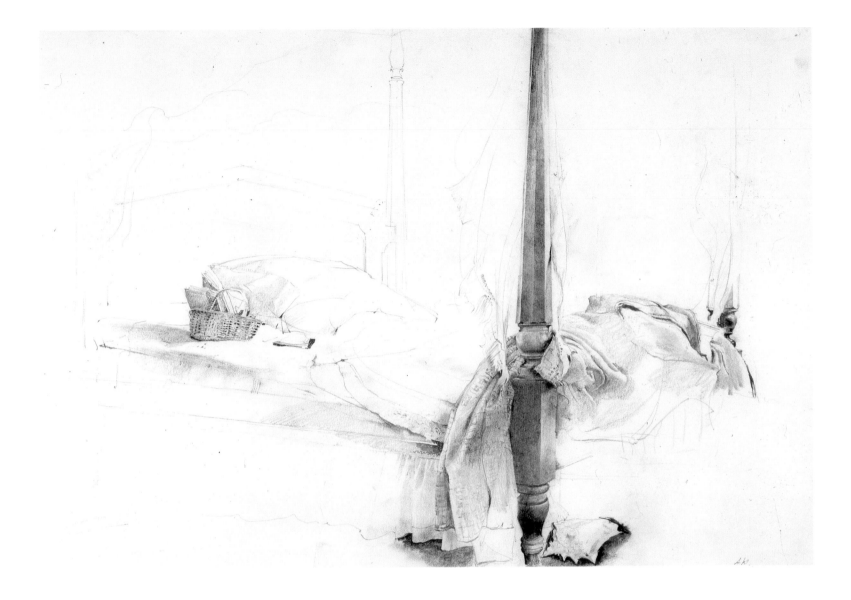

THE BED, 1956
Study for CHAMBERED NAUTILUS, pencil
13⅜ × 19⅞ inches (34 × 50.5 cm)
Mr. and Mrs. Andrew Wyeth

A study for *Chambered Nautilus* (see page 2), but not the first concept. Here, I was interested in the comparison in shape between the bed spindle and the canopy wrapped around it. I felt almost magnetized by that bedpost.

44

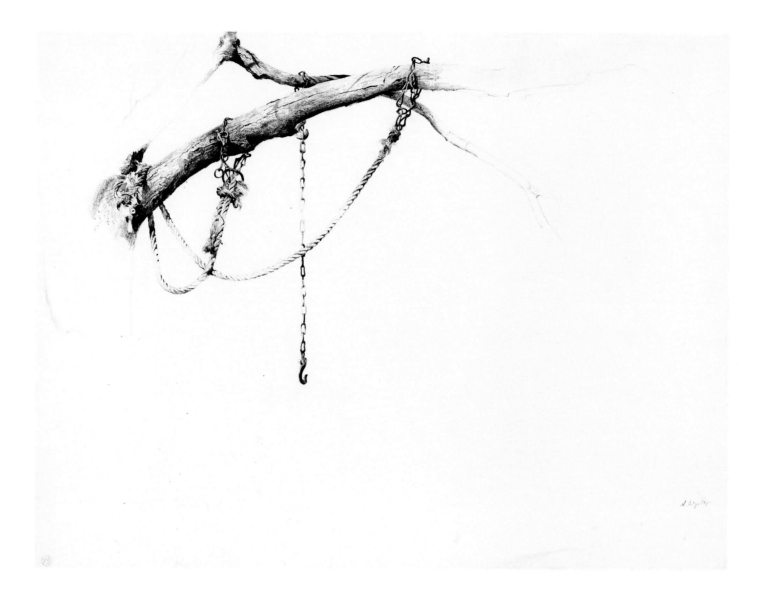

ROPE AND CHAINS, 1956
Study for BROWN SWISS, pencil
16¾ × 22¾ inches (42.5 × 57.8 cm)
Collection of Mr. and Mrs. Andrew Wyeth

This is a study for *Brown Swiss* (see page 47). The tree and chain was where Karl Kuerner had been slaughtering a pig. Under the chain are some child's bells—don't know how they got there—which to me give a childlike innocence to the brutality that goes with everyday farm life. At first I was disappointed at having missed the killing of the pig, but then I realized that these chains and the rope (and, of course, the bells) were better than having been present at the "gory details." Like this the drawing's more powerful; it's got no forced drama. It's natural.

45

BROWN SWISS, 1957
Tempera on panel
30½ × 61 inches (77.5 × 155 cm)
Private Collection

Brown Swiss was like doing a person's face—so complex! It's like a double portrait, because of the reflections of the house in the pond. If you look closely, you'll see many very fine details: for instance, the tin dishpan sitting there on the porch; and if you look in the top windows, you'll see the ceiling of the attic room where there are those strange hooks on which the Kuerners hung slipcovers, sheets, sausages, and onions, and those hooks are even reflected in the pond. All these things are related to the true sense of portraiture.

I had come in from walking over the hill late in the afternoon one November, and I suddenly saw the Kuerner house and the hill reflected in the pond. It got me. I went into my studio. A bottle of Higgins' ink was on my desk. I grabbed it and with a large, number 12 sable brush quickly did a first deep impression. The real conception, that quick flash, is a drawing done very freely. I wasn't satisfied with it, so I turned the page over and did a second one—in seconds—and put it in a drawer. Days later I happened to open the drawer, and this blackwash drawing caught my eye. Oh, oh, that's it, I thought. The balance, the flash of that black thing, brought the image of the scene clear to my mind, and I recalled the marvelous amber color of the rich landscape and the lucid pond looking almost like the eye of the earth reflecting everything in creation.

I made dozens of absolutely accurate drawings, but every once in a while I'd open that drawer and take a look at the black thing to keep it in my mind. After a month or so I placed a big tempera panel on my easel. The blank white is very exciting to me. When I started to paint *Brown Swiss,* I put the dozens of absolutely accurate drawings I'd made in the corner, and without referring to them at all, I started to work with charcoal, very freely, glancing at that first black abstract thing.

Brown Swiss is a double portrait of not only the Kuerner house but everything that is going on in that house. Many things are personal to me. The green rocks on the bare right side are serpentine that came from a house across the way that I'd known all my life. I used to go up there as a kid and see these ruins, which fascinated me. Karl Kuerner went up there and knocked some of that green serpentine down and used it for his porch and gateposts.

You can see the attic windows reflected in the pond. You're looking directly into them, but at the same time you're looking under them, too. You're looking up into the ceiling, and in the painting you can see details within that room. You can look right up under the eaves by means of the reflection in the pond. The picture mirrors almost all times of the year. I may have finally made it late afternoon in November, but it could be almost any time of day. The crystal quality of ice that was there from time to time showed up not only in the pond but in the dishpan, which is very silvery with a black shadow inside. It's almost as if it were a pond with ice in miniature.

The picture developed as I went along. For a while I had trees on the spare expanse on the right side. For a while I wanted the Brown Swiss cattle to be there. So I drew dozens of studies of the cattle, then I realized that just their tracks were better. Now some people say this painting is unbalanced, but to my mind the vacancy on the right balances the fullness on the left where the house is. The length of the picture is exactly what that first exciting idea was to me.

The painting is much higher in key than the original thought—not black-and-white. I didn't want it to be overdramatized. I wanted it to be almost like the tawny brown pelt of a Brown Swiss bull.

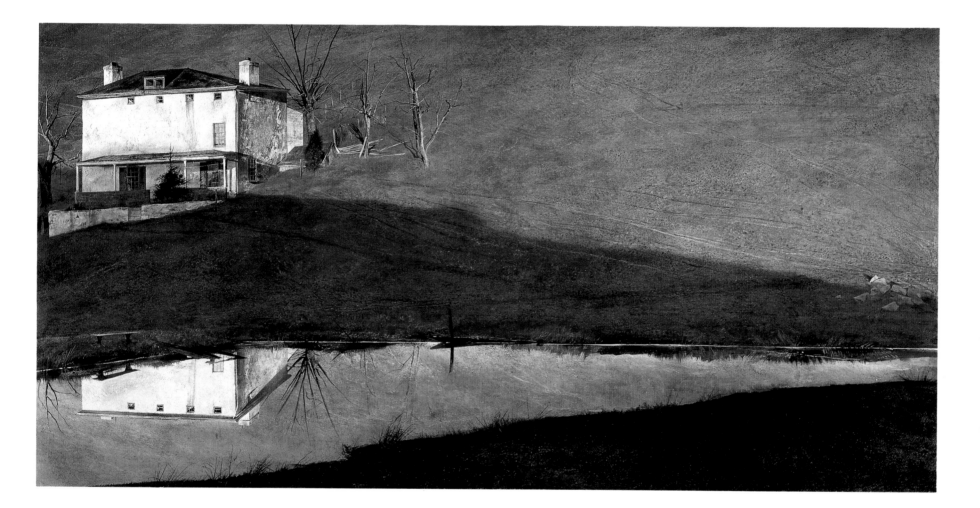

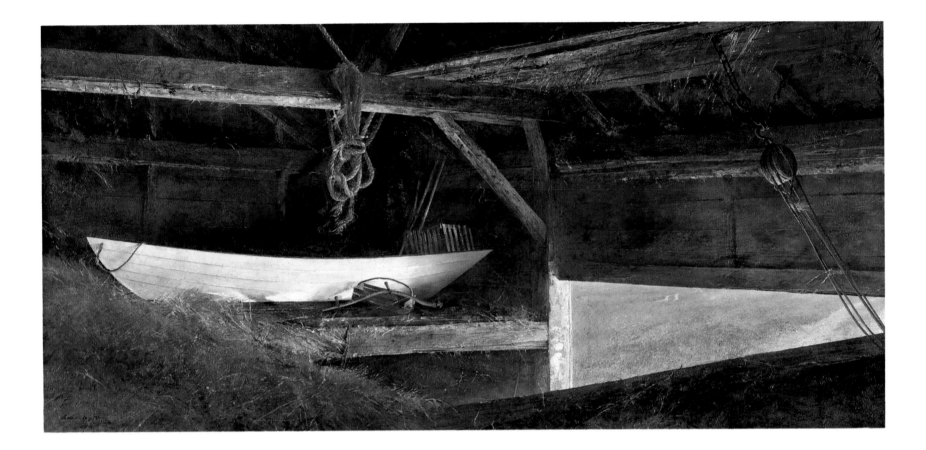

HAY LEDGE, 1957
Tempera on panel
21½ × 45¼ inches (54.6 × 114.9 cm)
Gallet Co., Ltd., Japan

Alvaro Olson used to fish and go lobstering, and then when his mother and father died, he realized that he'd be the only one who could take care of his sister, Christina. So he stopped lobstering—just stopped—and put his dory up in the loft. That beautiful Penobscot dory sat up in that loft in the hay. There were some boards with openings in them to hold up the hay, and the sun would come through and hit the boat. It reminded me of the phosphorescence that you get in seawater. I called it *Hay Ledge* because there's a ledge off the Georges River called Hay Ledge. But, of course, that was a different type of hay ledge.

RACCOON, 1958 ▶
Tempera on panel
48 × 48 inches (121.9 × 121.9 cm)
Collection of the Brandywine River Museum,
Chadds Ford, Pa.
See page 168 for list of donors.

You know, I'm not sure if I like this picture myself. The woman at the desk of the gallery in New York where it was first displayed said she thought she'd gotten fleas from that dog. He was a fabulous model. The poor creature was shot by the bastard who'd hunted with me. God, he was mean to those dogs—the sun would hit them only for a short time, and the rest of the time they'd be in a dark, dank place. I painted this, more than any other tempera, with a palette knife, because I wanted to get the feeling of the heavy masonry of the building. Thinking it over, maybe I *do* like it.

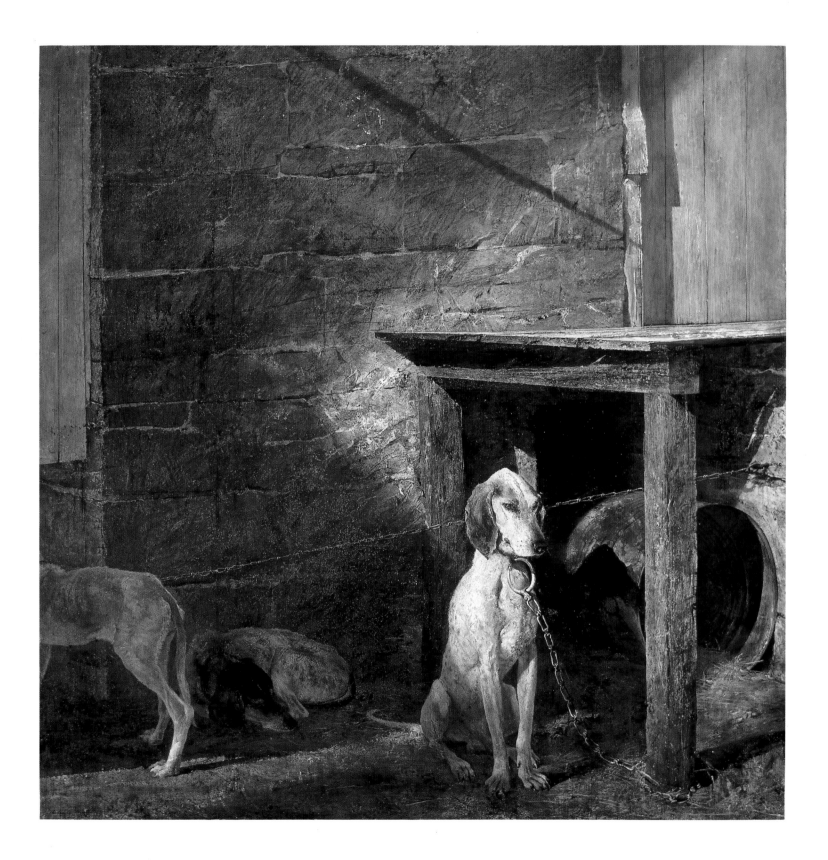

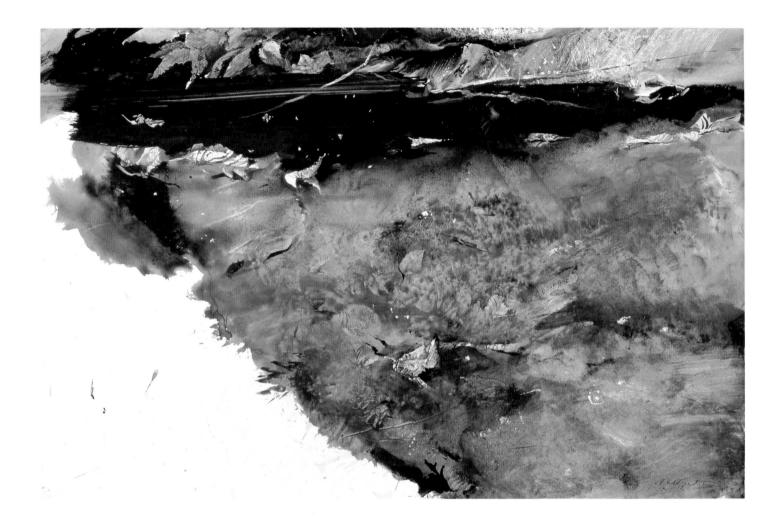

FLOATING LEAVES, 1958
Watercolor
13½ × 21 inches (34.3 × 53.3 cm)
Collection of Mr. and Mrs. Andrew Wyeth

The strange tempera called *Thin Ice* that I did later (1969) came out of this, but it's quite distinctly different. I was taken by the shape and idea of those leaves suspended, floating in the stream. I was intrigued by the concept of leaves floating and disappearing— exciting and melancholy at the same time.

GROUNDHOG DAY, STUDY, 1959
Watercolor and pencil
22½ × 16¾ inches (57.2 × 42.5 cm)
Collection of Mr. and Mrs. Andrew Wyeth

The work started off with Nellie, Karl
Kuerner's German shepherd—all his
sheepdogs had the same name—and Anna
was in there, but they both came out,
and I left only the gum tree with its
sharp fangs outside the window and the
table set with a knife—that's Karl because
he ate with a knife most of the time, no
fork. In the beginning I made many
drawings of that dog sleeping because she
was so important, but then I got inter-
ested in the table and the window, so the
dog disappeared, though the animal is in
the ragged, chopped, sharp sliver part of
the log.

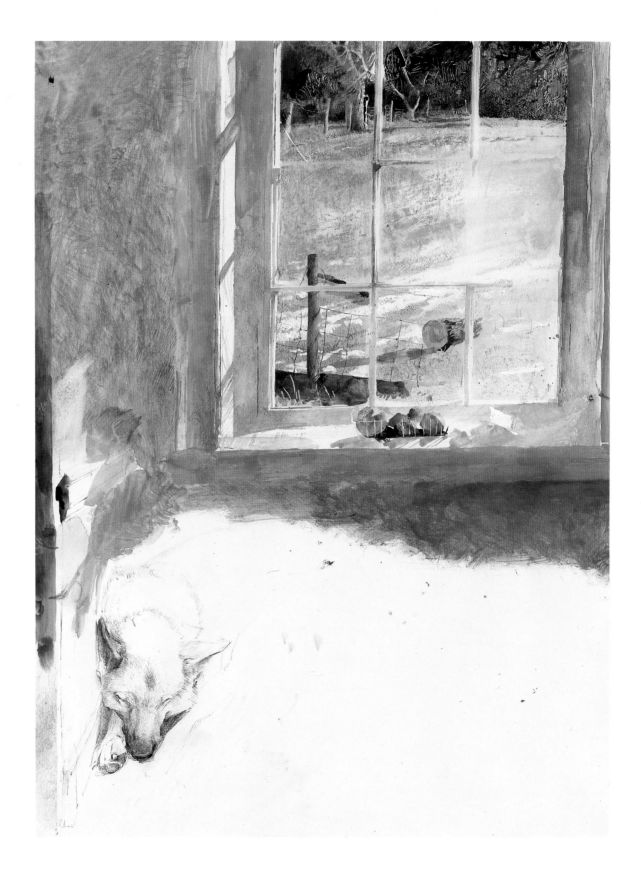

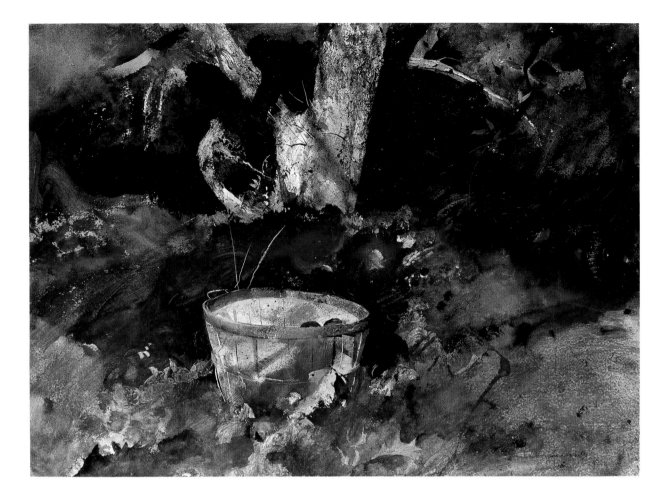

HALF BUSHEL, 1959
Watercolor
21¹¹/₁₆ × 30 inches (55 × 76.2 cm)
Joslyn Art Museum, Omaha, Neb.

This painting of apples was done in the late fall in Pennsylvania in my father's orchard. It's a portrait of autumn. Subdued. Russet colors. Deep crimson of the apples showing through the basket. I wanted it to be a free interpretation. Around this time Betsy said that she was amazed at the mess in my watercolor box—"I don't know how you can work without knowing that all the tubes are in the correct place. Don't you have to know where the reds, the greens, the blues are?" I said, "Ah, but not knowing is my secret."

I like to be surprised when I pick up a tube. It makes the process more exciting, frees it. When I squeeze, I get this revelation of the color that comes out. It's accidental, but it's an accident that I take advantage of. Sometimes you can express the color of something without using the obvious color. For example, once I grabbed a tube of Chinese white when I was looking for blue. I simply found the

blue and used some of the Chinese white, too. The mixture produced a quality that was unbelievable.

This is something you could never tell an art student. And it's something I do only with watercolors. You're in the lap of the gods—almost like painting with your eyes half-closed. Sometimes I don't want to see too clearly. You build up a kind of color that is purely an interpretation of the truth. Anything to get away from the predictable. This applies to the design of a picture too. Painting is all about breaking the rules. Art is chance. It's like making love. Hell, you don't have a written book for sex; it's always spontaneous. I started out painting at an easel but soon gave that up. It was too formal, too pat. I like to be in the scene I'm painting—sitting on a snowbank, lying in a marsh.

GERANIUMS, 1960
Drybrush and watercolor
20¾ × 15½ inches (52.7 × 39.4 cm)
Collection of Mr. and Mrs. Andrew Wyeth

One of the most important of the Christina Olson series. I like the way you can see the red of the flowers, through the house, and out the window on the other side, then out to sea. The black thing, by the way, in the opposite window is a black-and-orange work glove her brother, Alvaro, put there. Christina's barely seen—just that flash of her striped shirt. She was like a scarecrow when she wasn't rooted in that chair—just bits of tattered rags and hair all askew. What interested me about her was that she'd come in at odd places, odd times. The great English painter John Constable used to say that you never have to add life to a scene, for if you quietly sit and wait, life will come—sort of an accident in the right spot. That happens to me all the time—happened lots with Christina. The whole point of this picture, which is very abstract, is how you look through the windows and how that brilliant point of color in the geraniums catches light from the other side of the house.

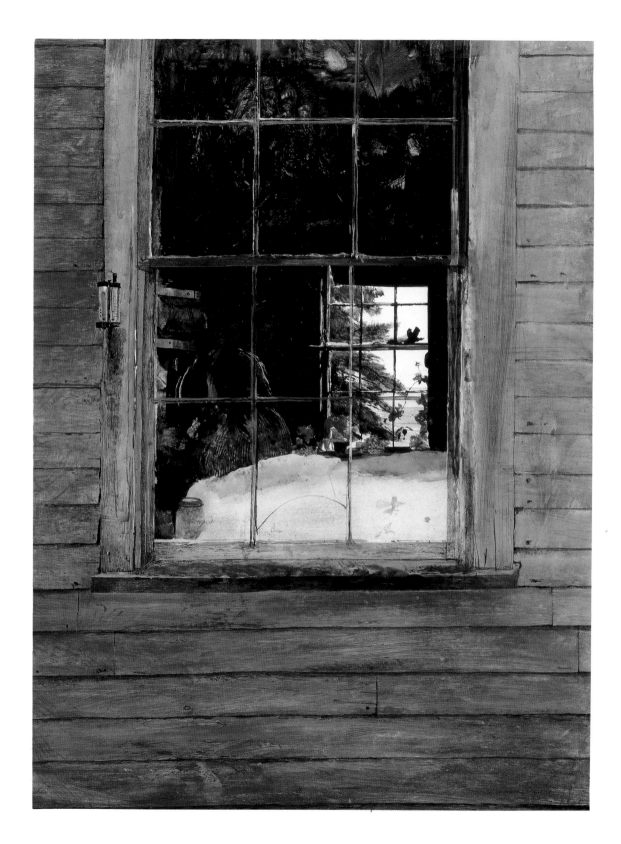

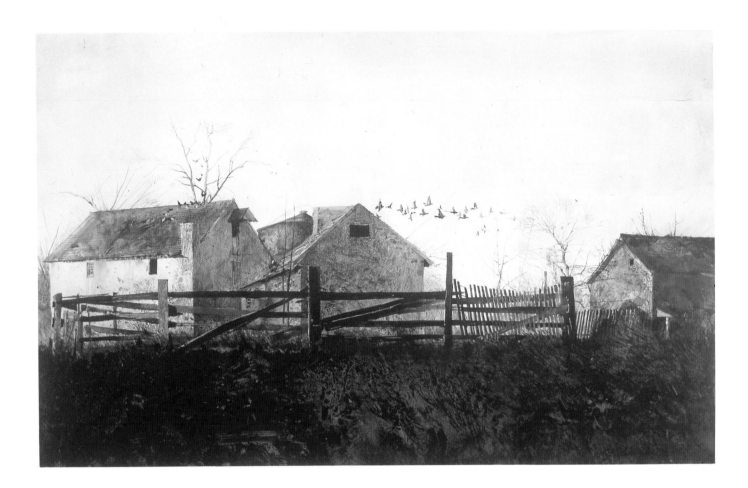

THE MILL, 1959
Watercolor
13¾ × 22½ inches (34.9 × 57.2 cm)
Private Collection

I think it's one of the best watercolors I ever did—fast, sure. We'd just bought the property in Chadds Ford, and this mill had not been fixed up yet and was falling down and highly mysterious.

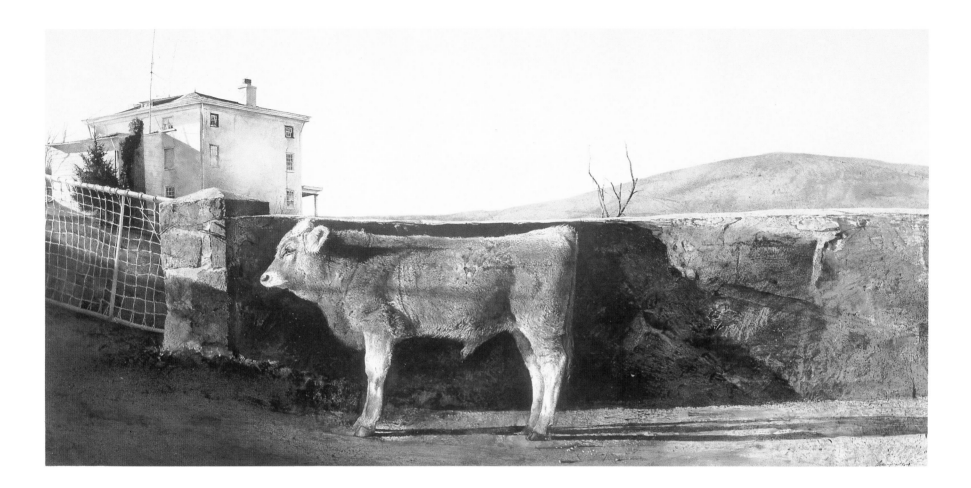

YOUNG BULL, 1960
Drybrush
19¾ × 41¼ inches (50.1 × 104.8 cm)
Private Collection

Of course, it's Kuerner's farm. I suffered through a long buildup for this drybrush—many, many drawings. When Karl brought the young bull out for me, I painted him on the spot. He was symbolic of so much of what went on at Kuerner's—the cattle and the house and the hills—tans and whites, the slight splash of urine on the hindquarters, the golden hill rising up behind, the house on the left, and the window where Anna was. I could hear her shouting, and every time she did the bull's ears would flicker and twist, and suddenly I could see that pink of the inside of his ear. I'd brought this long, scroll-like piece of paper. I started with the house and got interested in the bull's head, and the rest kind of flowed out from there. I kept on unrolling the paper, and the painting happened naturally. I was amused to be there by the road, in the country, just unrolling this scroll and getting it all down. It has a different sense of movement because of that scroll.

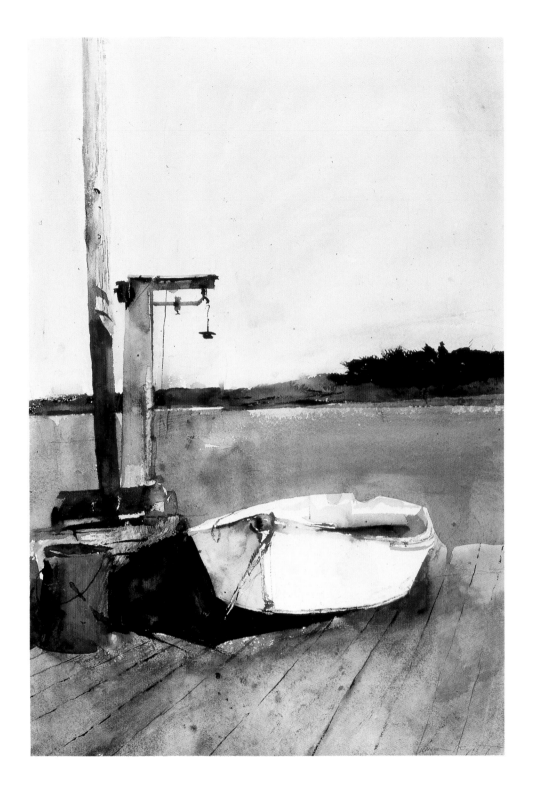

PLEASANT POINT, 1960
Watercolor
20 × 14 inches (50.8 × 35.6 cm)
Private Collection

Maine, near where I live. They sell the
lobsters they've just hauled in here. This
skiff has just come in, and there's the scale
to weigh the lobsters. It's so typical of
Maine—that pure white skiff in the early
evening, the sun hitting the delicate
scale. It's about delicacy and, even more,
a significant moment of time and place,
quiet and peace.

DISTANT THUNDER, 1961

Tempera on panel
48 × 30½ inches (121.9 × 77.5 cm)
Private Collection

The picture evolved in a strange way.
I had wanted to paint my wife, Betsy,
picking blueberries. I completed a num-
ber of drawings, but nothing worked. It
was just someone picking—sort of trite.
I really struggled but got nowhere. Until
I decided to hide. I sneaked along the
edge of the woods and found her sleep-
ing. I made a quick drawing. As I
finished it, I could hear thunder way off
in the direction of East Waldoboro. Sud-
denly, out of the grass, popped our dog
Rattler's head, his ears up, cupped, hear-
ing those distant sounds. The sky had that
yellowish cast it gets before big storms.
All of a sudden I realized that there was
too much face. I painted in the hat. That
made the picture.

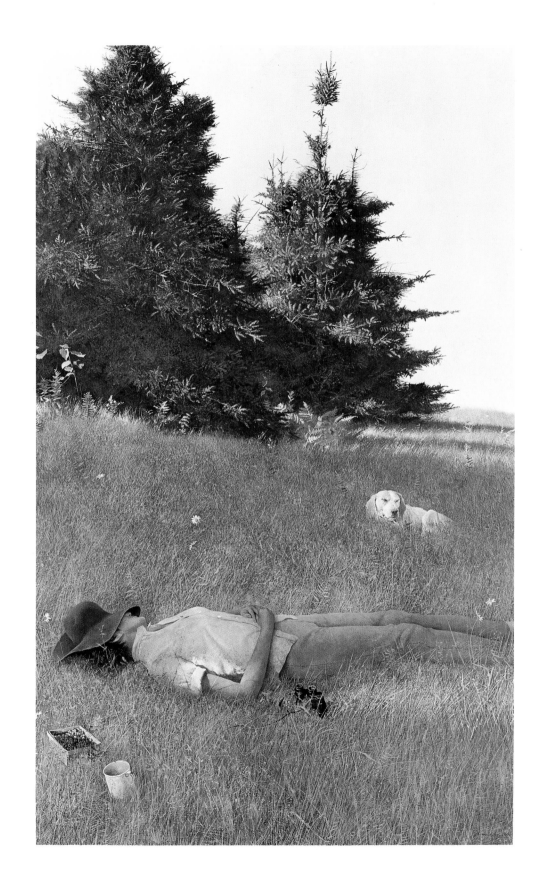

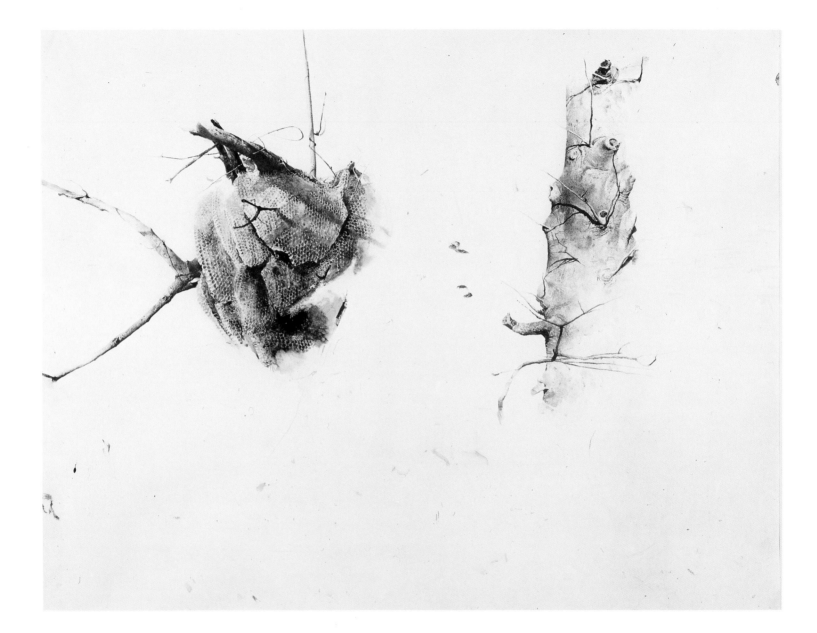

WINTER BEES, 1959
Drybrush
21 × 27 inches (53.3 × 68.6 cm)
Collection of Mr. and Mrs. Andrew Wyeth

The comb was bursting with bees. I found it low down on an oak tree in the night, and I watched, entranced, listening to the bees. When the sun came out the next day, they'd come out and sit on my brush. When American Indians found a big comb, they'd pitch a camp and have a celebration before getting the honey. God, the quality of that transparent, golden honey in those incredible hexagonals is amazing! I didn't finish it because some animal came and ate it. When it was at a show, along came the sculptor Jacques Lipchitz, the man who made all those huge bronzes, and he studied it for, I guess, half an hour, intrigued by the nature of it.

MILK CANS, 1961
Drybrush
13¼ × 20¾ inches (33.7 × 52.7 cm)
Collection of Mr. and Mrs. Andrew Wyeth

Pictures happen; you don't sit down to
make them. One day I was down at
Adam's farm in Chadds Ford and saw
these intriguing rusted cans in the cold
near that building where Adam kept his
pigs. Rust, cold, snow, those hills.

ADAM, STUDY, 1963
Watercolor
18¾ × 23⅞ inches (47.6 × 60.7 cm)
Collection of Mr. and Mrs. Andrew Wyeth

I found a tremendous charge of energy in
that strange shack. It reminds me of a
train barreling down a track. It's long,
elongated, like Tom Clark.

Garret Room, 1962
Drybrush
17½ × 22½ inches (44.5 × 57.2 cm)
Private Collection

I made this drybrush of Tom Clark in his attic room. I came across him—I just prowl around people's houses, when they let me, of course, at all times of the day and night—stretched out on that amazing bedspread that his grandmother had made. I guess the length of the figure is exaggerated, although he *was* tall. A few days before, his daughter had told me, "When we get the casket someday, we won't be able to find one big enough—will have to take off his shoes, I guess." Tom had the bluest eyes and very thin lips. Notice the red around his hands, almost like blood. When I find an exciting subject, I find it easy to relate it to other evocations. The scene in front of me is only a window to a whole universe of other ideas. I try to go far beyond the pic-torial. Otherwise it'll be simplistic—you know, merely an old Negro lying on the coverlet. What I wanted to get here was very much the feeling of party and holiday and bright-colored flags. To me he had become a king laid out there in state. Seeing him reminded me, too, of a vivid childhood experience—the echoes of a Christmas stocking I used to feel on my own bed when I was very young. Before I went to sleep I'd feel it and it was thin—disappointing. When I awakened, still in the dark, it was thick and full, and there was some sort of figure sticking out of the top. As dawn came, I could see the figure but was afraid that when the light hit it, it might evaporate. Tom Clark was like the stocking and the thing in the stocking.

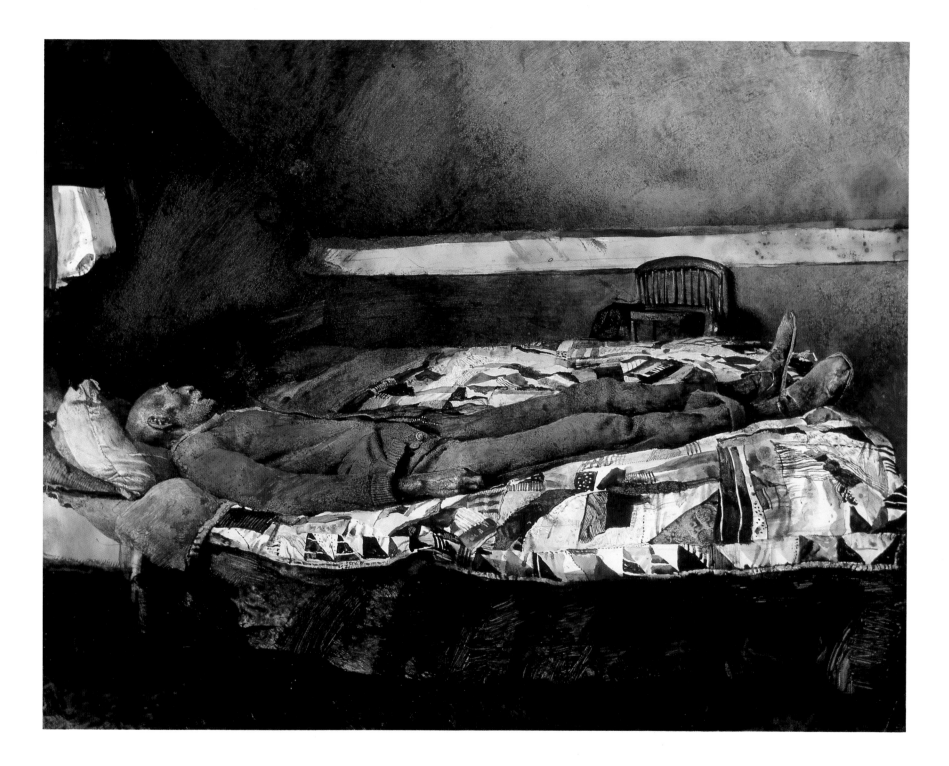

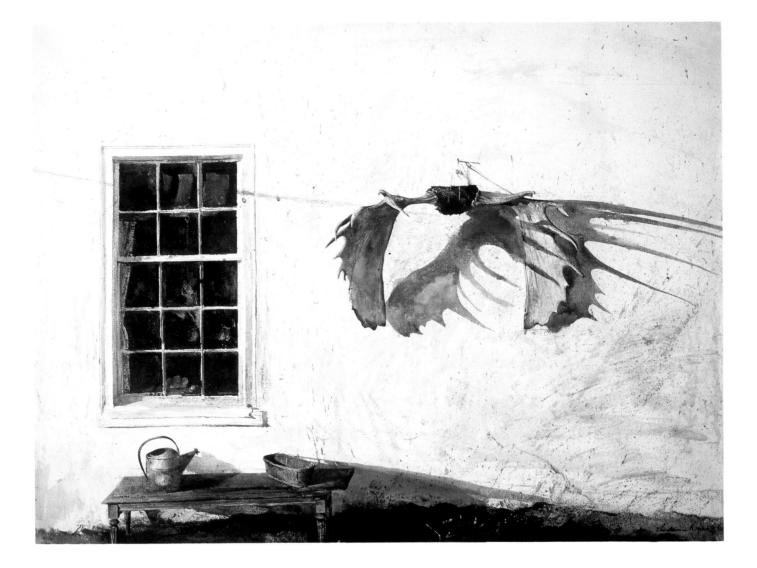

THE TROPHY, 1963
Watercolor
22⅜ × 30½ inches (56.8 × 77.5 cm)
Mr. and Mrs. Tate Brown

Karl Kuerner would hunt in northern Maine and would bring back the racks and hang them around the house. I came over the hill one day and saw that strange shadow. It summed up a lot of Karl's sharpness. God, he had a quick mind and eye. I never had to romanticize Karl. I loved the hidden side of his nature. He was sort of a father, yes, but I also knew about the Negro girl he'd taken into his attic, and that's in his portraits. I never look at the outer surface of a person. My people aren't just "characters."

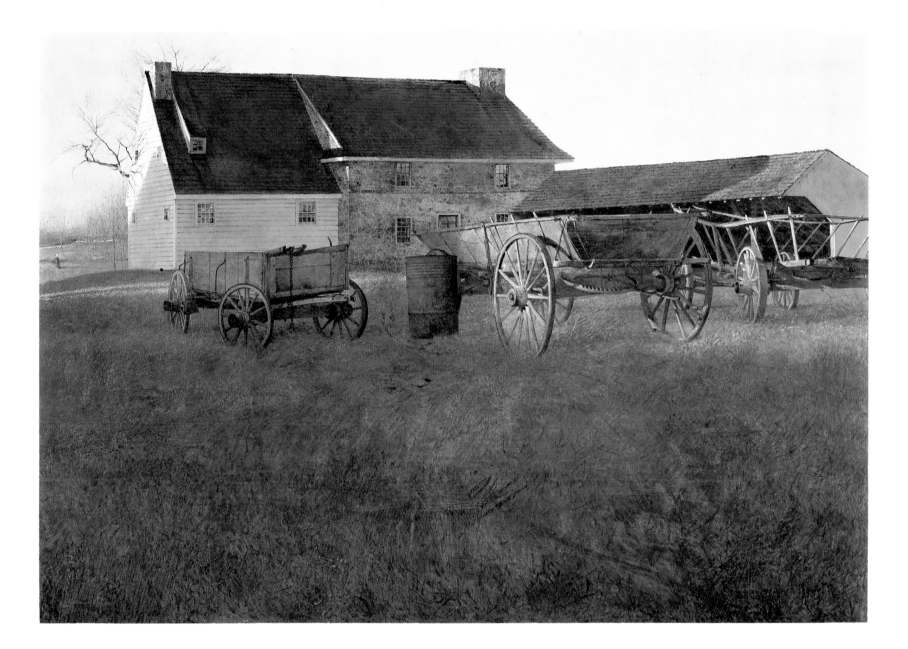

MARSH HAWK, 1964
Tempera on panel
30½ × 45 inches (77.5 × 114.3 cm)
Private Collection

This tempera was done in Pennsylvania. The hay wagons were given to me by the Harveys, who lived nearby. I found their colors wonderful and their craftsmanship beautiful. I was taken by the shape of the carts and the way the wheels were built. They dated back to around 1850–1860. Their wheels and hubs were magnificently constructed. Some of my best drawings are details of them. To think that these very wagons rolled over those rugged hills of Chadds Ford! The title comes from the marsh hawk sitting on the fence in the left distance. Late afternoon light is streaking across. The wagons were all swept away in a flood down the river to Wilmington. Nothing lasts. Shouldn't.

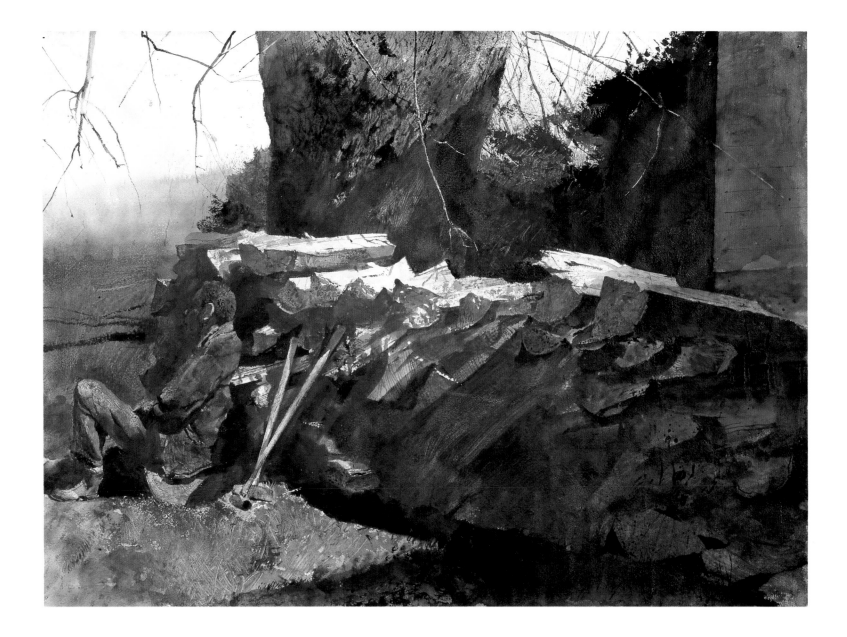

WOODCHOPPER, 1964
Watercolor
22 × 30 inches (55.9 × 76.2 cm)
University of Delaware, Newark

This is Willard Snowden sitting under a silver maple. He worked for me for many years and lived in my studio for a while. I wanted to paint the image of relaxation. This is one of those brief, quick, seemingly casual glances at a human being. But it's more, much more. I think, very strongly, it's what's *not* there that's important.

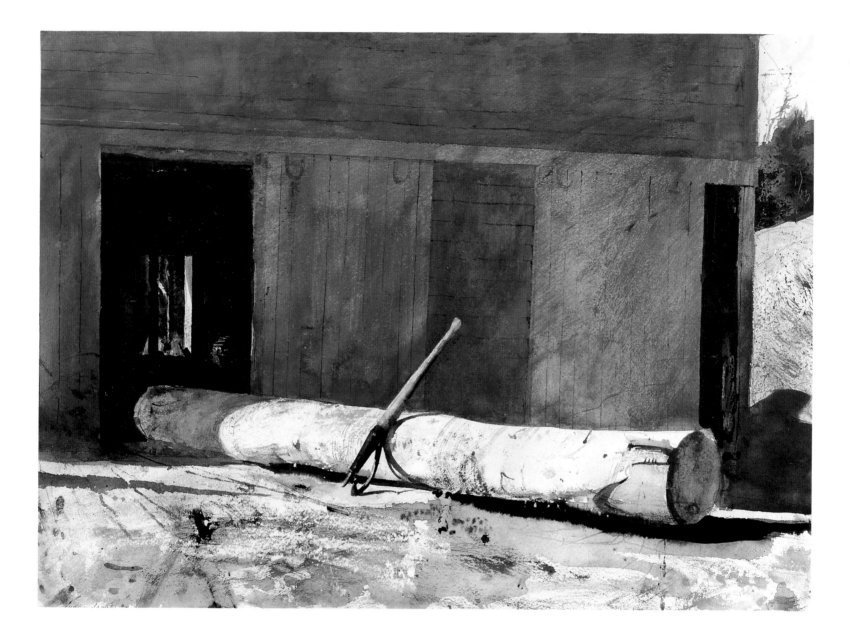

THE PEAVEY, 1965
Watercolor
21 × 29 inches (53.3 × 73.7 cm)
Private Collection

Peaveys are the most extraordinary-looking tools—those draggers and pullers used by woodsmen and loggers and rivermen. I was fascinated by the polish of use on this one. And that spike—the claw that grabs and never lets go. Peaveys are big. You have to be muscular to lift them. A peavey brings to my mind some terrible medieval instrument of destruction. They tell strange, frightening tales just by being there.

65

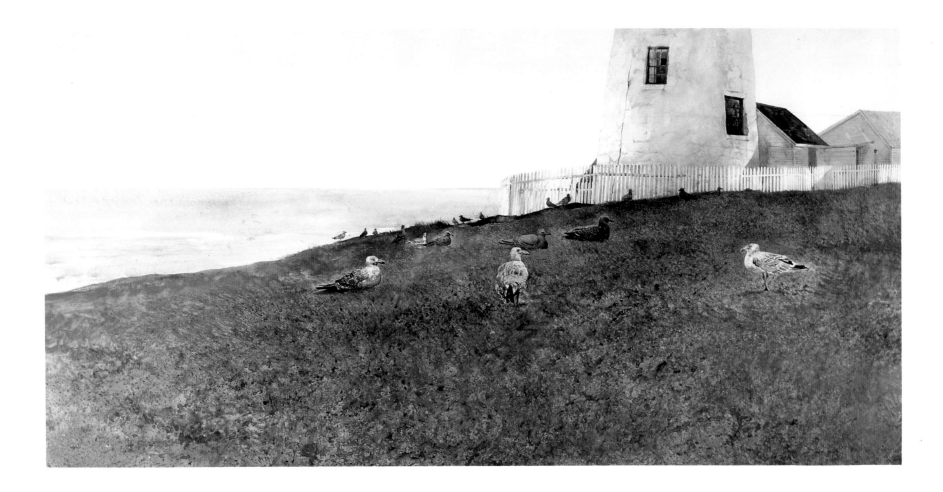

STORM AT SEA, 1965
Drybrush
19½ × 39¼ inches (49.5 × 99.7 cm)
Private Collection

I was entranced—yes, that's the word—by those seagulls all walking around.
I asked the lighthouse keeper why, and he told me, "There's going to be a
storm at sea—big." I loved the shape of the base of that lighthouse and the
light. It was late, late fall—November. A couple walked by as I had almost
finished this, and one said to the other—I wasn't supposed to hear, but I
heard—"You can see he's an amateur by how he's cut off the top of the light-
house." I had to laugh. I'd been working on it a helluva long time, too!

WEATHERSIDE, 1965
Tempera on panel
48⅛ × 27⅞ inches (122.2 × 70.8 cm)
Gallet Co., Ltd., Japan

I made more studies for the portrait of the Olson house than for anything else. I was intrigued by the structure of that building. It was monumental, but I had the feeling that the house was made of thin boards, not real timbers; I felt that it was something like the game "pick up sticks," which one day the house would look like.

In my drawings I literally put the building together as if I were the builder, and I actually counted up and studied each one of those clapboards. Up on the right-hand side of the painting, near the top windows, near where the cloth is stuffed into the broken pane, there are a couple of pieces of white wood. They're from my own house. Alvaro Olson wanted me to repair his clapboards, and I did. With the Olson house, I never left out a window, as I would subconsciously do at Kuerner's. The pictures and drawings of the Olsons' house are much more precise than those of the Kuerners' farm, right down to the individual pieces of its manufacture, its nails and pieces of wood.

I wanted *Weatherside* to be a true portrait of the house—not a picturesque portrait, but one I'd be satisfied to carry around in my wallet to look at, because I knew this house couldn't last. I did it purely for myself. I had this feeling that it wouldn't be long before this fragile, crackling-dry, bony house disappeared. I'm very conscious of the ephemeral nature of the world. There are cycles. Things pass. They do not hold still. My father's death did that to me.

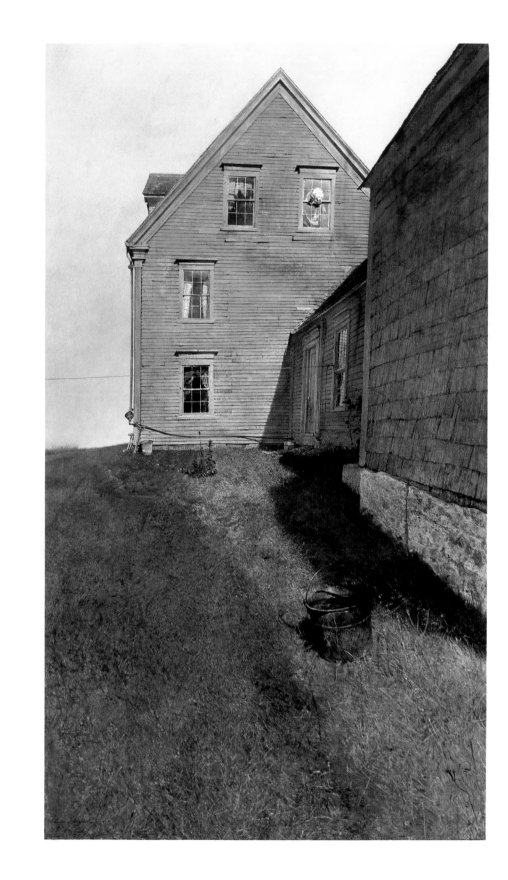

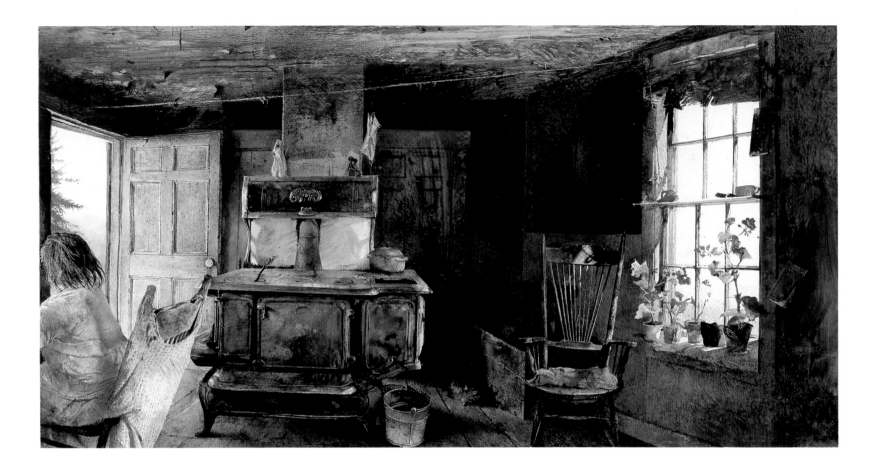

WOOD STOVE, 1962
Drybrush and watercolor
13¾ × 26¾ inches (34.9 × 67.9 cm)
William A. Farnsworth Library and Art Museum, Rockland, Me.

This drybrush is intended to be a portrait of the Olson house, both outside and inside. Outside is total fragility. Inside is full of secrets. There's Christina sitting in the kitchen, on the left, and everything's in there—the stove, the geraniums, the buckets, and the trash. I had to overdo it here and reveal all the secrets. Some people say that artists ought to work for utter simplicity. I say to hell with that! Let's get it all in there! I'm afraid of editing too much; it's not natural to be simple and pure. It's not good, either, to show too much artistic ability. You have to fight technique, not let it take over. You can't be nice about things. Like painting a nude—there's got to be some ugliness there. I like to paint in places that are not too nice. That's why I like painting Helga. She's not in love with the neatness of life or things. My father tried to clean up my paintings. Once he took out the hook that Bill Loper wore for his severed hand. That's too neat; too nice. Can't be.

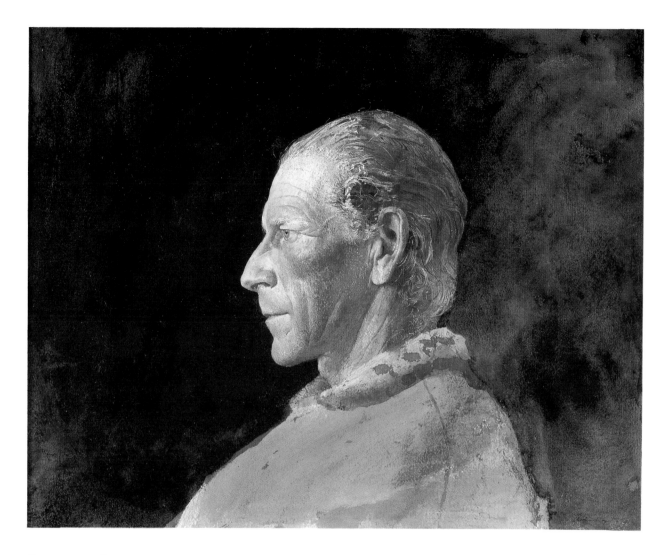

GUNNING ROCKS, 1966
Watercolor and drybrush
19¼ × 24 inches (49 × 61 cm)
Fukushima Prefectural Museum of Art, Japan

The man is Walter Anderson—a wonderful Maine boy, part American Indian, part Finnish. I knew him from when he was thirteen and we sailed together and fooled around in boats and dories. We'd row in a dory out to Allen Island, standing up—which is how you row a dory—about three miles. Standing up, you can row forever. It's the easiest thing to do. Of course, you don't just stand. You shove your feet forward as you bring the oars back. I was taught that by the fisherman Ernest Maloney, who died on this island at ninety-eight. Walter

Anderson died at fifty-four. He was walking with me, carrying my watercolors, and he turned to me and said, "What're you going to do when I can't carry your box anymore?" He died within the week. I almost never came back to Maine after that. I like the way the mouth is painted—sensuous. He was arrested once for stealing lobsters. I thought the court had taken his license away and asked him what he was going to do. He laughed and said he'd go get a license. The fact is, he'd never had one.

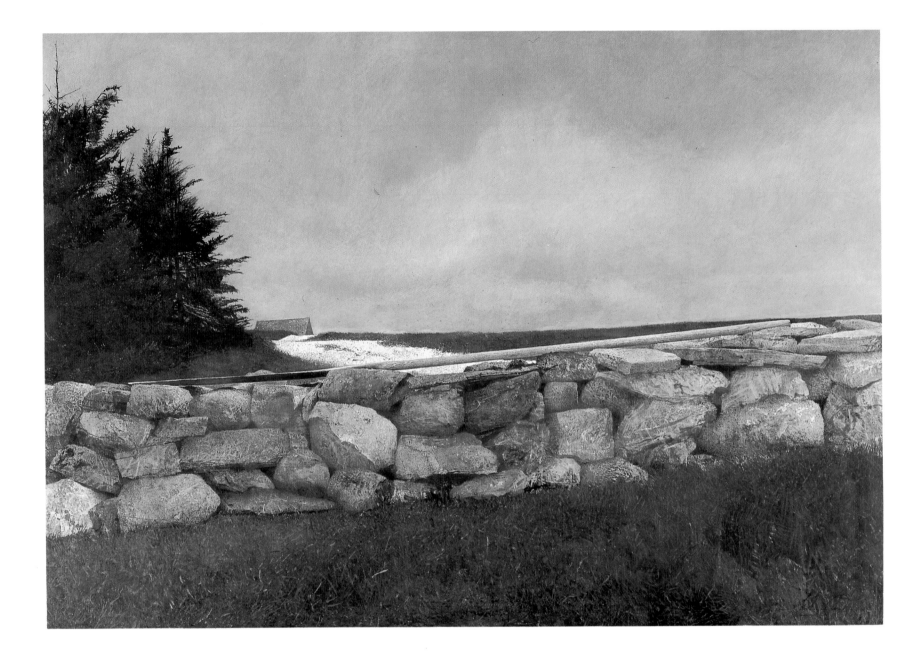

THE SWEEP, 1967
Tempera on panel
23⅞ × 34¹³⁄₁₆ inches (60.6 × 88.4 cm)
Flint Institute of Arts, Flint, Mich.
Gift of Viola E. Bray Charitable Trust

It's a sweep partly because of the sweep of the view in the lowering wet sky and partly because of the sweep of the long oar used to move a lobster smack along. That oar lying there on top of the stone has a strange significance for me—although I don't know exactly what. It may be that there's something terrific about the blade of an oar, especially the ones used for a long time. It's for me the symbol of a very special beauty—a streamlined beauty—for it's made to serve a purpose, like the streamlining of an airplane.

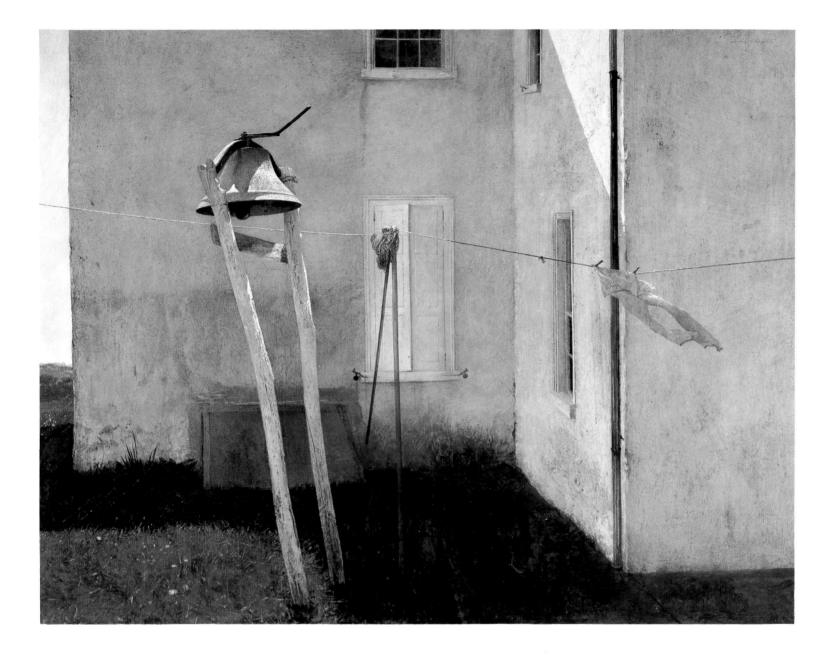

SLIGHT BREEZE, 1968*
Tempera on panel
24½ × 32½ inches (62.5 × 82.9 cm)
Mrs. James Wyeth

This is the Woodward farm in Chadds Ford. The scene reminded me of my daughter-in-law Phyllis on her crutches. The bell seemed to me to be her wearing a characteristic big hat. It's early spring. There are the wild flowers. The wind is blowing around the corner. I loved the way the light hit that white-painted bell and the building beside it. I wanted it to be spiritual and I think it is. Phyllis saw it and without a word, bought it. Though I never told her that the scene reminded me of her, she knew.

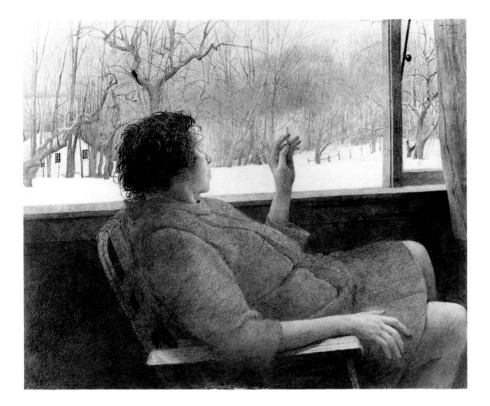

◀ MY SISTER, 1967
Pencil
13 × 17 inches (33 × 43.1 cm)
Collection of Mr. and Mrs. Andrew Wyeth

Now this is *really* Carolyn—how she would look when contemplating. I didn't ever do anything more with this, for this time the drawing had it all. I knew it would be impossible to carry the portrait out in any other medium, and it struck me at the moment that no medium has limitations. The limit is within the artist himself. Pencil had grabbed her character and her pose so that not a piece of color was needed to make it better.

SPRING FED, STUDY, 1967 ▶
Pencil
21 ½ × 28 ½ inches (54.6 × 72.4 cm)
Collection of Mr. and Mrs. Andrew Wyeth

I started this drawing because I was moved by the remarkable variety of sounds surrounding the Kuerner farm. One day I became conscious of the sound of running, trickling water—nature pouring itself out. The painting that emerged is about the clang of the bucket, the crunch of hooves, the spilling of water. My sister Carolyn said that the basin looked like a sarcophagus. Yes. And that shining bucket's the helmet of a knight who's in that grave. Deep down, of course, the painting is about farming, but it goes far beyond that. It's about the brutality and the delicacy of life on the farm symbolized by that thin tin cup, that crooked faucet. There's some of the best tempera painting I've ever done in the tin cup. It is almost transparent against the wall, except for the little glint on the lip and the handle. I've drunk that water many times; it's the most delicious water. The way it comes over the ledge of the great trough and runs down the side is timeless. It's like life itself, endlessly moving.

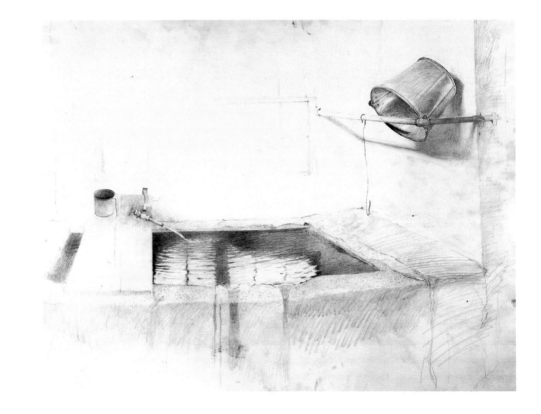

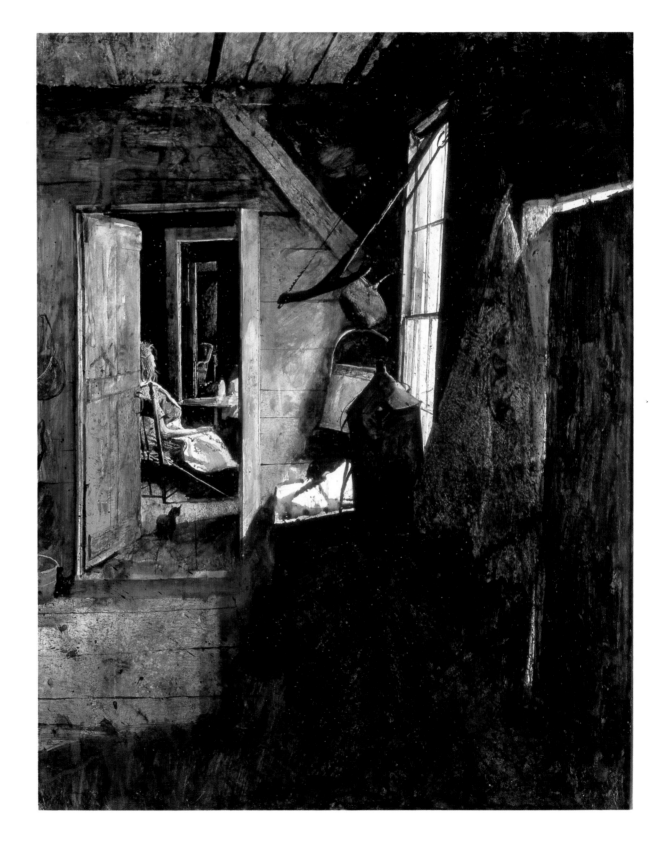

ROOM AFTER ROOM, 1967
Watercolor
28⅞ × 22⅞ inches (73.4 × 58.1 cm)
Collection of Mr. and Mrs. Andrew Wyeth

I just bought this for my own collec-
tion—Betsy and I gave it to each other
for Christmas. Summer. Christina Olson.
What got me was that narrow part of the
house and the strange succession of
rooms. What an impact! There she is. See
the flash of light from the poker she's
holding? That poker is tough and bitter,
but I made it a stroke of light—with the
pure white of the paper. This is kind of a
magic moment, I think.

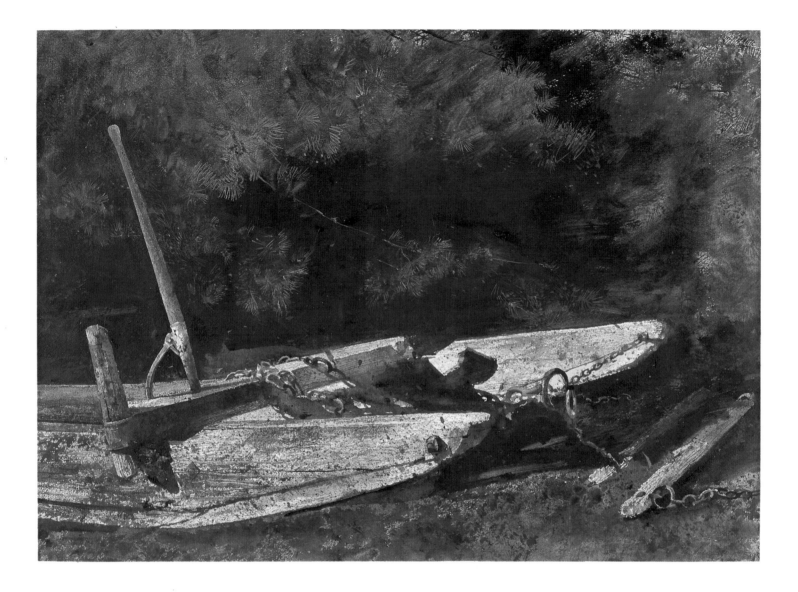

LOGGING SCOOT, 1968*
Watercolor
22 × 30½ inches (55.9 × 77.5 cm)
Gallet Co., Ltd., Japan

A Maine picture. They drag these scoots or sledges over the snow in the winter. And they even use them in the spring to get the big logs out of the woods to the mills. God, in the spring mud that thing must weigh a helluva lot. Most of the mills in Maine were tide mills, with the saw fixed up to the movement of the tides. The saw would turn one way when the tide came in and reverse when it went out. There's a difference between logging mills in Pennsylvania, where they were built for all time, and those in Maine, where they were almost purposefully ephemeral, just made out of wood. They have simply blown away.

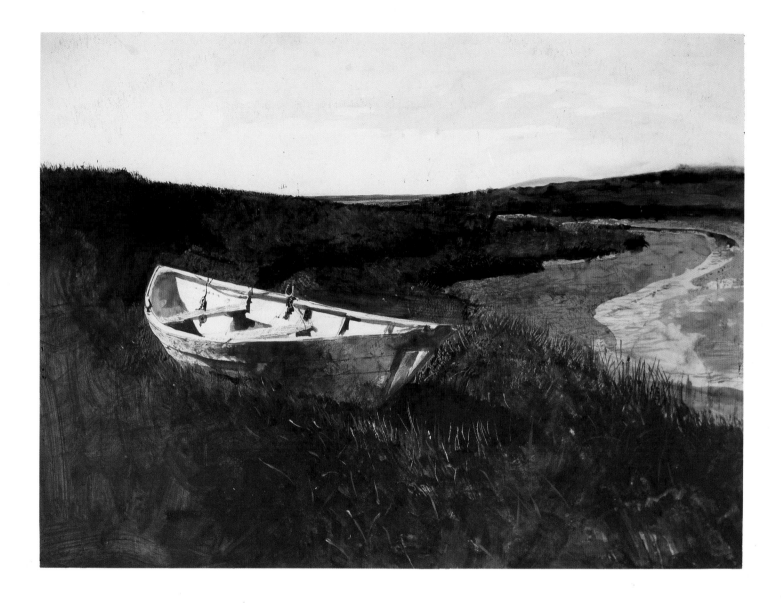

INCOMING SEA, 1966
Watercolor
17½ × 23½ inches (44.5 × 59.7 cm)
Nicholas Wyeth, Inc., New York

This watercolor is of a dory dragged up on the flats in front of Broad Cove on the Georges River—one of the points that juts out there. Broad Cove is an inlet on this inland river, near where Captain Weymouth landed in the seventeenth century. The tide has just turned—a moment that has always been magical to me. There's a stillness, with the feeling that this unstoppable movement is about to begin again. The picture is the heart of Maine and something that's not going to change no matter what happens.

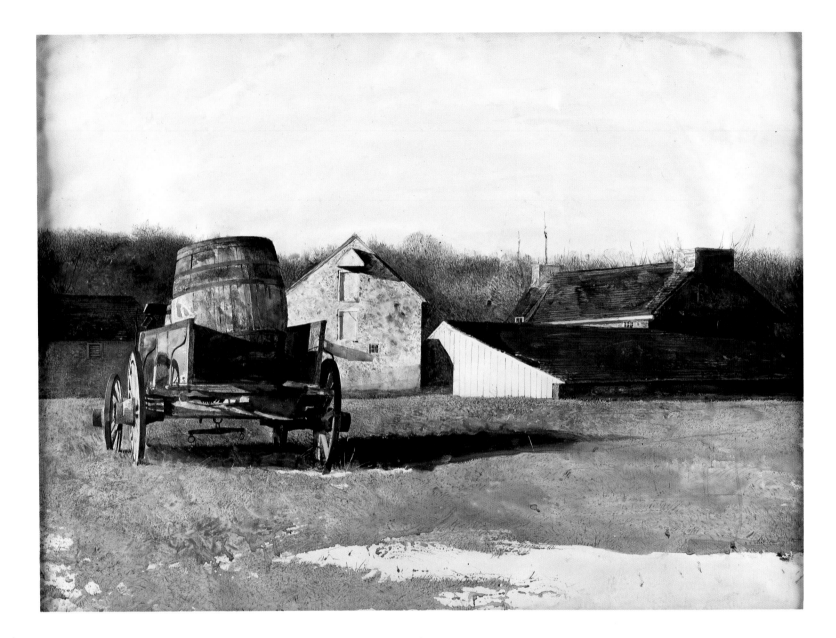

CIDER BARREL, 1969
Watercolor and drybrush
22 × 29 inches (55.9 × 73.6 cm)
Gallet Co., Ltd., Japan

This is one of Karl Kuerner's cider barrels in his springhouse. What you have to do to make hard cider is to take the bunghole out and fill the barrel up until the apple juice froths out the top and evaporates. It's critical to keep it filled to the brim. Once the juice has stopped frothing, you seal the barrel and let the cider work. These barrels can explode if you let the cider stay too long. And you must keep putting fresh cider in there all the time until the mix has stopped fermenting. Karl never let me or anybody know how he made his hard cider. Not even his son. His cider was clear, and going down there was nothing like it. He died with the secret formula. His son couldn't make it the same way—his just turned to vinegar. Maybe Karl pissed in it or something.

POST AND RAIL, 1967
Watercolor
$29\frac{3}{8} \times 21\frac{1}{2}$ inches (74.6 × 54.6 cm)
Richard and Barbara Ward

Willard Snowden again—this time down
at the post with a shovel, quite close to
my studio one late afternoon. I happened
to have my watercolors with me, and I
sat down and rushed it off. What inter-
ested me was how his head looked against
that evening sky, which is more impor-
tant than anything he may be doing.

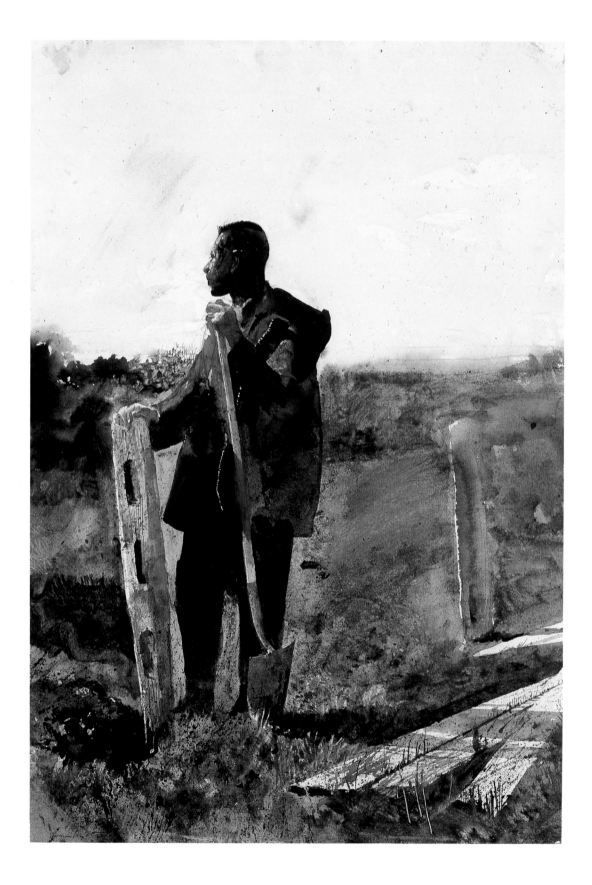

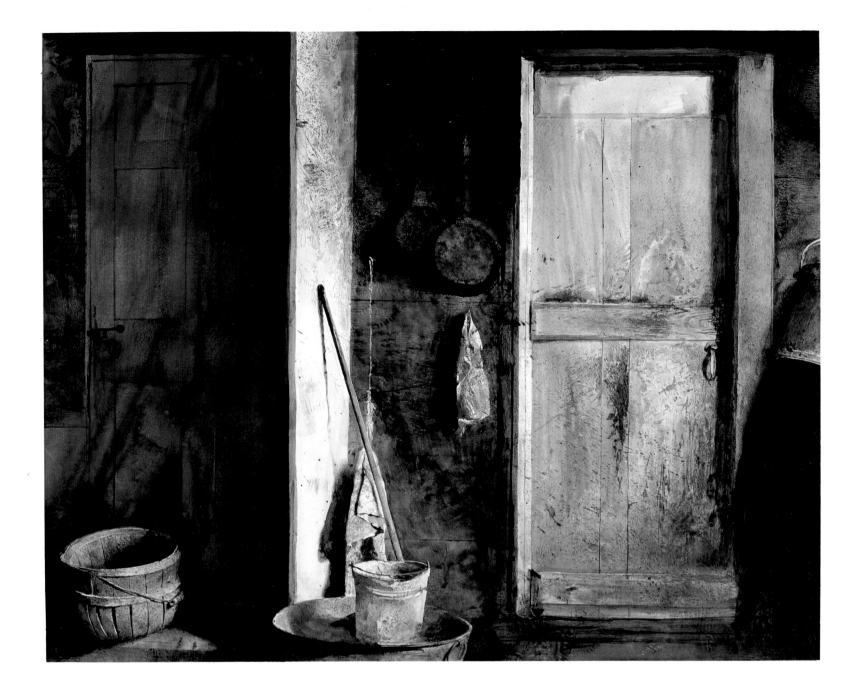

ALVARO AND CHRISTINA, 1968
Watercolor
22⅞ × 28¾ inches (58 × 73 cm)
William A. Farnsworth Library and Art Museum, Rockland, Me.

I conceived this as a portrait of the whole Olson environment, and I painted it the summer after Christina and her brother, Alvaro, had both died. I went in there, and suddenly the contents of that room seemed to express those two people—the basket, the buckets, and the beautiful blue door with all the bizarre scratches on it that the dog had made. The Olsons were all gone but powerfully there nonetheless.

PUMPKINS, 1969
Watercolor
20½ × 28½ inches (52 × 72.3 cm)
Private Collection

I did this at Erickson's house, where I
painted Siri. He grew a lot of pumpkins.
I painted a few pictures of pumpkins. But
after I saw all the pumpkins that other
people did, I stopped painting them. That
ruined it for me. I don't think I'll do any
more nudes either. I've seen too many
lying around since Siri and Helga. The
imitators quickly take the charisma out
of it.

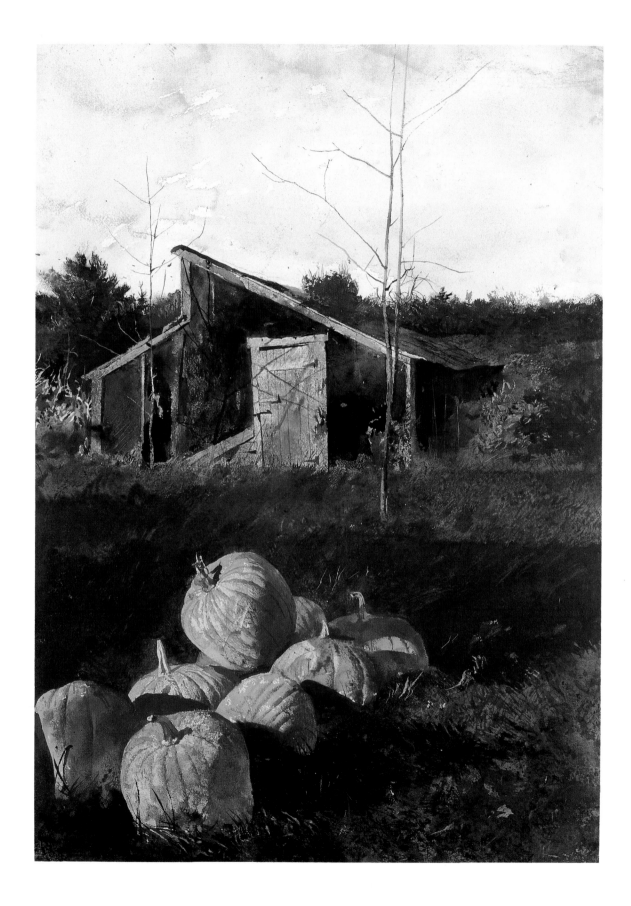

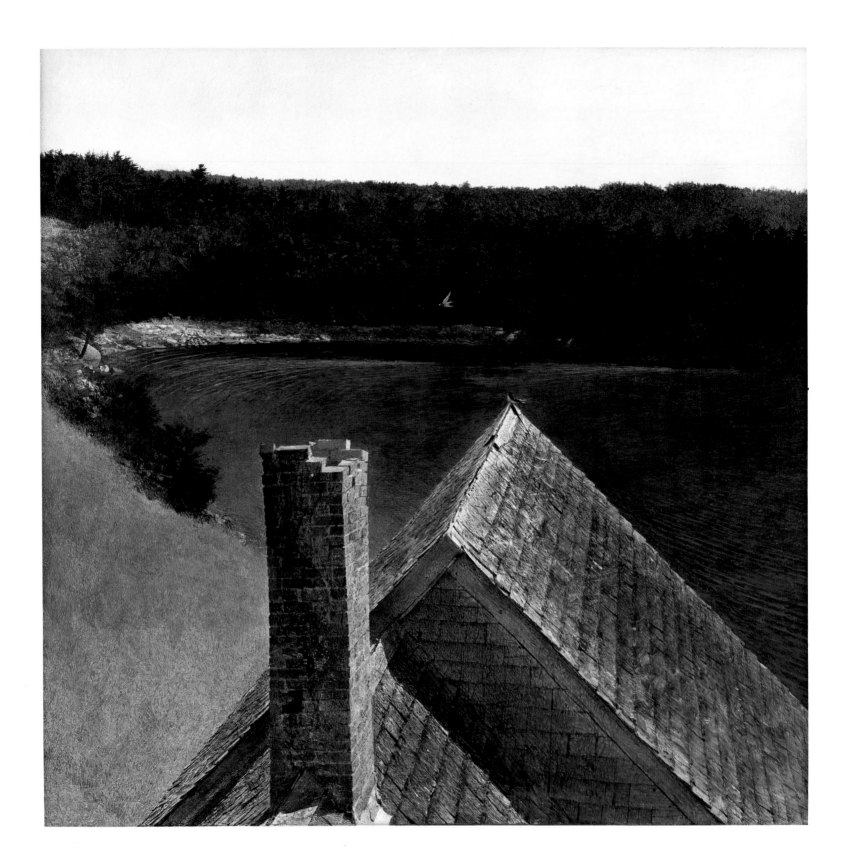

BUZZARD'S GLORY, 1968
Tempera on panel
18½ × 23⅞ inches (47 × 60.6 cm)
Gallet Co., Ltd., Japan

A Chadds Ford boy—Johnny Lynch—
Jimmy Lynch's half brother. A real Lynch.
I, frankly, was intrigued by his jet-black
hair. Often my interest in a subject comes
from an apparently insignificant detail. I
liked his character. He was strong and
quick. The title is the section of Chadds
Ford—the Italian part of town—where
his family lived for some time. Why Buz-
zard's Glory? Well, this was where people
lived who used to shoot buzzards to eat,
and the place was always called Buzzard's
Glory. I can't imagine how anyone could
live after eating a buzzard.

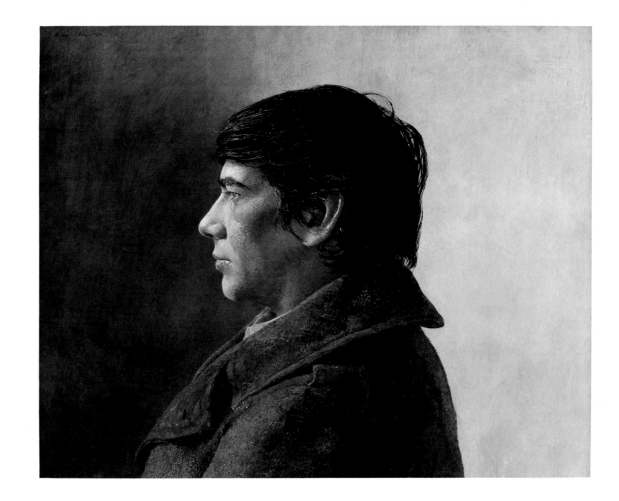

◄ END OF OLSONS, 1969
Tempera on panel
18¾ × 19⅛ inches (47.6 × 49.5 cm)
Gallet Co., Ltd., Japan

After Christina and Alvaro had died, I began this painting with studies looking
through the window at the end of the house and then came right in on the
chimney, which to me was the ear of the house. This was the last painting I did of
the place, which accounts for the name. When the Olsons were alive and I was up
in the attic, I could hear their voices carrying right up that chimney. The way the
chimney bulged on the top due to the masonry giving way seemed to be like an
ear listening. Of course, it wasn't listening to me; I was listening to it. But just the
same, it had that feeling for me. I think a picture must contain those remem-
brances, those voices, faces, conversations.

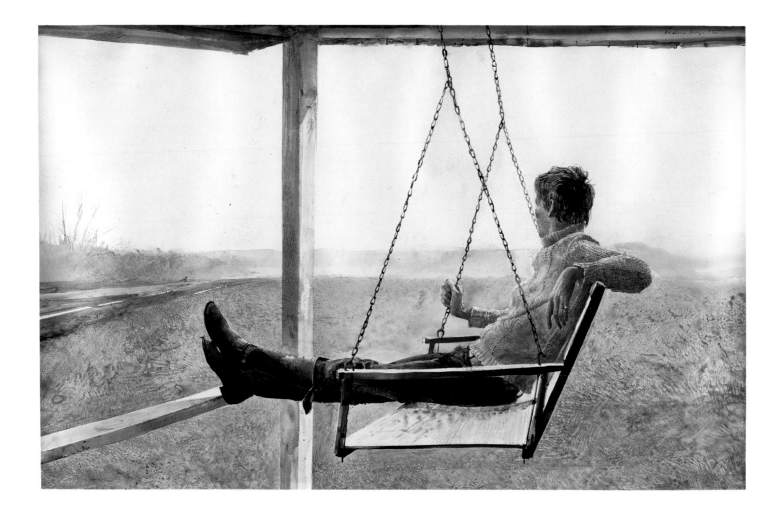

THE SWINGER, 1969
Watercolor and drybrush
15⅓ × 25⅔ inches (39.1 × 65.2 cm)
Gallet Co., Ltd., Japan

Jimmy Lynch, sitting on a porch of a house in Chadds Ford in his debonair boots watching the cars go by. This is the same guy as in *Man and the Moon* (see page 148). He was a marvelously natural person—a piece of the earth. Hunted all over the place. Loved the land. He was a Pennsylvania version of Walter Anderson, whom he knew, and he came up with me from Chadds Ford when Walter died. Jimmy was around the house all the time when my boys were growing up. He was Jamie's best friend and best man, and he came to the wedding in a car with chickens in the backseat because his car had broken down. It was amusing to see him standing there with all the Du Ponts. I liked him because he was of the earth. He was an appealing vagabond. I was taken by his posture, the way he walked—so loose and casual, very American.

THE VIRGIN, 1969

Tempera on panel
57 × 34½ inches (144.8 × 87.6 cm)
Collection of the Brandywine River Museum,
Chadds Ford, Pa.
See page 168 for list of donors.

Siri. I first saw her on the way to Christina's funeral, and in a sense she took Christina's place—life out of dust. After doing a painting of her called *The Sauna*, I finally decided to ask her to pose completely in the nude. She agreed. The session took place in her father's chicken house, a strange place in which to work. She went upstairs and then came down and suddenly stepped into the light coming through the windows high up there. That was it! I saw this gorgeous virgin with this high color in her cheeks. Amazing! No one knew about this picture for a long time. There was a sculptor, Bernard Langley, who lived nearby and was hacking away at a wooden Indian at the time, and I had a good laugh thinking about him working on that wooden thing while at the same time I had this beautiful fifteen-year-old in the secrecy of the chicken coop. My wife, Betsy, knew beforehand that I was going to paint Siri in the nude and told me, "In the future do it and tell me later." I did.

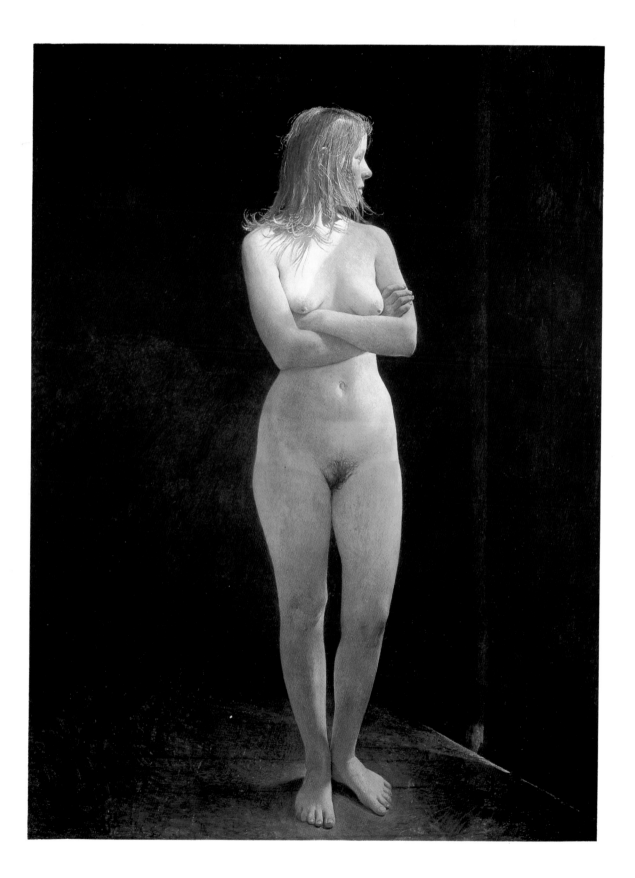

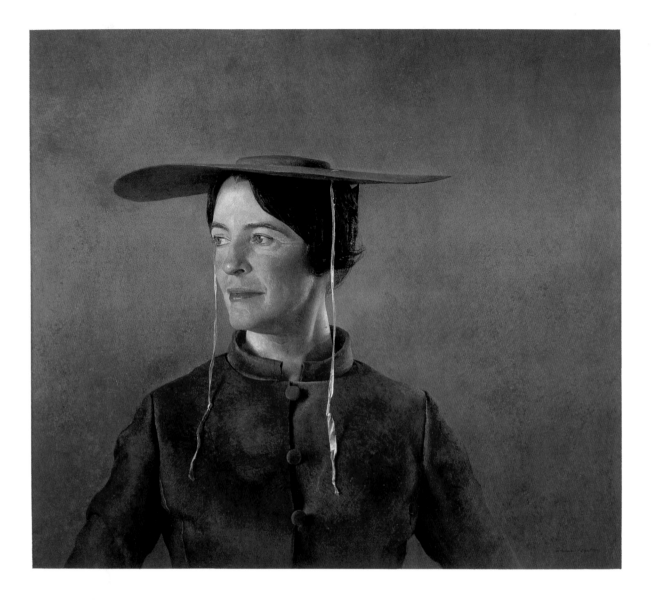

MAGA'S DAUGHTER, 1966
Tempera on panel
26½ × 30¼ inches (67.3 × 76.8 cm)
Collection of Mr. and Mrs. Andrew Wyeth

It's my wife, Betsy. I had worked a long time on this and knew it wasn't working. At the time I was on the board of trustees of the Smithsonian Institution—quite prestigious. But Betsy didn't like it, telling me that my work would suffer because of all these boards. I left for Washington one morning, and Betsy got furious, really flew into a rage. All the way down I kept thinking of that color rising up high into her cheeks. I knew I had captured her. The color of those cheeks under her coal black hair and that hat gives the portrait a real edge. *Really* caught her. It's more than a picture of a lovely looking woman. It's blood rushing up. Portraits live or not on such fine lines! What makes this is that odd, flat Quaker hat and the wonderful teardrop ribbons and those flushed cheeks. She could be a Quaker girl who's just come in from riding.

The Finn, 1969
Drybrush
29¾ × 21½ inches (75.5 × 54.6 cm)
Gallet Co., Ltd., Japan

This is a portrait of Siri's father, George
Erickson. I painted it after I had asked his
permission to paint his fifteen-year-old
daughter. George suggested I paint her in
the sauna. I had done Siri with a towel
around the upper part of her body, and I
asked her if she'd pose without it. She
started taking it away, and I said, "Wait a
minute. You go and ask your parents, be-
cause this can be a rather tricky thing."
She said, "It's strange you say that, be-
cause Daddy said last night, 'If he's going
to do you in the sauna, why do you have
a towel around you?'" She came back and
said, "Fine." She had asked her mother. If
I ask her to take off that towel, I had
thought, George Erickson will maybe
shoot me. He was a strong man.

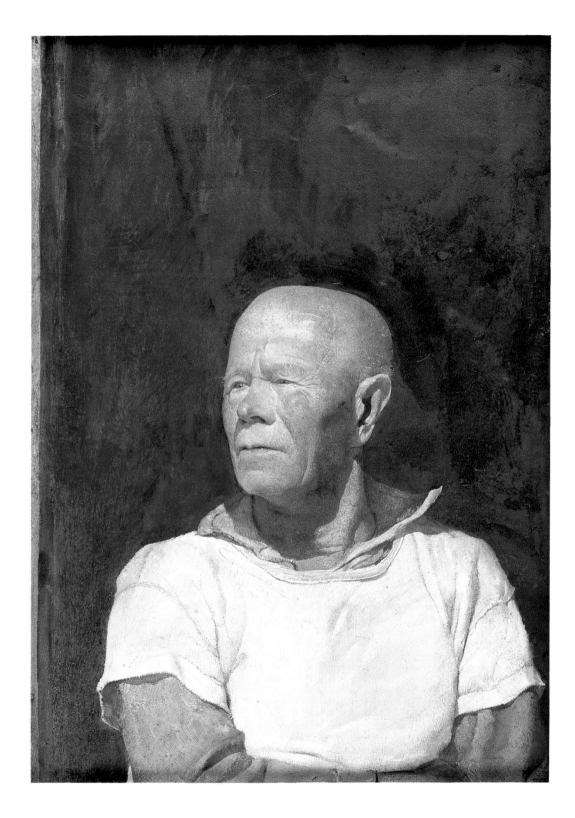

SIRI, 1970
Tempera on panel
30 × 30½ inches (76.2 × 77.5 cm)
Collection of the Brandywine River Museum,
Chadds Ford, Pa.
See page 168 for list of donors.

The idea of painting Siri came right after *Anna Christina*, the last portrait I ever did of Christina Olson. That fall, just before I left for Pennsylvania, we stopped in at a certain farm owned by George Erickson. Now George is that Finnish man—I painted him in *The Finn*—and he had a little blond-haired daughter. As Betsy talked to George, I saw behind him a lovely towheaded little girl. She said her name was Siri. I asked her if I could come back the next day after school because I wanted to make a drawing of her. She said, "Sure," in a shy way. I made a brief sketch of her standing in the doorway.

During the early winter in Pennsylvania I kept thinking about this little girl. Then I got word that Christina had died, and I went up to the funeral. I remember going by the girl's house as I followed the hearse to the funeral. And as we passed, I looked at her house surrounded by some enormous pines and thought, God, that little girl's in there. I was really hanging on to the thought because I realized that that very moment was the end of Olsons. All the rest of the day I kept thinking that the young girl was there. It was almost as if it symbolized a rebirth of something fresh out of death.

To me all the pictures of young Siri are continuations of Olsons, and at the same time they are sharp counteractions to the portraits of Christina, which symbolize the deterioration of something. With Siri, you suddenly get this change of such an invigorating, zestful, powerful phenomenon. Here was something bursting forth, like spring coming through the ground. In a way Siri was never a figure to be painted, but more a burst of life.

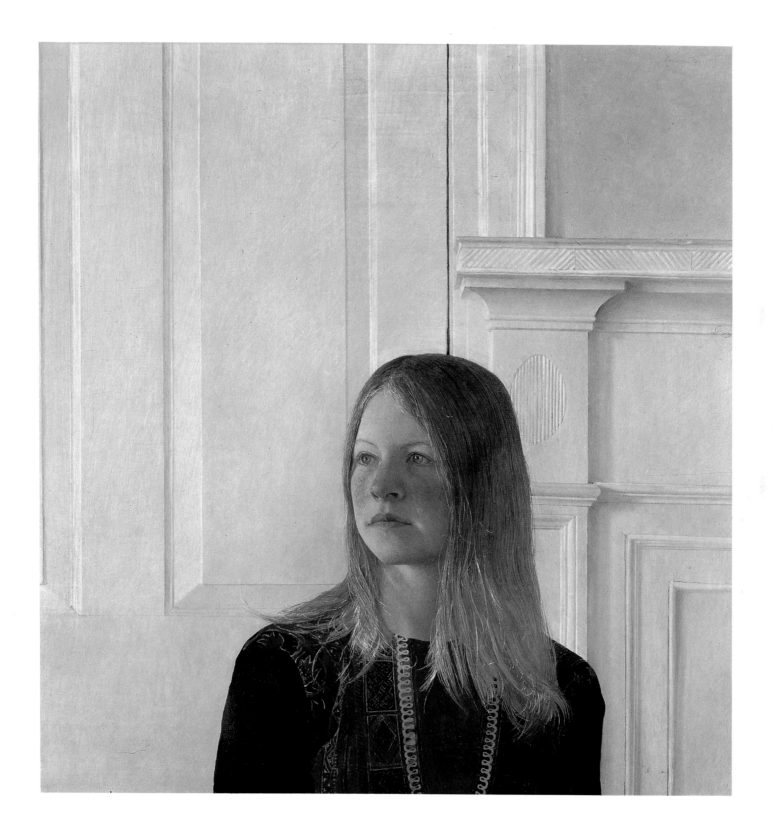

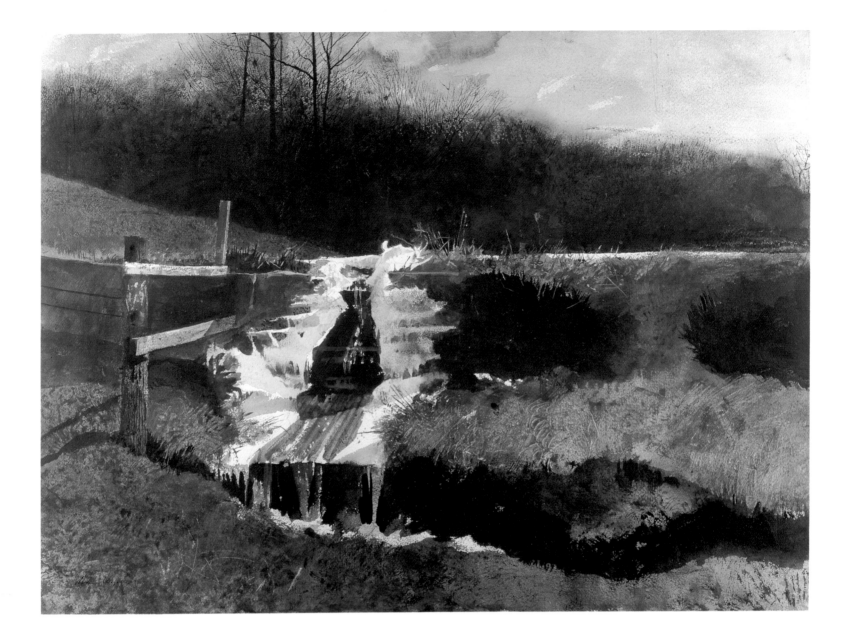

DAM BREAST, 1970
Watercolor
20⁷/₈ × 28²/₃ inches (53 × 72.8 cm)
Private Collection

This was at Kuerner's in the middle of winter, and what intrigued me was that spume of water froth and the brilliant feeling of ice. The water would freeze, and then some of it would suddenly thaw. This time I saw the moment when the dark water began to move with the ice still there. I came over the hill and saw the pond and liked the abstract shape, and then I saw this sudden movement in the ice. It had, strangely, a somewhat sexual feeling to it. I don't know why. That pond was built for cutting ice, for back then all farms had icehouses.

ICE STORM, 1971
Drybrush
29 × 21 inches (73.7 × 53.5 cm)
Private Collection

Black-haired Johnny Lynch in the studio in Pennsylvania looking, broodingly, out the window as the sleet strikes outside. Seemed to sum up Pennsylvania to me.

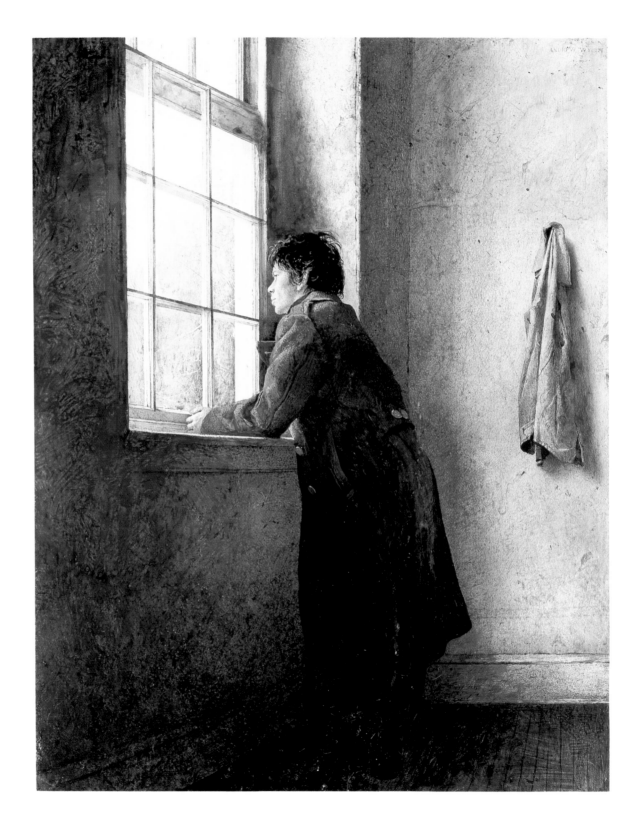

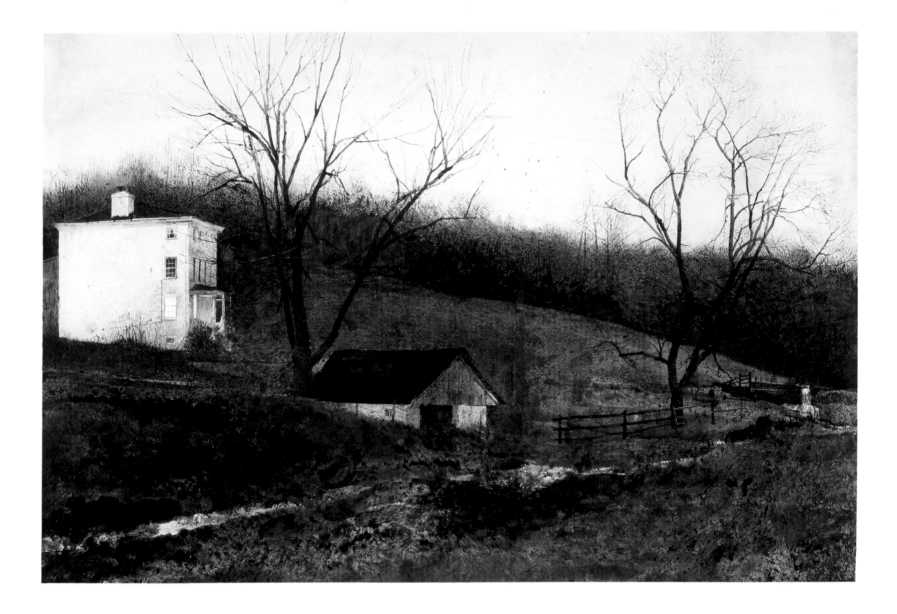

EVENING AT KUERNERS, 1970
Drybrush and watercolor
25½ × 39¾ inches (64.8 × 101 cm)
Private Collection

There are few studies for this because that was the year that Karl was very ill. Many evenings with the light burning there quite late, I had a foreboding that this might be the end. I'd go over there evening after evening and just watch. I'd hear the water and see that light in Karl's room, and I'd lie in bed at night thinking about that square house sitting in that valley with the moonlight casting such a strange liquid light on its side. The light in the window, which is pure paper, by the way, seemed to me to be Karl's flickering soul. For me it's a very emotional picture. I saw Helga for the first time when I was doing this.

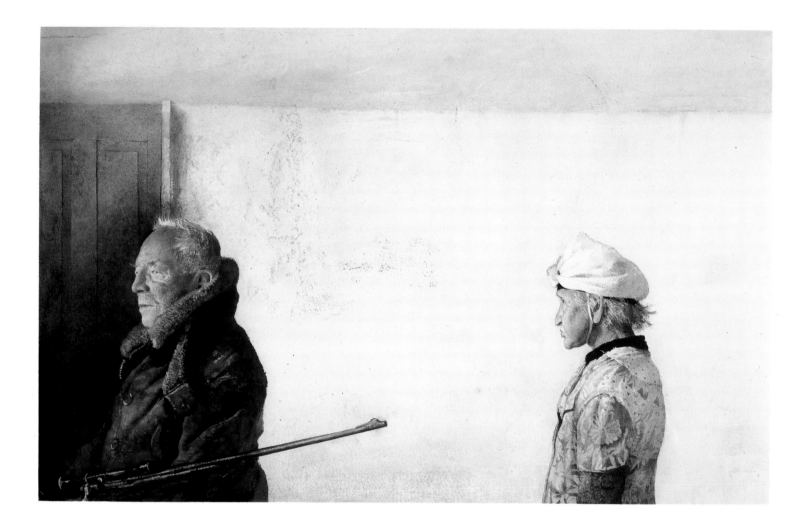

THE KUERNERS, 1971
Drybrush
26½ × 40 inches (67.3 × 101.6 cm)
Collection of Mr. and Mrs. Andrew Wyeth

Karl had just gotten this rifle with a new scope. I had him sit in the room where he kept his trophies. I worked for a year and a half and put one of those moose heads in the background. But I set the picture aside for two years and worked on a painting of Anna. Then I went back to it, for I liked the way that rifle stuck out. I was working there, especially on the rifle, when around noontime Anna came into the room. She looked at Karl very quizzically and spoke in German, saying, "Why didn't you come down for dinner when I called you?" She was quite severe. And I thought, That's it; I've got it. God, her expression when she looked at him, with that gun by chance pointed right at her, was incredible. I asked her to pose for me, and she did. I sandpapered out that moose head, and that gave the most perfect texture to the wall. I don't think you could get a clearer portrait of these two people and what their life had been like—an absolute portrait in a very abstract way. I love the feeling of figures this size. It is as if you could pick them up and take them home and hold them like dolls in your hand.

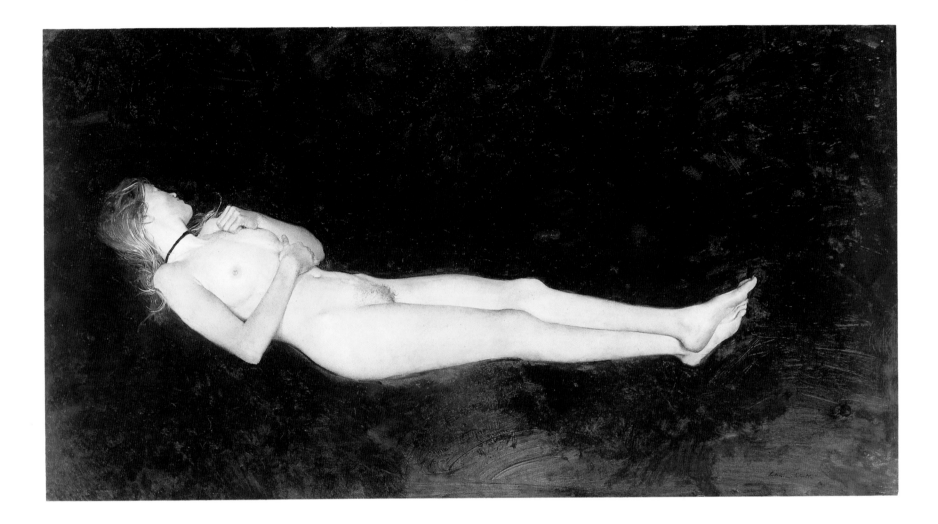

BLACK VELVET, 1972
Drybrush
21¼ × 39½ inches (54 × 99.7 cm)
AM Art Inc.

I always wanted to do a long nude figure but didn't want to have false or "artistic" perspective in it. So I sketched her upper body, then moved my chair along and painted the middle section and then the legs. You couldn't take a photograph of a person and get what I painted—it's my own foreshortening. I thought of doing it outdoors, but it was too cold. So I took this piece of velvet and laid it out on a couch in my sister's studio in Chadds Ford. I worked on it a long time. There's some rather fine drawing in the thing—the hands and the head turned away. The black choker didn't come from Manet's *Olympia*, despite what some of the critics of the Helga series wrote. She always wore it, and that black line on the neck was an important accent. This is, to me, one of the most consistent paintings I've ever achieved. She's floating on the velvet. The whole thing has a grace and delicacy—not weak in any way. I think the pubic hair on the vagina is rather well painted, too.

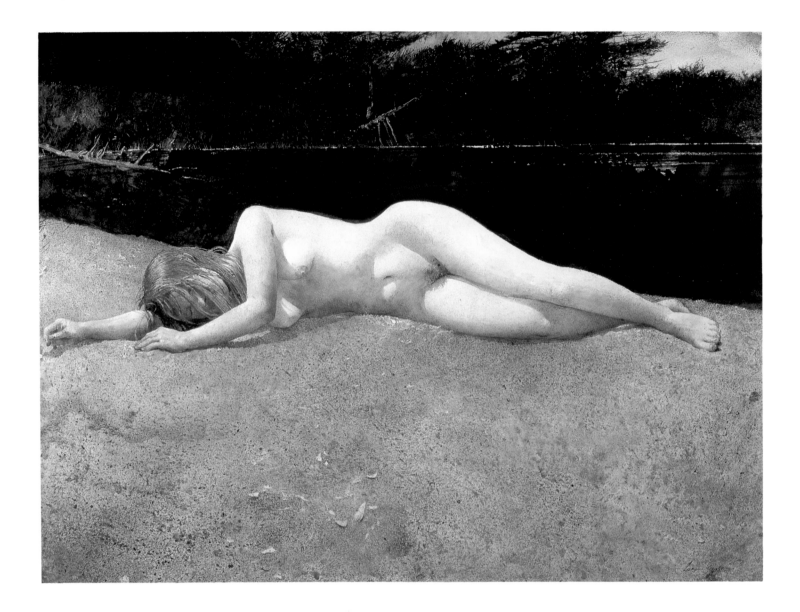

BLACK WATER, 1972
Drybrush
21 1/2 × 29 1/2 inches (54.6 × 74.9 cm)
Collection of the Brandywine River Museum,
Chadds Ford, Pa.
See page 168 for list of donors.

This is Siri. Just before going to Maine I had completed a picture of Helga, *Black Velvet*, and wanted to find out if I could do Siri in the same way on a sandspit. It's a composite in a way, in which all the elements overlap, are woven together—both Chadds Ford and Maine brought together into one painting.

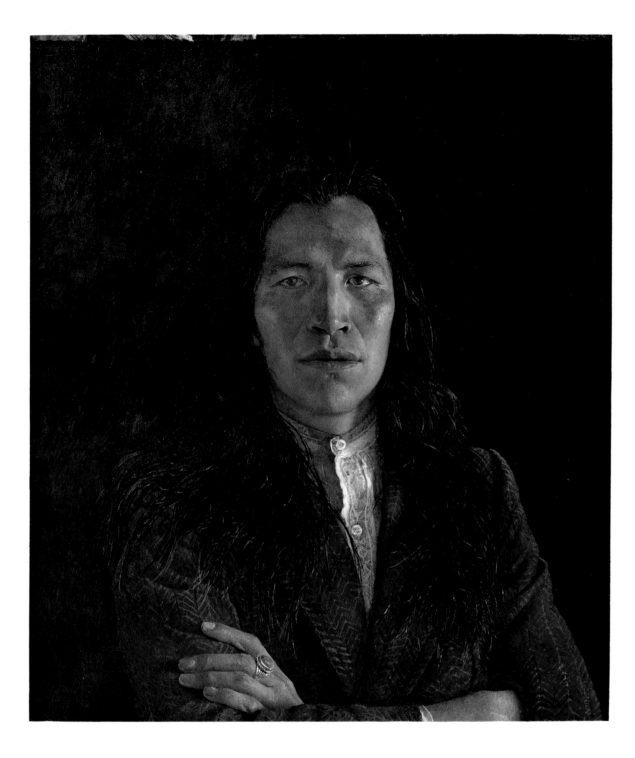

NOGEESHIK, 1972
Tempera on panel
24⅝ × 21¹⁵⁄₁₆ inches (62.5 × 55.7 cm)
Gallet Co., Ltd., Japan

It was winter and there was a storm—God, it was spitting snow—and there was a knock on the door of the Mill, and here was this extraordinary Indian standing out there in the snow. He wanted money for his Indian reservation in Canada. He'd heard about me, so he dropped by. I gave him some money and I demanded that he come back early the next spring because I wanted to do a portrait—a head—just for my own interest. My father had done so many paintings of Indians—especially for *The Last of the Mohicans*.

On the first of May there was a knock on the door, and there he was. We had a great time in the studio. The only problem he had was firewater and women. He left his wife—a German concert pianist—because she liked to bring her dogs to bed. I taught him fencing. He disappeared and when he came back he wanted to fence with me. He had taken many more lessons. I said to myself, Be careful; this guy wants to hurt you. I was able to parry all his thrusts, and finally I thrust against him, knocking his wind out. I told him I didn't want to fence anymore. After that we got along quite well.

Nogeeshik was living in the Mill. Then he vanished, eventually returning, wearing a black derby. With that deep, penetrating voice of his he asked me for a loan. In the backseat of his car there was a young girl, about seventeen and stark naked. That night very late I got a call saying that Nogeeshik had suffered an auto accident and was pinned under the car. But the girl, who came from a wealthy family, stuck with him and is still with him today. He's in a wheelchair and gives talks and raises money for his nation.

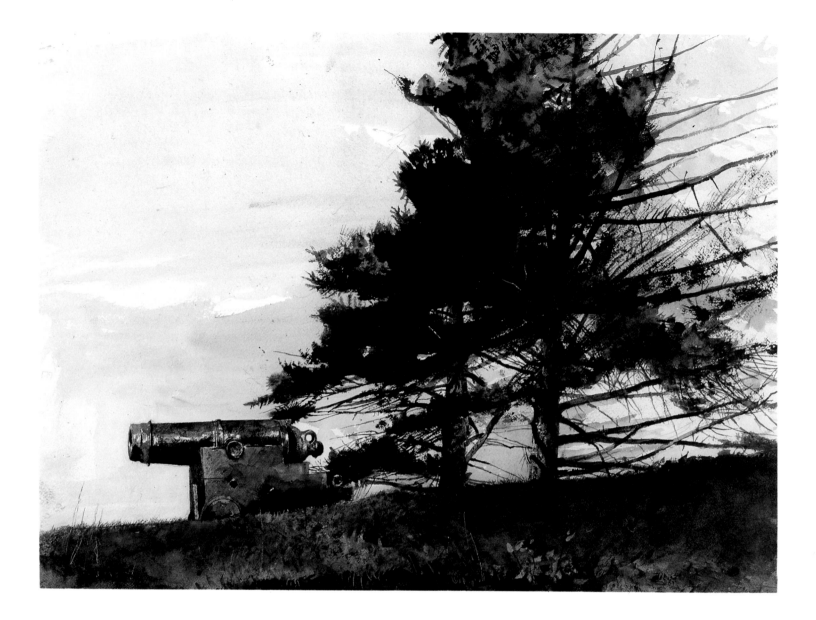

SPRUCE GUN, 1973
Watercolor
21¾ × 29⅞ inches (55.2 × 75.9 cm)
Private Collection

On our point in Maine, where there was a cannon that came off a British frigate of 1812. Now the cannon is on Southern Island. It's real. There's a number on it, and through that number I was able to find out the name of the vessel. I got it at auction. I bid against the Smithsonian Institution and won!

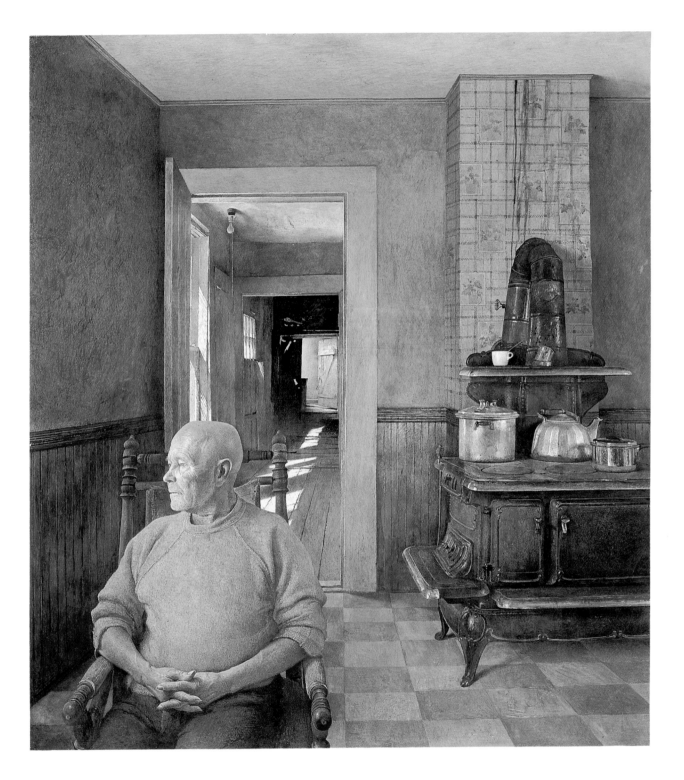

ERICKSONS, 1973
Tempera on panel
42 × 38 inches (106.7 × 96.5 cm)
Private Collection

Siri was going to pose with her fa-
ther, but she got mixed up with a
French boyfriend and was too tired
to pose. I was going to have her
stand next to her father—topless,
which is the way she always was
around the house. I was fascinated
by the woodstove behind him and
that white cup for his coffee. He's
sitting in a strange kind of chair—
Victorian—looking out the window
where the light is coming in, with
the sun shining down that long
hall. It's an absolute portrait of
Erickson in his house. Portrait of a
stove with the shining silver-plated
mechanisms. He kept it very pol-
ished. He was a very interesting
man. He came from Finland as a
stonecutter and worked in the
Maine quarries and then in the
shipyards of Philadelphia. He fell
off a roof and broke his back and
became an invalid. He married very
late in life and had this beautiful
daughter. All of that I wanted to
get into this portrait. I believe I
did, too.

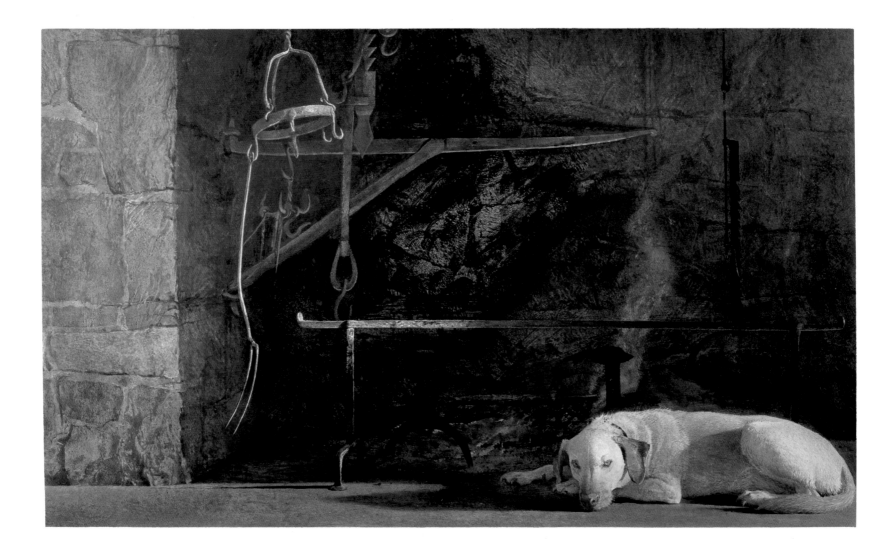

THE IDES OF MARCH, 1974
Tempera on panel
24½ × 41½ inches (62.3 × 105.5 cm)
Private Collection

That's my dog Rattler, sleeping in front of the fireplace in the Mill in Pennsylvania. March. He'd lie there and watch the glow of the sparks, and he'd look over at me. Rattler was a golden retriever. The only sound was the sound of the embers of the fire from the night before and the sparks rising, sort of hissing or popping as they did. A portrait of a wonderful dog.

FROM THE CAPES, 1974
Tempera on panel
24½ × 18⅝ inches (61.6 × 47.3 cm)
Gallet Co., Ltd., Japan

Dr. Margaret Handy sometimes let her hair
fall down, and, boy, that was when her part-
Indian blood rushed into her amazing Indian
eyes! And she was usually so tweedy, so de-
mure. I adored the contrast.

RUM RUNNER, 1974
Tempera on panel
28 × 48 inches (63.5 × 121.9 cm)
Gallet Co., Ltd., Japan

This is Walter Anderson leaning against a dory. I started it in 1945 on Teel's Island. I first called it *To the Westward*. The painting was sold and was exhibited at the Boston Museum [of Fine Arts] and was supposed to be given to the museum, but the people died before that could happen. When I saw the painting, it had been badly damaged. My gallery asked me to restore it, but I didn't want to repaint Walter's boots and do what I'd done before. I wanted to put an extra zip into it—frankly I thought it would be more salable. I repainted it by moving Walt to the other side of the boat and put in a sloop. Walt came out to Teel's Island to pose for the second version. I'm not sure I improved it by repainting it. Artists sometimes have this urge to repaint things, and I don't think it works all the time. Then again, I do like this one.

EASTER SUNDAY, 1975
Watercolor and drybrush
27 × 40 inches (69.4 × 101.6 cm)
Private Collection

I had painted Helga sitting on the Kuerners' porch in almost the same pose. I came across Anna sitting there wearing this funny hat. I was taken by the strange idea that someone would be actually sitting out there in the cold—there's no place colder than a porch in winter—and I wondered what Anna was thinking, looking out over that hill and that frozen pond and the sweep of those pines that Karl had had brought over from the Black Forest. The wind made *such* a sound in those pines that day.

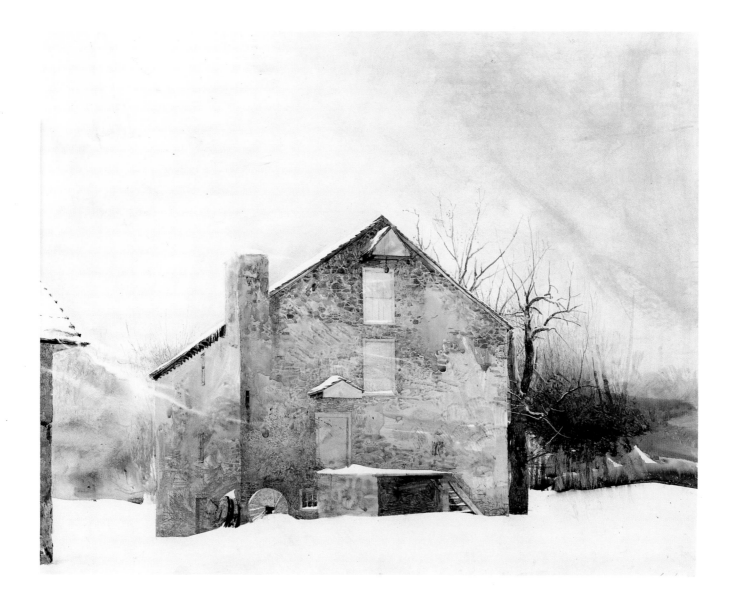

MILL IN WINTER, 1978
Watercolor
23 × 28½ inches (58.4 × 72.4 cm)
Fukushima Prefectural Museum of Art, Japan

This is a view looking at our gristmill in Chadds Ford at the very beginning of what became a blizzard. I'm intrigued by the first moments of a snowstorm. There's danger in it. You never know how it's going to turn out. I love the bleakness of winter and snow and get a thrill out of the chill. God, I've frozen my ass off painting snow scenes! I'm taken by the bleakness—not the melancholy feeling of snow. My winter scenes differ from those of other artists in that they're not romantic. No! They capture that marvelous, lonely bleakness—the quiet, the chill reality of winter.

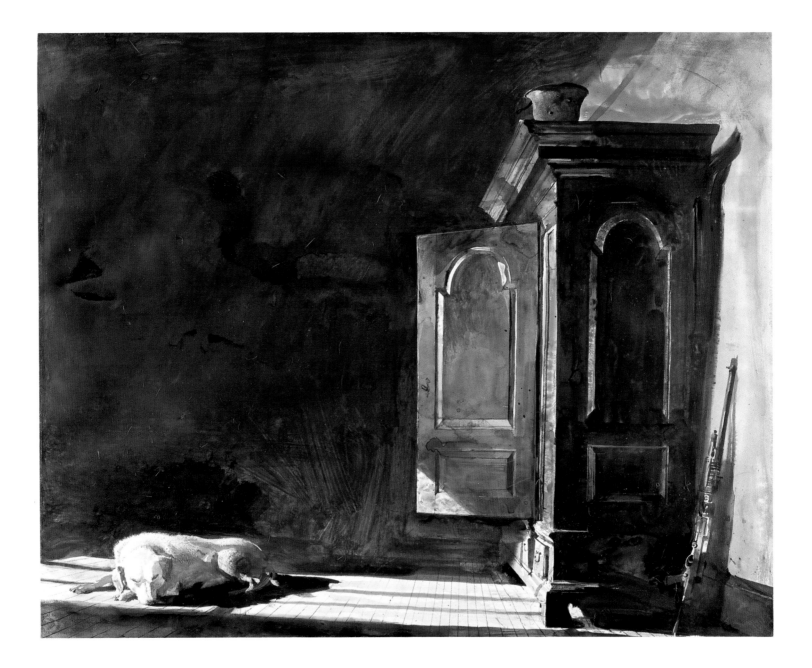

THE KASS, 1975*
Watercolor
22⅞ × 28¾ inches (58.1 × 73.4 cm)
Gallet Co., Ltd., Japan

Dr. Margaret Handy would never send me a bill for medical examinations for my sons, so one day I sent her a portrait I'd done of her to thank her. Two days later they delivered to me this splendid piece of Pennsylvania furniture, called a kass, with all those wooden dowels. Dr. Handy had bought it and sent it—one of the finest cupboards of its type in existence.

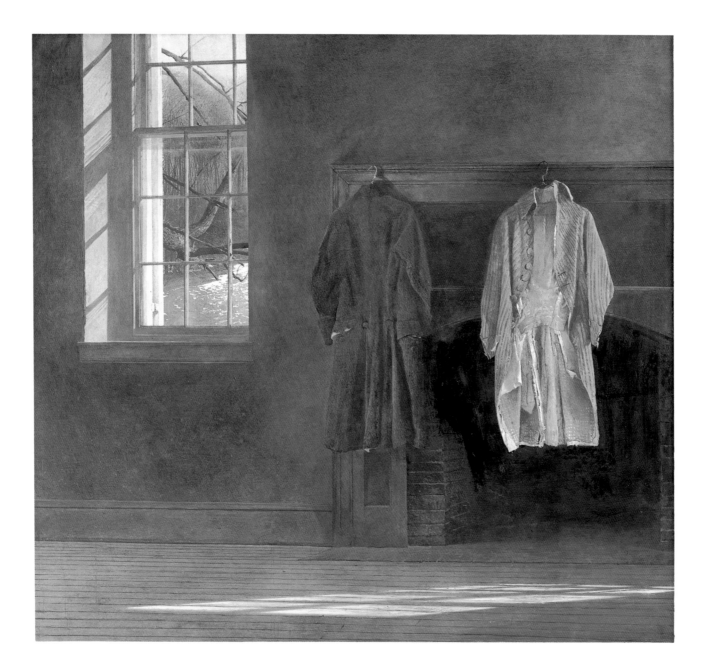

THE QUAKER, 1975
Tempera on panel
36½ × 40 inches (93.3 × 102.6 cm)
Gallet Co., Ltd., Japan

These coats were in Howard Pyle's collection of old cos-
tumes. The one on the left is a Quaker coat. The one on
the right is a fop's costume. The late-afternoon light strikes
across and hits the Quaker coat. Outside my studio window
you can see my car tracks in the snow. I was painting
Helga at the time, and I'd drive up the back way—in
secret—to Kuerner's and paint her. This was my most pro-
lific period. Hell, I was painting two full careers. This
picture and other important ones like *Night Sleeper* (see page
119) and *Ides of March* (see page 97), plus all those Helga
things. At the same time. Whew!

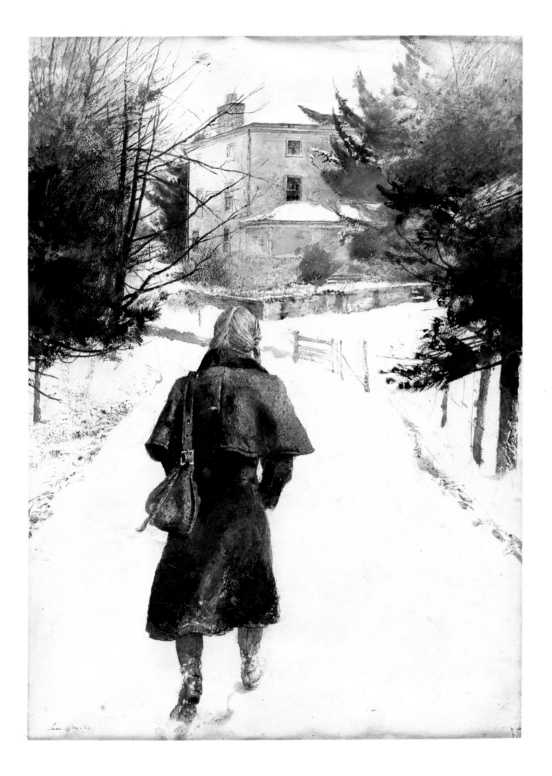

LODEN COAT, 1975
Watercolor
30 × 22 inches (76.2 × 55.9 cm)
Gallet Co., Ltd., Japan

This is Helga. My son Jamie calls her
"the Panzer Division." When I saw her
walking down that entrance road, I
thought of all her German qualities that
the Kuerners symbolized—her strong, de-
termined stride, that Loden coat, the
braided blond hair. I always wanted to
paint the Kuerners' four daughters—in
the nude—but I was too young then and
didn't have the guts to ask. Helga became
the daughters. She was my most perfect
model, and part of why she was so satis-
fying was that she worked hard at it.
With a model there has to be a relation-
ship—not a sexual one, but a give-and-
take sort of thing. When a model is cold
and shows little interest, it's a disaster. Or
if a model thinks it's just a job, nothing
will come out of it. I've been lucky with
my models. Walter Anderson was superb.
Siri was great at first while she was anx-
ious and thrilled, but then she got blasé.
Helga posed nonstop. I'd get tired, but
she'd say, "Hey, I'm not at all tired; keep
going!" Where do the ideas for the poses
come from? I like to find them by
chance. The model has to do something
that makes things click. Choosing models
is a chancy thing. You can be around a
model for months and nothing will hap-
pen, until suddenly you see something
and it works. *Loden Coat* was a quick, vi-
tal moment.

WOLF MOON, 1975

Watercolor

40⅛ × 29 inches (101.9 × 73.7 cm)

Collection of Mr. and Mrs. Andrew Wyeth

About one o'clock in the morning I was
up in back of the Kuerner house. The
moon was full and illuminated the melted
patches of snow on the hill in a mysteri-
ous way. Then I heard this soft, regular
sound from the woodshed where there
was a light, and I knew it was Anna
chopping wood. God, I can still hear that
chopping sound, chopping the kindling
very fine, putting it into a small basket,
to start the early-morning breakfast fire.
I stood there in the crisp, chill moon-
light, entranced. Finally she stopped. The
light in the woodshed went out, and I
watched as the other lights went on and
off as she went upstairs. I made some
pencil studies and went back to the studio
and painted the picture in pure watercol-
or—in maybe a half hour. The tone of
color is what I love the most. To me it
represents winter, crystal-chill air, the
sound of cracking ice when you skate at
night. All the whites are pure paper.
These snow patches have a wild, almost
primitive feeling. The sounds of the
wolves are there. You can almost hear
them howling.

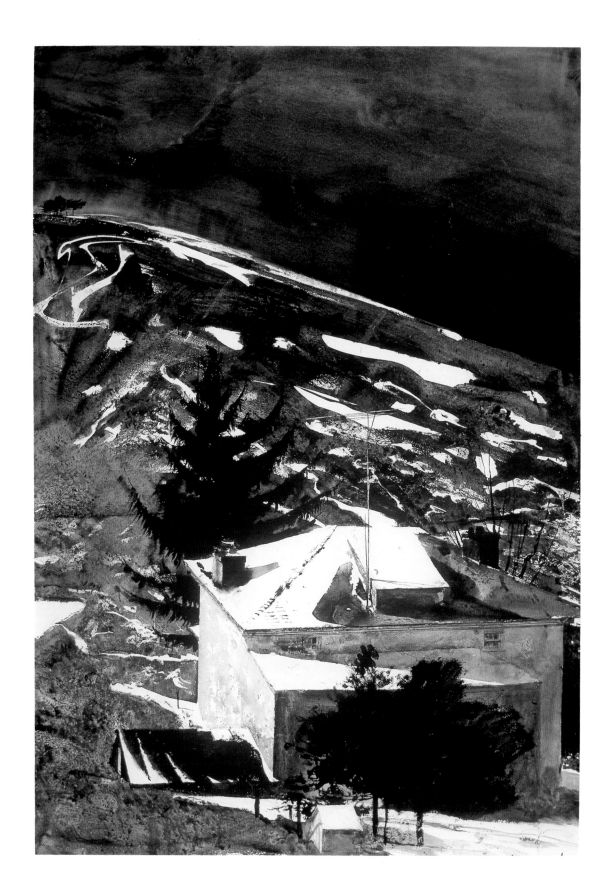

ROCK ISLAND, 1975
Watercolor
14¾ × 29¼ inches (37.5 × 74.3 cm)
Collection of Mr. and Mrs. Andrew Wyeth

This is a huge rock in a Maine cove—where I painted *River Cove*. When the tide is out and that rock is out of the water it looks like a huge animal's head. See the strange eye there? This rock appears only at low water; when the tide is in it is completely submerged. When the barnacles and the blue mussels dry out it looks like one of those Russian fur crowns with the fur and the gold and the diamonds—the ones you see in the Kremlin Museum. When that rock stays out of the water, the barnacles glisten like diamonds. Then when the tide races in—we get ten, twelve feet of tide—the barnacles change color underwater and you see an amazing underwater golden cast. The abstract shape of it and the changing textures intrigued me. I'd rush to paint it while it was out of the water and had dried off just so. Then that tide would rush in and bury the rock and I'd have to rush back when the tide was out again to capture it at the right moment.

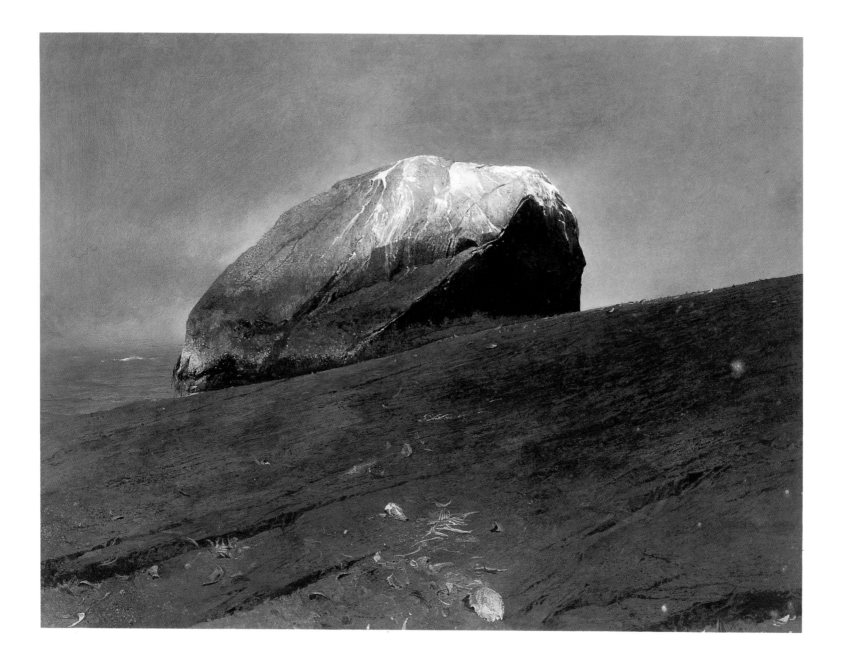

FLINT, 1975
Tempera on panel
21¾ × 28¾ inches (55.2 × 72.3 cm)
Private Collection

Not far from my studio in Cushing, Maine. This huge boulder—like
a piece of flint—epitomizes the power of the glacier that left it here.
It was a foggy day, and I saw the incrustations where the gulls had
dropped shells and bits of sea urchins. The color's interesting, particu-
larly the deep blue and the pink of the lobster claws in the foreground.
There aren't any gulls, just the feeling that they'd been here. The black
of the rock is like the bluish cast you get with flint. I'd love to have this
picture back.

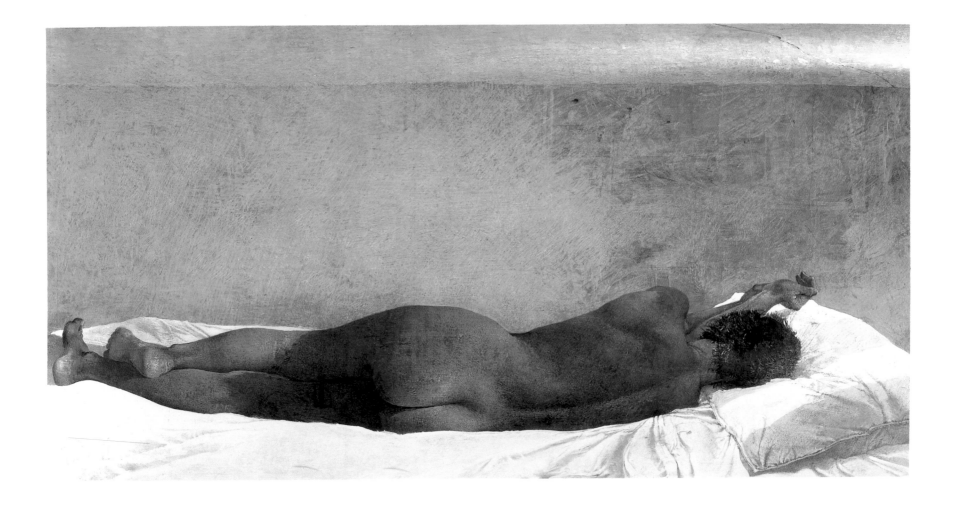

BARRACOON, 1976
Tempera on panel
17¼ × 33¾ inches (43.8 × 85.7 cm)
Collection of Mr. and Mrs. Andrew Wyeth

My best nude—though it's way beyond a nude. It's something almost stream-lined, like a figurehead on a clipper ship. What I was trying to achieve was something dateless, and I think I did. No garment dates it. This could be any period—Egyptian, the Renaissance. It's beyond being one human being, too, for it's pure imagination. I was lying in bed and thinking of drawing Helga like this, and I also got to thinking of Karl Kuerner and the black woman he'd told me he'd once taken up into his attic, and the picture just spilled out. I obliterated the hooks in that room and changed the shape of the window in order to alter all specific shapes and dimensions. I was also thinking of the enclosures in which they kept slaves in the time of Thomas Jefferson, called barracoons. To me this is purity, simplicity. You don't need a lot of trimming when you feel strongly enough.

ON HER KNEES, 1977
Drybrush
29¾ × 21¾ inches (75.6 × 55.2 cm)
AM Art Inc.

Helga was the perfect model. She put everything into it. I doubt if I could get an American girl to be this good a model—no, I don't think so. This is, of course, a passionate picture. You can feel the sexual passion—in the fullness of the breasts and the high cheekbones, the arms folded back, the color of the face, the enticing pubic hair. Most of the critics missed the freshness of this. It was painted with deep emotion; it's not a studio concept. After this, I'm not going to paint any more nudes. I've shot my wad.

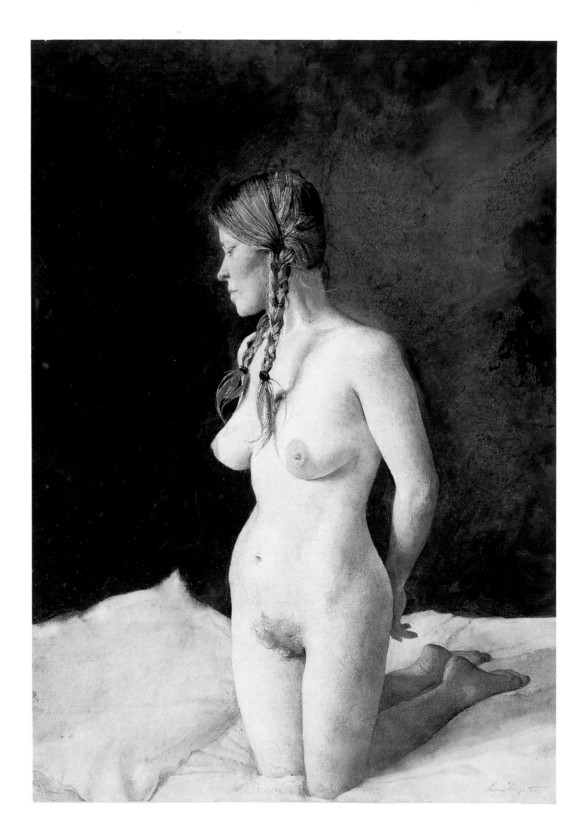

STEEL HELMET, 1976
Study for PINE BARON, drybrush
23 × 28½ inches (58.4 × 72.4 cm)
Mr. and Mrs. Andrew Wyeth

This is a study for *Pine Baron*. I like it because it has a certain boiled-down author-
ity to it. I saw it and just painted it and, in this instance, wasn't held down or back
by any drawing. There are multiple meanings in this. It's Karl's World War I
helmet. Dr, Margaret Handy always referred to it as "After Verdun," and there's a
lot of the terror of that battle in it, I think. I see in it the fire and the peace, too.

PINE BARON, 1976 ▶
Tempera on panel
31½ × 33¼ inches (80 × 84.5 cm)
Fukushima Prefectural Museum of Art

I was driving my jeep into the Kuerners' entrance one day
when I suddenly saw this helmet under the pine trees. I
jammed on my brakes. I could hardly believe my eyes. There
was a World War I helmet filled with pinecones. My hair went
on end. It's what Anna Kuerner thinks of war and her hus-
band's army experiences. And she was using it just to carry the
pinecones in to start fires with.

I always carry a watercolor box, and I did the watercolor.
I didn't arrange the scene. It was there. I wanted to catch the
helmet as it was, not in a way I might place it, but the way she
had left it. You can never place a thing the way it's naturally
done. To me it expresses Karl's background, his experience in
the Black Forest during the war.

Sometimes I am moved, shocked and delighted all at the
same time, by something of a powerful and yet extraordinarily
incongruous nature. This is the kind of thing that gets me. It's
just a helmet sitting there, but to find it there is strange.

I made the tempera square because I wanted to emphasize
the shape of the helmet—and for stability and placidity with a
sudden horizontal diagonal feeling of the branches going out
that road. I wanted to capture the strange rusty quality that
pine trees have at this time of year, so I coated the panel with
alizarin crimson and painted the green over it. It's the only
way I could get that quality of pulsation and vibration. I love
the shape and dryness of the pinecones—there's something on
the edges of each one that looks like frost, dried pitch. Ever
since I was a child in Needham [Massachusetts], I've loved
them. There's something about the wind whistling under cat
spruces and pines that is unbelievable. I love the spiky, swift
gesture of pines, their sinewy branches that are so tough, re-
silient, bending, stronger than steel—marvelous! The needle
base under a pine tree is soft and velvety and yet rather harsh.

In the background, if you look closely, you will see the
place the cattle go up into the fields—by that post. You see the
cattle tracks? I wanted to jam this painting with all the rich-
ness I feel at the Kuerners' farm. This picture is not just a nice
grove of pine trees.

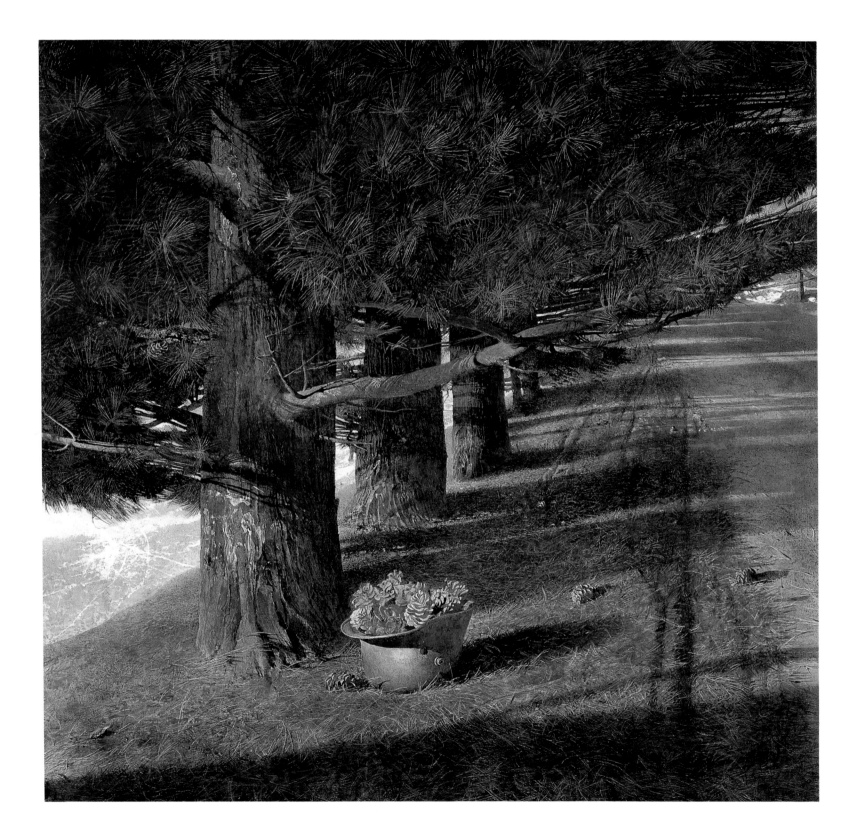

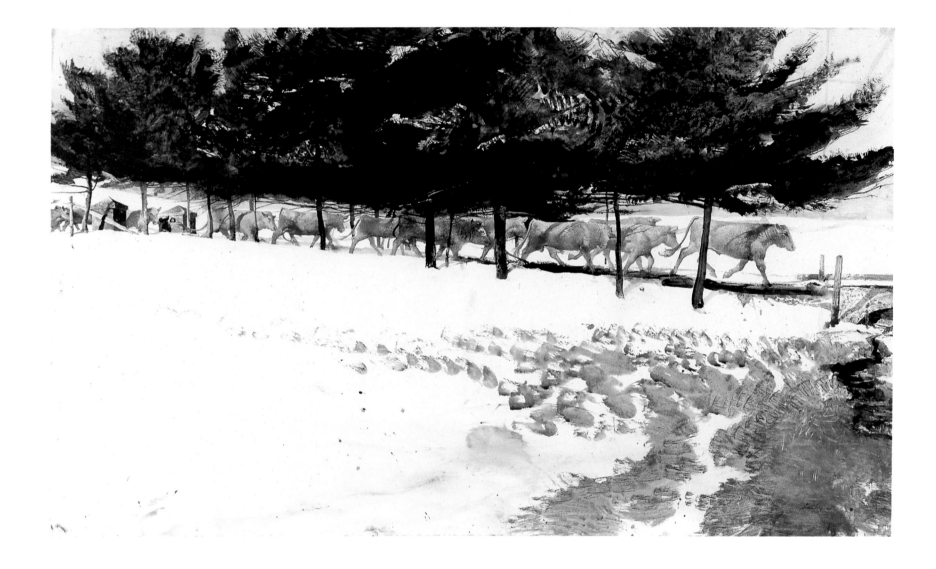

BULL RUN, 1976
Watercolor
30 × 52 inches (76.2 × 132 cm)
Private Collection

Every afternoon the cows at Kuerner's would run in from the fields. I'd be struck by the hollow sound of the cows' hooves on the tar road—they'd just tear along to get the fresh hay. If you stood in front of them, they'd just mow you down. It's a picture full of movement—and sounds.

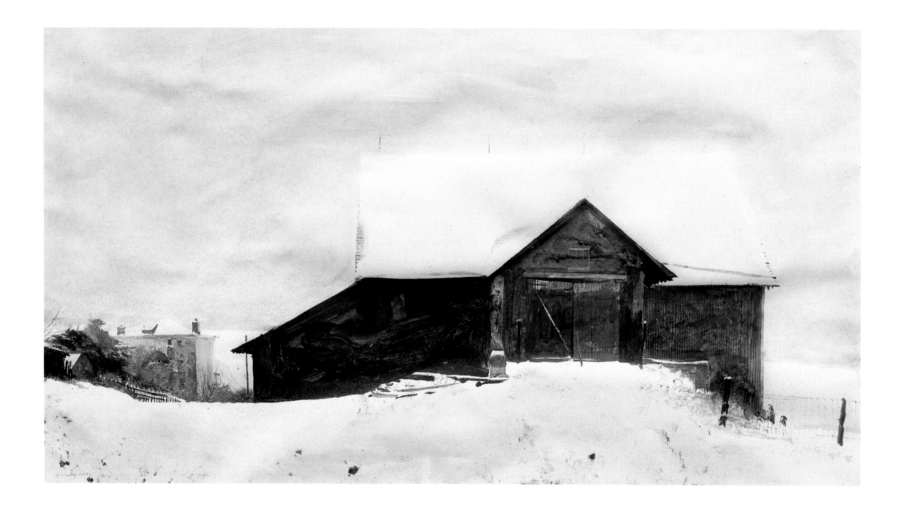

TRAMP IN THE BARN, 1978
Watercolor
21⅝ × 39¹¹/₁₆ inches (54.9 × 39.7 cm)
Louise Philibosian Danelian

It's one of the few paintings I ever made of the Kuerners' barn. Karl and Anna allowed railroad tramps to go in there at night, which is why the door is slightly ajar. It seemed to me to express the power of what could have been in there and what was not there any longer. It's a watercolor I did on the spot, trying to get a sense of immediacy.

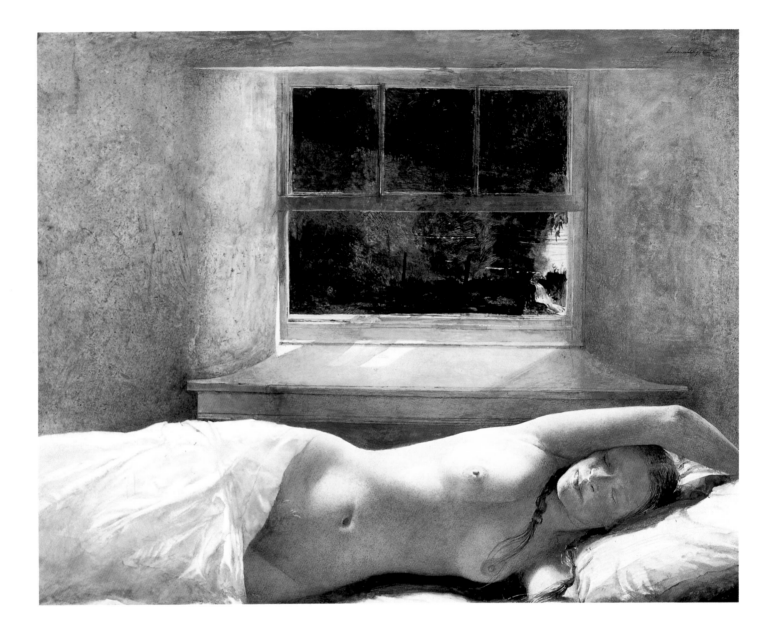

OVERFLOW, 1978
Drybrush
23 × 29 inches (58.4 × 73.7 cm)
AM Art Inc.

Look at the feeling of the lips, the feeling of the sleeping eye, and the light that goes over the body. Anyone who's watched a female form at night in that kind of light knows that this has a strong female smell to it. This picture—and most of the Helga pictures—are too real for some people. You have to feel deeply to do this kind of thing. You cannot conjure it up. Of course, there's a penetrating and throbbing sexual feeling in all of the Helga pictures. I felt the country, the house, Germany, the dreamy moist, rich female smell—the whole thing. This is truly wholesome. It's fresh, really American.

THE CLEARING, 1979

Tempera on panel
23 × 20¼ inches (58.4 × 51.4 cm)
Collection of
Mr. and Mrs. Andrew Wyeth

I finally had a hip operation and
went up to Maine. I knew this
handsome boy, Eric, an extraordi-
nary specimen. There I was,
hanging around with a crippled
leg, and here was this perfect
thing. The thought got me
going—*really* to do him, totally
nude. I was fascinated with that
blond hair coming down from his
chest all the way to his pubic hair.
The painting became more than a
body; it was like finding a won-
derful deer in the woods. It's
sexually powerful—everything
open, not sordid, just remarkable.
I sensed he'd had sex the night
before—the size of his penis
showed he'd been worn out. This
is utter reality. The point-
counterpoint of him and myself—
him so perfect and me with this
crippled leg.

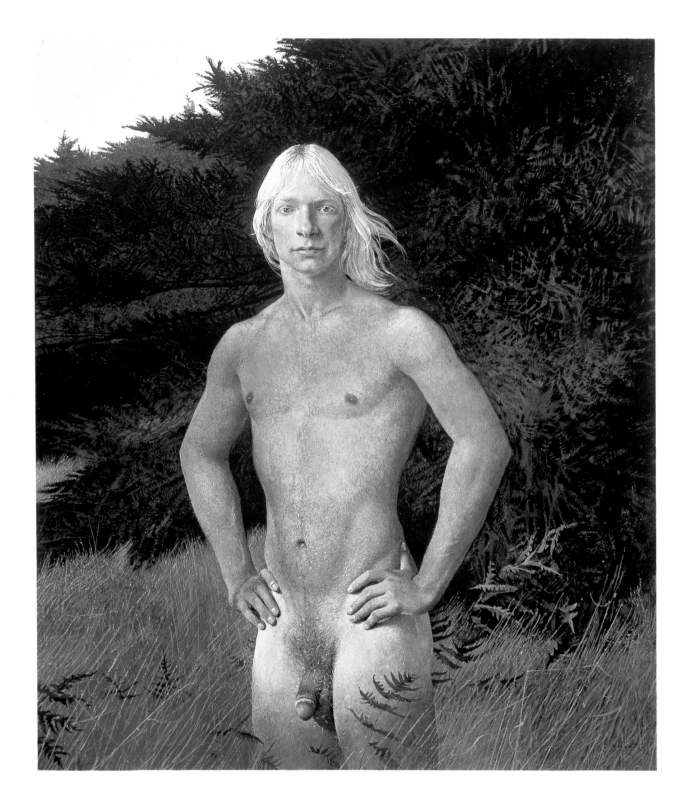

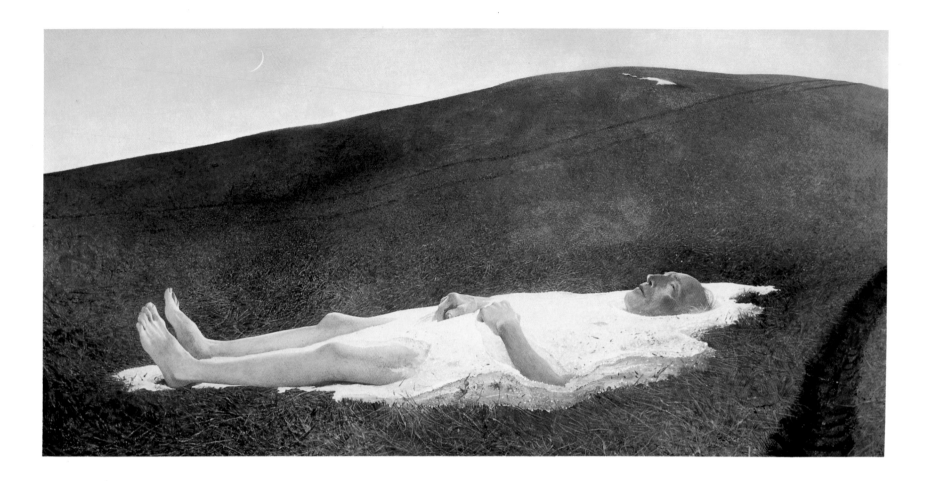

SPRING, 1978
Tempera on panel
24 × 48 inches (61 × 121.9 cm)
Collection of the Brandywine River Museum, Chadds Ford, Pa.
Gift of George A. Weymouth and his son in memory of
Mr. and Mrs. George T. Weymouth

This is a strange picture of Karl Kuerner that took me over the deep end. It's got a good, pulling quality. It came out of my seeing him in bed when he was old and getting sicker. He woke up suddenly and said, "Andy, did you hear that *snapping?*" He had this far-off look. The snapping was his memory of the barbed wire being cut on the line in the First World War. When he'd heard this sound one night, he'd opened fire with his machine gun. His officer gave him hell. When dawn came, there was a whole battalion of French dead on the wire just in front of his position. Got the Iron Cross. God, I felt I was there on the western front sitting with him. That story broke me loose from where I was—with an old man lying in bed—and I thought, This man is timeless, and I began thinking about those drifts up there on the hill and why not just put him in one. There's that other drift there, and I hope people who look at this picture will ask, "Who's in *there?*"

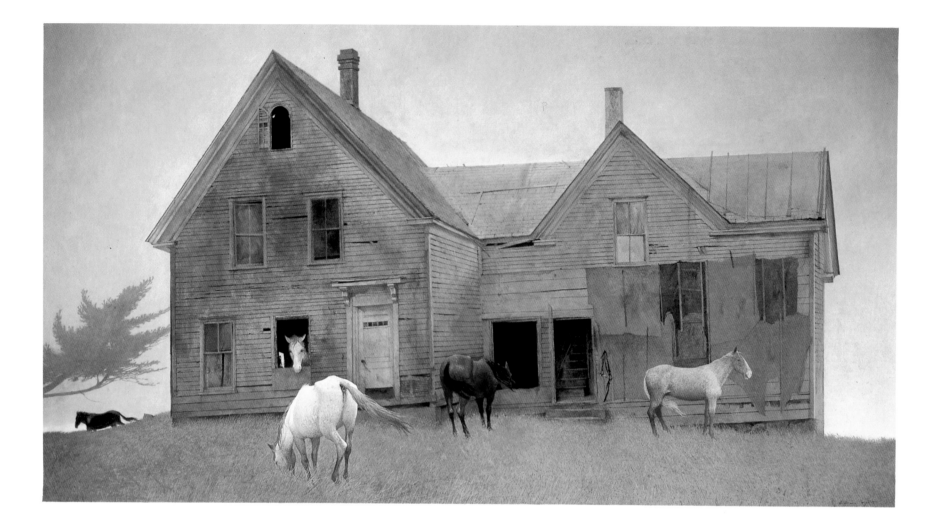

OPEN HOUSE, 1979
Tempera on panel
26 × 48 inches (66 × 121.9 cm)
Yoji Takahashi, Japan

This tempera is of a house on a back road in Maine where horses were rented out to ride. I took the nurse who was taking care of me—it was after I had had my hip operation—to this place, as she loved to ride. It was a foggy day. The house was gray, with all these horses—one was even inside the house, sticking his head out the window. The owner had a daughter who kept the horses, and he told me, "She's got a few boards missing in her attic." Funny, but Helga helped restore a bit of damage in the center of the painting in the foggy sky. I've trained her in tonalities and hues, and she works with unbelievable precision with tiny brushes. She's an excellent restorer.

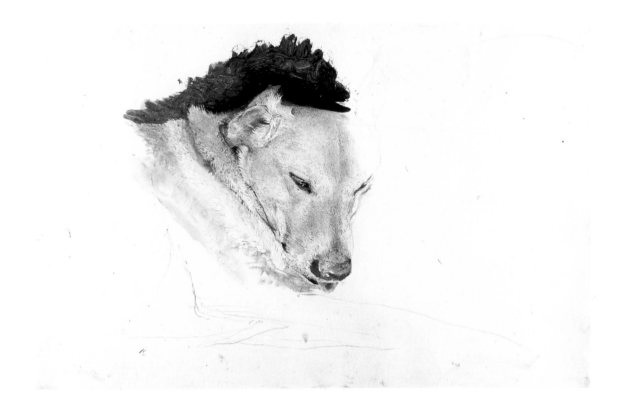

NEL, 1979
Study for NIGHT SLEEPER, drybrush
14 × 21¼ inches (35.6 × 54 cm)
Collection of Mr. and Mrs. Andrew Wyeth

My dog Nel. It was for *Night Sleeper,* the first idea. My dog with
an unexpected strange look on her face. She seemed almost like
someone else's dog when I came across her that night.

NIGHT SLEEPER, 1979 ▶
Tempera on panel
48 × 72 inches (121.9 × 182.9 cm)
Collection of Mr. and Mrs. Andrew Wyeth

I woke up one night and went down-
stairs, and there was my dog Nel with
this strange expression on her face. I made
a drawing and a watercolor and a dry-
brush—life-size just of her head. The idea
kept building in my mind, and I began
to make drawings of the Mill in the
moonlight. Finally I got an eight-foot
panel and decided to put in the other
window with the view behind and the
bag with the dog's mysterious treasures.
Why do I call it *Night Sleeper?* Because
that patch of light reminded me of the
sleeper trains I used to take to Maine
when I was a child. This thing just grew.
I had this enormous panel and kept on
and on until it was used up. I didn't want
a half thought; I wanted a whole one.
People think it's half Pennsylvania, half
Maine. It's actually Woodward farm in
Chadds Ford, based on actuality but freed
from any beginnings or ends.

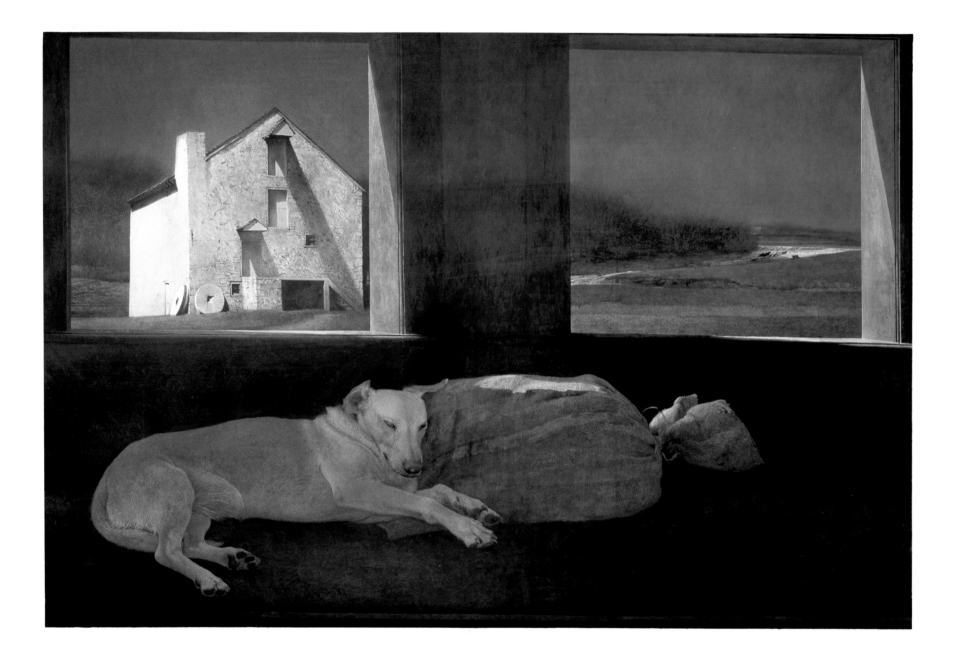

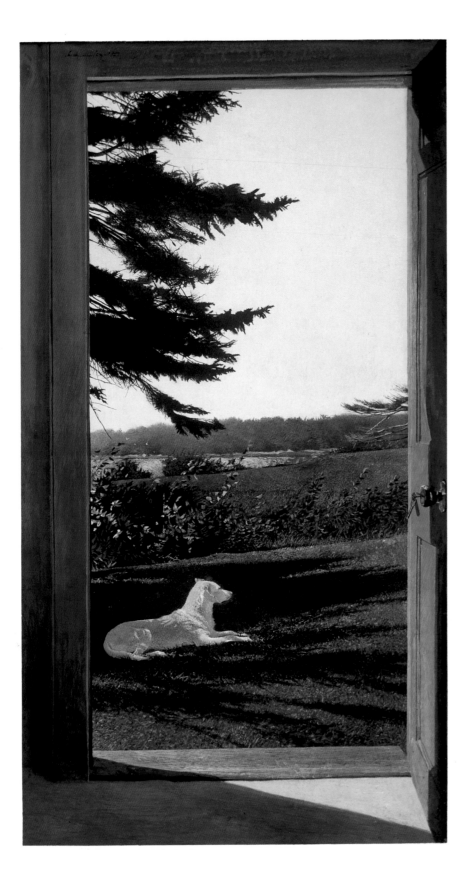

SUN SHADE, 1981
Tempera on panel
26½ × 14¾ inches (67.3 × 37.5 cm)
Private Collection

This one's a highly personal image of my
dog Nel. The key is in the lock of my studio
and the dog's looking up the road.

JACKLIGHT, 1980 ▶
Tempera on panel
43¼ × 44½ inches (109.9 × 125.7 cm)
Private Collection

I knew that local hunters were out trying
to catch deer with their headlights. It's
called deer jacking—totally illegal. There
was a deer hanging around our property
eating windfall apples, and it was almost
a pet. I had made a study of the deer eat-
ing one of these apples. The next day I
went up to Karl Kuerner's barn and found
the deer there. It was strung up, gutted,
with its nose almost touching the floor,
and the apples I'd seen the deer eating the
night before seemed to have mixed with
the blood.

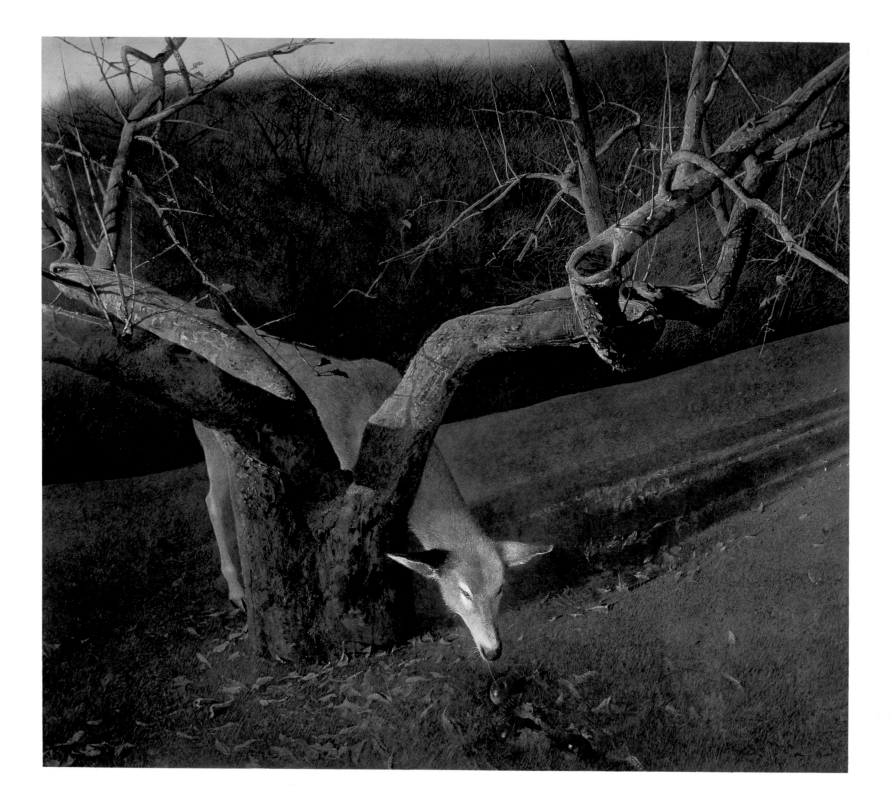

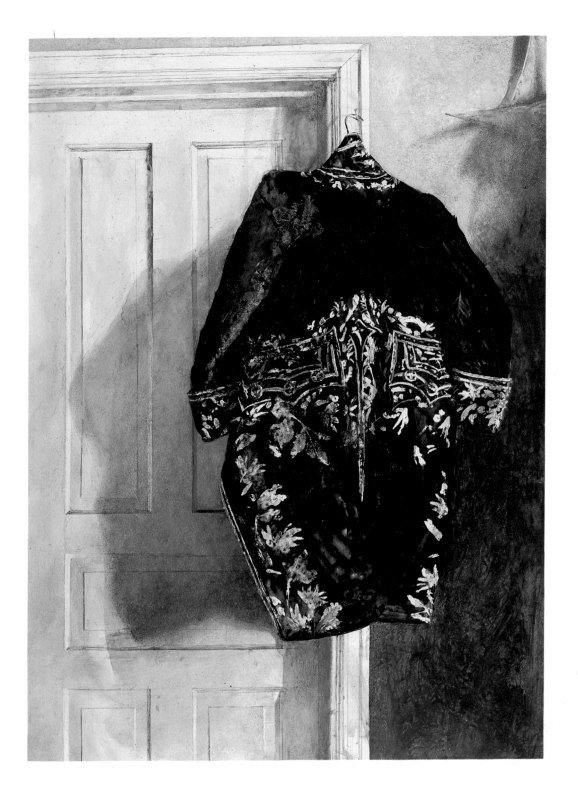

FRENCH CONNECTION, 1980
Watercolor
27 × 20½ inches (68.6 × 52.1 cm)
Frank E. Fowler Gallery,
Lookout Mountain, Tenn.

Father's studio. The costume—an authentic one—was owned by an aide to Napoleon III. The uniform reminded me of the Marquis de Lafayette. You know, he had soil from the Brandywine Valley put in his coffin in France. Notice up on the right side the sail of an American sloop of war. The painting is all about my strong feelings for the American Revolutionary War, the aura of which surrounds me here and which I feel from my constant wandering around these hills in the Brandywine Valley.

Thin as Vanity, 1981

Tempera on panel
31 ¼ × 16 ⅛ inches (79.3 × 41 cm)
The Nelson-Atkins Museum of Art,
Kansas City, Mo.
Gift of the Enid and Crosby Kemper
Foundation

She's Adam Johnson's granddaughter,
whom I saw at his funeral. She was wear-
ing these astounding earrings, and I had
her pose for me. But then she had some
epileptic fits, and I stopped. The painting
sat around for months, and I finally fin-
ished it because I got interested in that
mirror. So I painted it around the picture.
I was trying to get the feel of the flak-
ing of the veneer of glass over cheap mir-
rors which peels away. The peeled gesso
I think works perfectly. I let myself go a
little wild on this and amused myself
by tricking around with the material.
I found something there almost by chance
and tried to lift it out. I believe
I did, too.

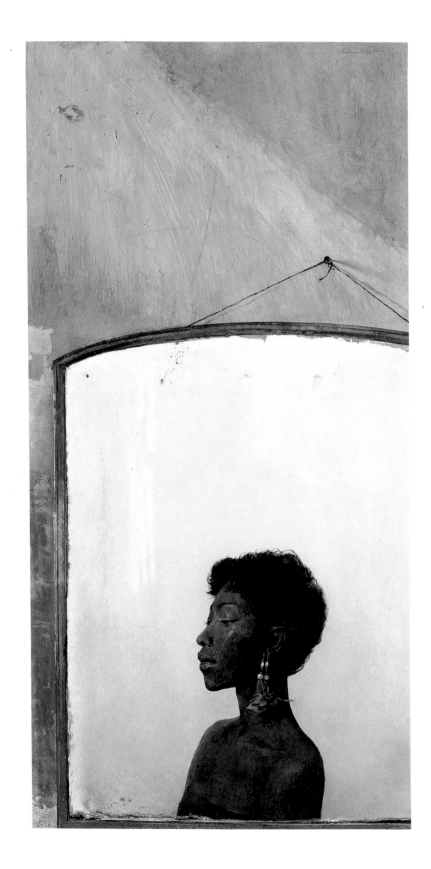

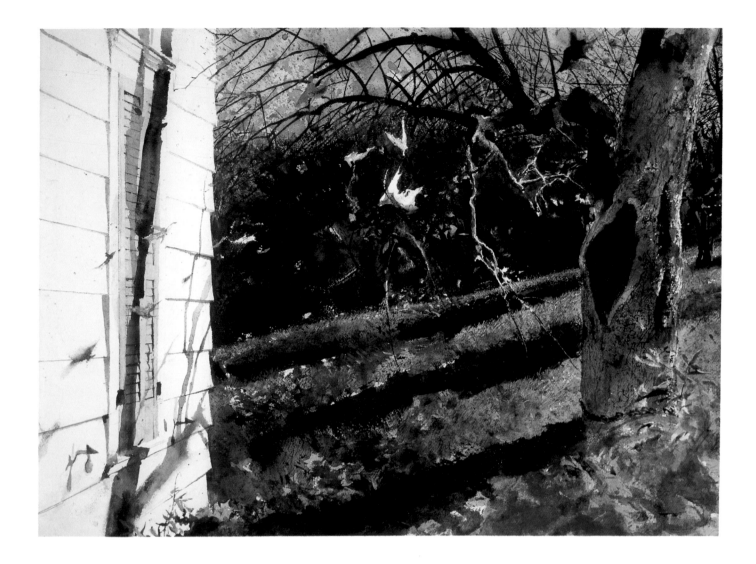

BLOWING LEAVES, 1980
Watercolor
20 × 27 inches (50.8 × 68.6 cm)
Private Collection

Leaves are floating through the air against a white back-
ground—one of those things that takes place and is
instantly gone. I was trying to capture that instant of
the leaves floating down—and the abstract excitement
of the studio where I studied as a boy.

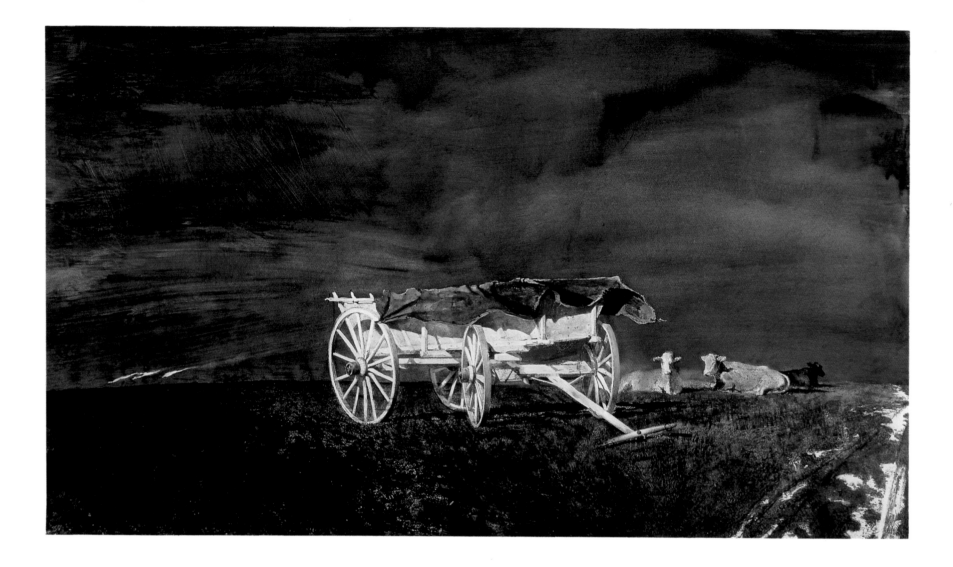

BIG TOP, 1981
Drybrush and watercolor
28¾ × 51 inches (73 × 129.5 cm)
Collection of Mr. and Mrs. Andrew Wyeth

I saw this wagon one night in the moonlight at the Moore farm. It's an authentic wagon of 1812, in which the Du Pont company used to haul powder. That wagon evoked vivid memories of circuses.

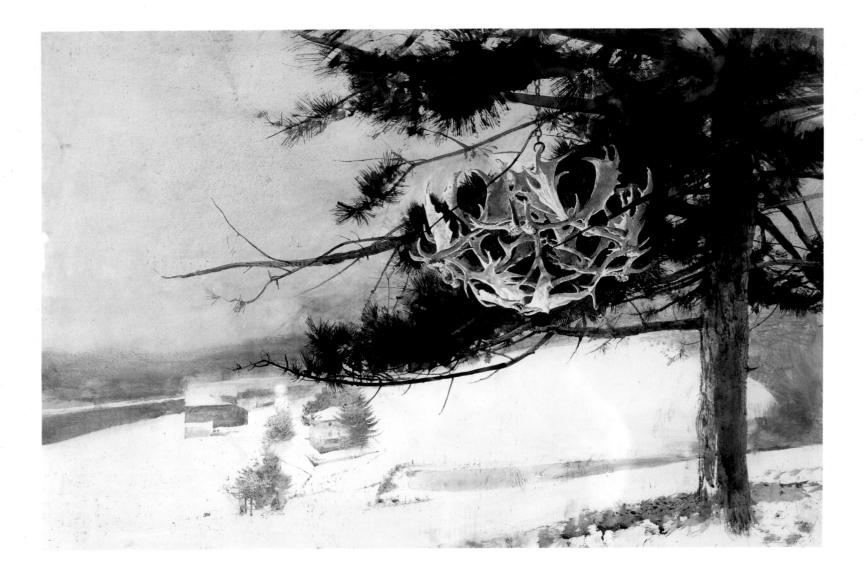

RACK AT KUERNERS, 1983
Study for ANTLER CROWN, watercolor
26 × 40 inches (66.04 × 101.60 cm)
Mr. and Mrs. Frank E. Fowler

Betsy bought this rack of caribou antlers someplace and hung it in the Granary, and I fooled around with this idea—I should have done it as a tempera—as a "portrait" of Karl Kuerner, who was a great hunter. The rack was never in this precise place, and so this picture is completely from my imagination. I had drawn the rack so many times that I had visually memorized it, and so when I saw this winter scene I put it in. I like the mood of it.

FLOUR MILL, 1985
Watercolor
27½ × 19⅝ inches (70 × 50 cm)
Private Collection

The title comes from the strange light on
the white building reflected in the water.
When I was looking at it, I thought of all
the flour that had been milled there since
the Revolutionary War. The whole pic-
ture looks like wheat flour, which is, I
think, what saves it from being trite. The
tonalities are not in any way realistic, but
they were what I felt about the building.

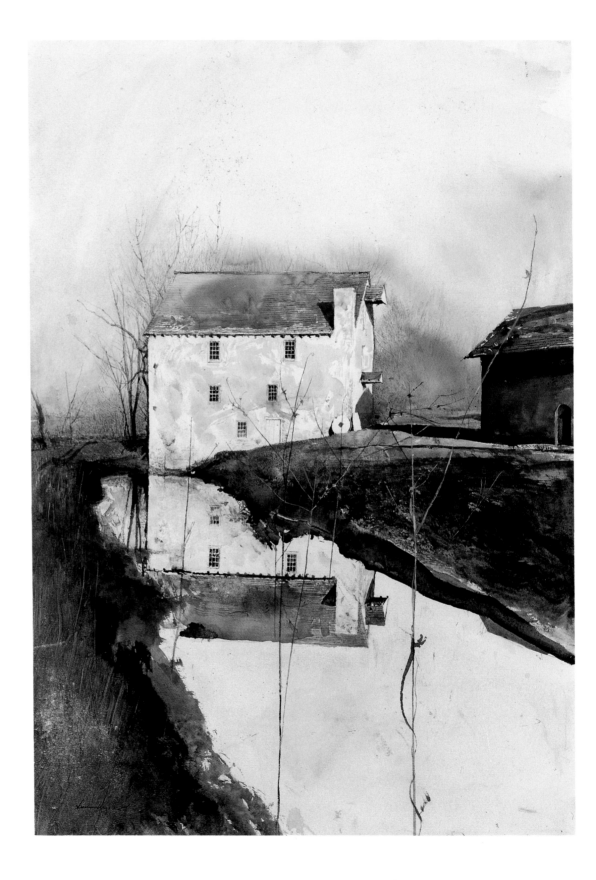

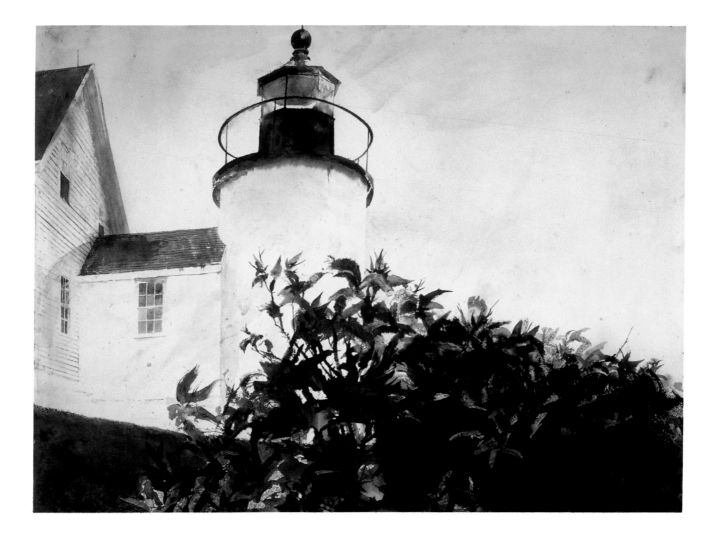

SAILOR'S VALENTINE, 1985
Watercolor
21 1/2 × 29 5/8 inches (54.6 × 75.3 cm)
Mr. and Mrs. Crosby Kemper

I used to own this island in Maine that had a lighthouse. I became fascinated with the wild roses and that light and by the fuzziness of those damp spots just underneath the top of the light—the old, stained metal part up there at the lip, the rim, the gray area, where there's wet, old paint. That, and the luminosity of the light, was perfect. Almost *too* good. Eventually I had to leave that island—it was too good. When I was there, I felt I was getting out of touch with the earth. The island was too perfect for my personality. You see, I have to go against myself. Many times I find a subject to paint and say, "Marvelous!" Then I think maybe it would be even better for me to walk away from it, and I do. I think it's interesting to reject things. Keeps me on my toes.

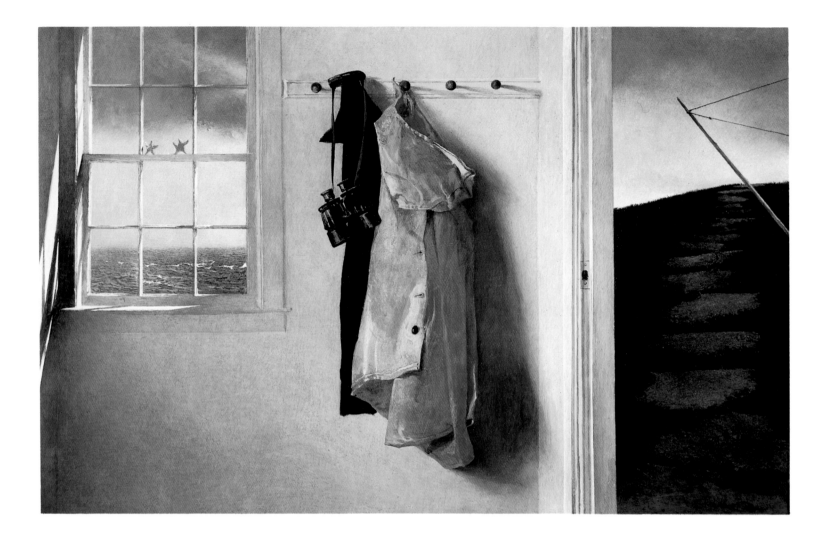

SQUALL, 1986
Tempera on panel
17¾ × 28½ inches (45 × 65 cm)
Yoji Takahashi, Japan

This is up in the house on an island that we once owned in Maine. In the kitchen. My wife was sitting outside watching a regatta of Friendship sloops. I was inside. I did a watercolor of her looking at the distant boats. While I was doing it over the next few days, a series of squalls came up. Rain beat upon the windows, the sea churned up, whitecaps—a chilly feeling. You know, that strange quality reflected inside the white kitchen became more luminous as the squalls grew stronger, and then I noticed the clothesline outside. Those impressions evolved into the tempera. Betsy's slicker is there, and her binoculars. Betsy's no longer in the picture, but she's still there.

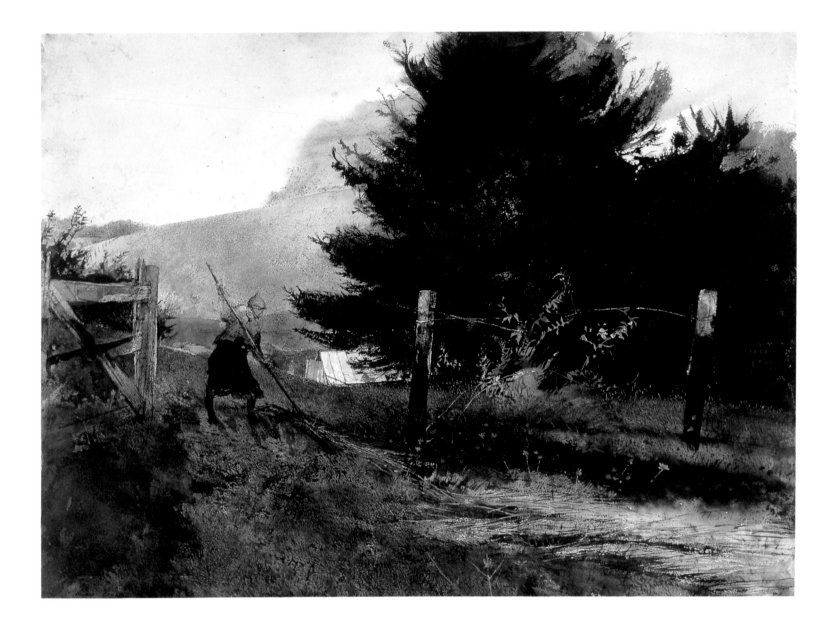

CORNFLOWERS, 1986
Watercolor
21¾ × 29⅞ inches (55.2 × 75.9 cm)
Collection of Mr. and Mrs. Andrew Wyeth

Anna Kuerner is at the back of the house raking. She's eighty-six years old and mopping up, with that long-handled rake, the hay that has been left behind after her son has been haying. Typical of her. I painted it about six-thirty in the morning. I loved the misty hills, the pale blue color of the cornflowers, and the deep hues of those pines.

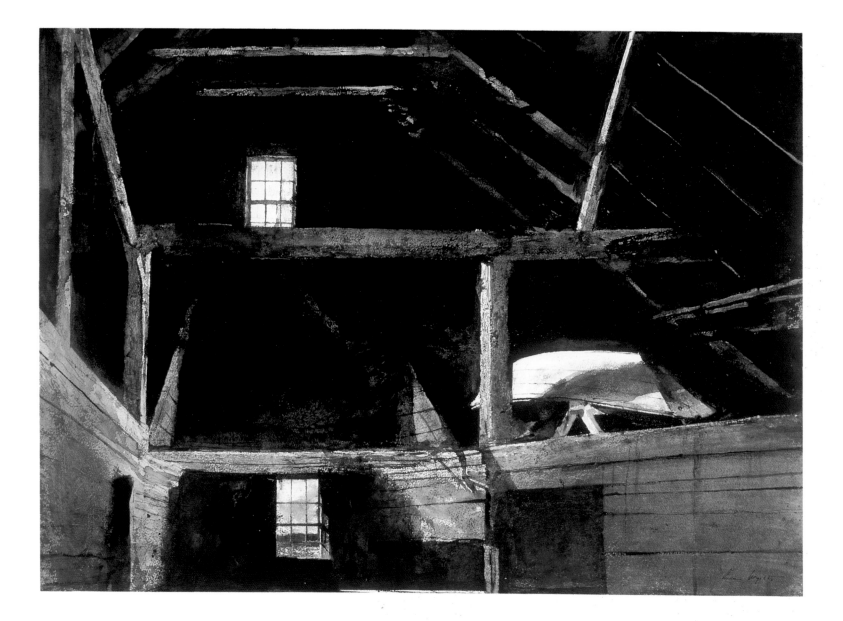

RAFTERS, 1985
Watercolor
20 × 28 inches (50.8 × 71.1 cm)
United Missouri Banks

This shows a white dory in the rafters of the barn at Broad Cove in Maine—a typical dory made on the coast of Maine. I had had it made for me in Port Clyde. I was up there one morning, just having come from Pennsylvania, and I was intrigued by the abstract shapes I saw there and first made a watercolor. I'm far more interested in abstract shapes than many people think.

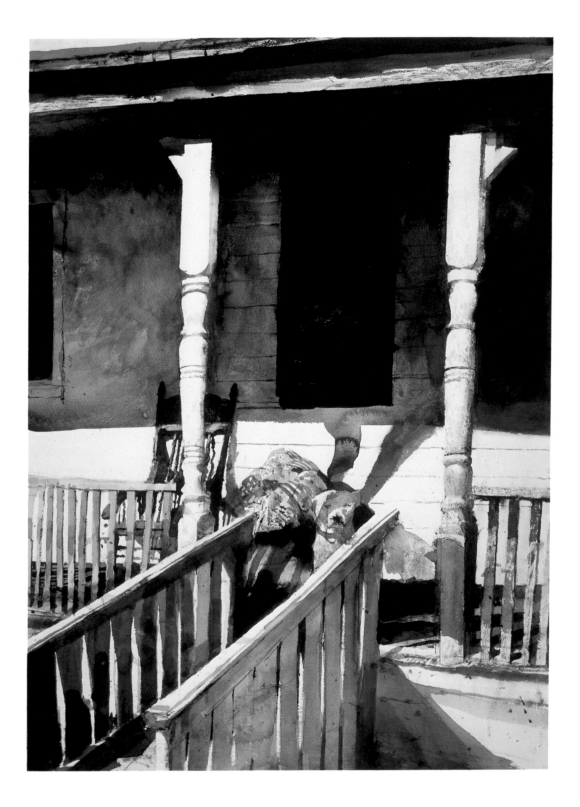

RAG BAG, 1986
Watercolor
30 × 22⅜ inches (76 × 57 cm)
Yoji Takahashi, Japan

A Chadds Ford painting. That dog was called Killer; he finally was killed by a car on the highway. The house is so "Negroid" to me—that's what got me—especially the bag filled with bits of cloth and strange candles on the inside of the house. The dog looked at me, guarding the bag. Those eyes had marvelous rings around them—he was a sort of mixture of a Boston or an English bull and a hound dog. I had just had all my teeth capped—in two days. It was awful. When it was over, I came home, took a shot of whiskey, and was so elated I went up and did the watercolor. I think the picture shows a certain sense of triumph.

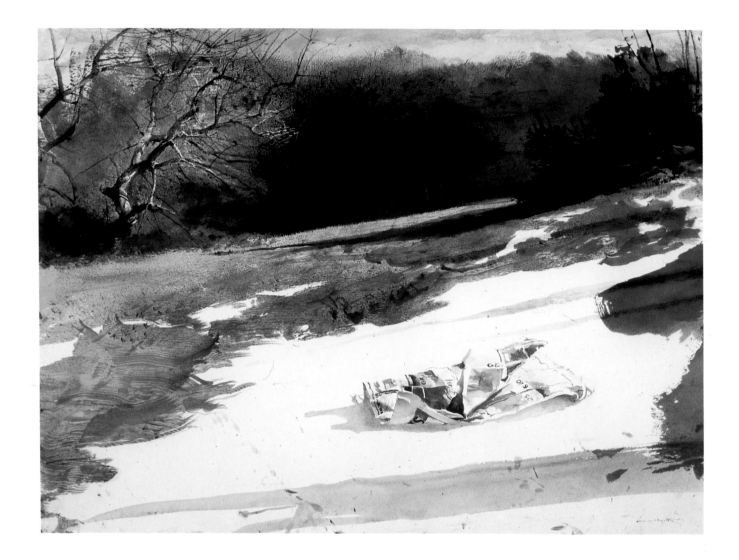

SUNDAY TIMES, 1987

Watercolor

22 × 30 inches (55.9 × 76.2 cm)

Collection of Mr. and Mrs. Andrew Wyeth

I was down in Chadds Ford. It was winter, and I was driving back to the studio after I'd been painting the apple trees in the snow, when all of a sudden the wind came up and a bright piece of paper—it was the *Chester Times* advertising supplement—just blew there. Funny, but it *made* that picture. I found it so expressive of the countryside around here and the crap people throw out of their cars—really rural, so thoughtless. I experienced an unexpected joy of seeing vibrant colors at the decisive moment. I put my foot out and stomped on that piece of paper. And it worked. I found it a sort of liberation, freeing me from having to force outrageous color into a picture. It's impossible for me to inject into a scene a built-in idea of what color is. I was carried away by the very lack of color one finds in the Brandywine area, so I loved the contrast of the normal drabness and that bright, flashing piece of paper blowing furiously into the scene.

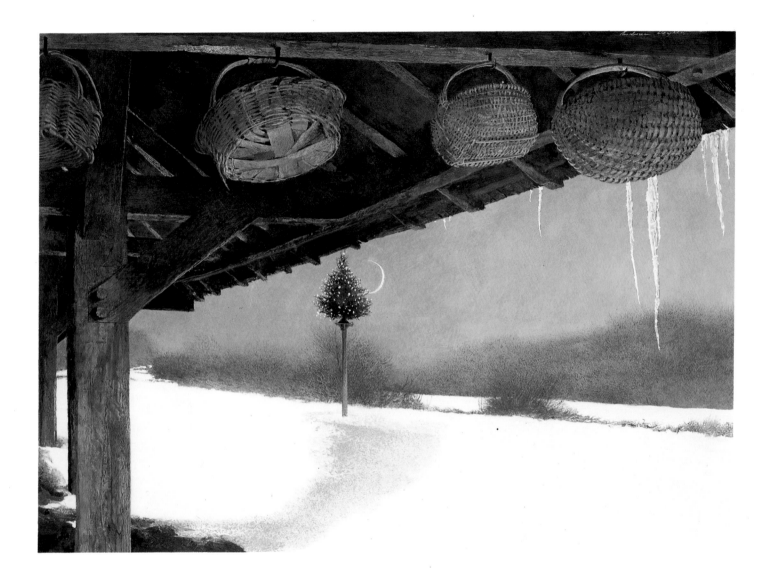

CRESCENT, 1987
Tempera on panel
15¾ × 21⅞ inches (40 × 55.6 cm)
Private Collection

At our mill in Chadds Ford. One of the things that got me was the wooden beams, so dark and damp and cold. If you turn this picture upside down, it looks like a Chinese junk going down the Yangtze River or something. It's better upside down! In fact, one of my collectors has a painting he always hangs upside down. Told me, "Hope you don't mind, but it looks better that way." It's all right; I don't care.

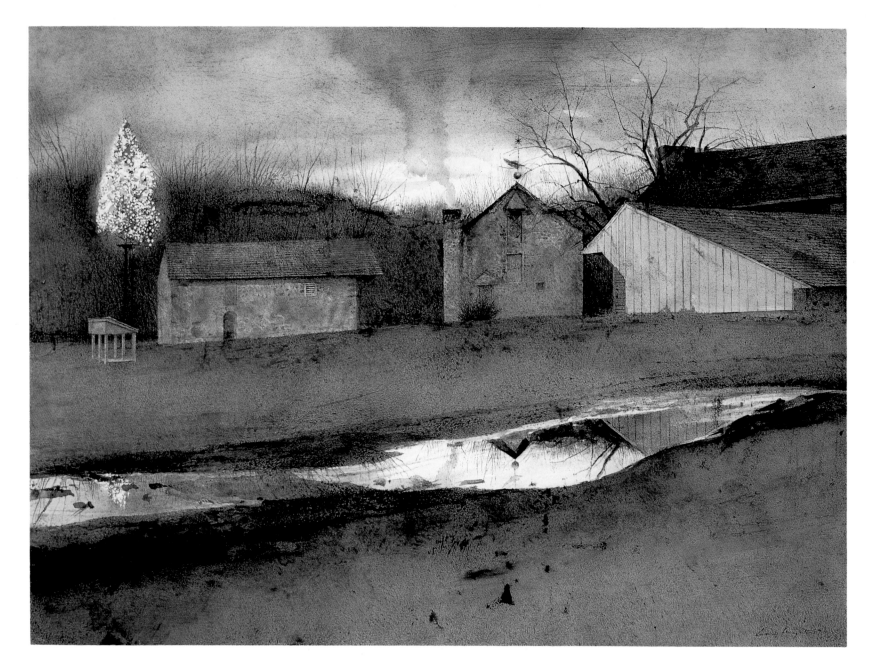

LAST LIGHT, 1988

Drybrush
21¾ × 29⅞ inches (55.2 × 75.9 cm)
Private Collection

This is, I admit, a very odd picture, but I became fascinated by the poetry of the last light of the day and that Christmas tree reflected in the puddles of the road and the smoke coming out of the chimney against the rain clouds. I painted it very tightly so that it would become a tonal picture, for I seek what you might call other dimensions in tones. A storm has just passed, and there are reflections in the water in the road. There's always a fire in the cellar in the Mill. The quality of the original is drybrush watercolor, minutely painted with many tiny strokes. It's one of my purest drybrush watercolors. I painted it after Christmas and was seeking the last light of the dying of day and the last lights on the Christmas tree.

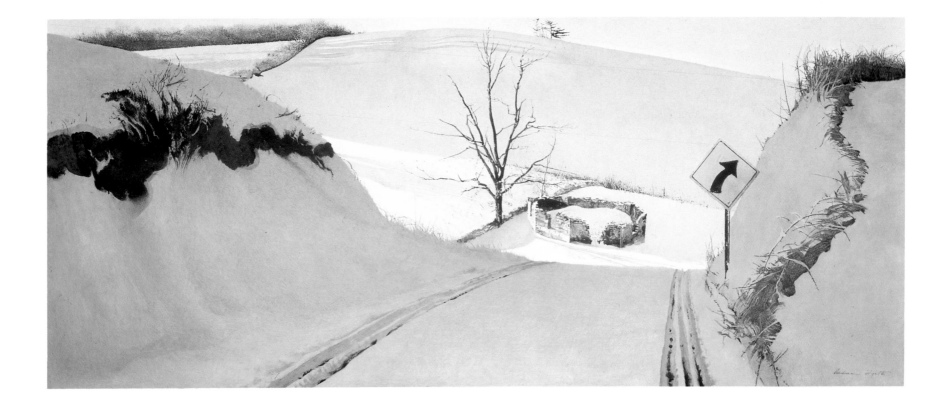

RING ROAD, 1985
Tempera on panel
16⅞ × 39¾ inches (42.9 × 101 cm)
Private Collection

That harsh shot of yellow in that modern road sign is why I did this picture. Some people said that if I took the sign out, they'd buy the painting. Why would I do that? I love that mesmerizing sign. I've almost gone over that corner and crashed, and the thing made me recall those dangerous moments. Take it out? Hell, no.

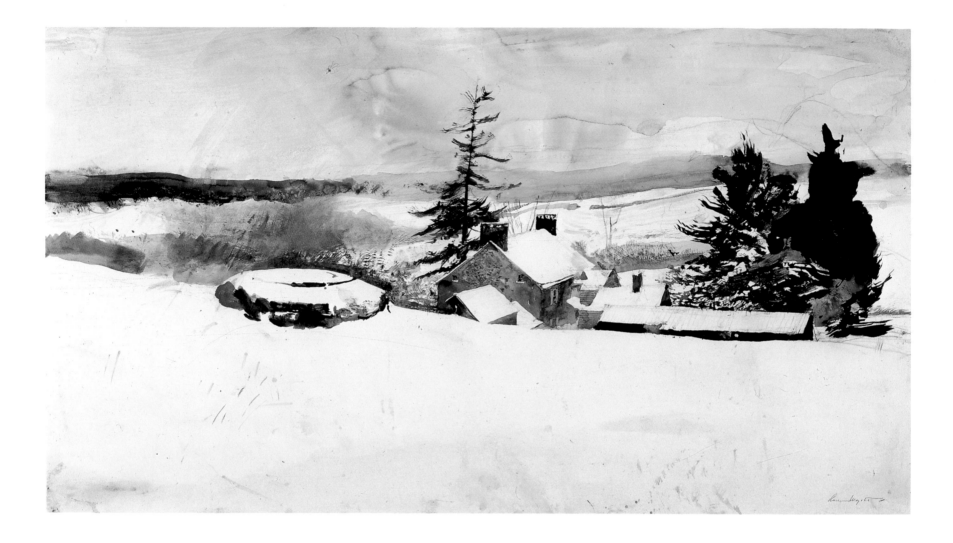

CISTERN, 1988
Watercolor
21⅝ × 39⅝ inches (54 × 97 cm)
Yoji Takahashi, Japan

It's the Wylie house in Pennsylvania, a Quaker farm. I've painted there for many years. *Cooling Shed* (see page 34) was painted there. It's from up on the hill looking into the valley where the farm is. You can see the long Quaker meeting shed on the right. The curve in the snow in the foreground is the cistern.

GREY SQUIRREL, 1987
Study for FAST LANE, drybrush
9¼ × 29⅞ inches (23.5 × 75.9 cm)
Collection of Mr. and Mrs. Andrew Wyeth

See the real blood of the squirrel? I just
put some on my finger and placed it into
the prestudy. Blood never seems to
change, no matter how old it is. I have
seen some old, old dueling swords with
blood that looks almost fresh.

FAST LANE, 1987 ▶
Drybrush
14 × 16⅝ inches (35.6 × 42.8 cm)
Collection of Mr. and Mrs. Andrew Wyeth

A roadkill. The roughness of life. The difference be-
tween now and then. I've seen so many kills, and when
I went out to the highway that day, there it was—this
beautiful squirrel with the blood running out. I even put
my finger into the creature's blood and stuck it in the
drybrush. I'd been painting that house for several
months. The painting grew like topsy—that's the way I
work. I like this one because it's weird and off balance.
That house is a pre-Revolutionary one, owned by a
Negro family by the name of Winfield. I was thinking
about the covered wagons of Revolutionary days and
that age-old house and the difference between that and
the modern highway with the cars whizzing by through
Chadds Ford—those tire marks and the squirrel killed by
those fast cars.

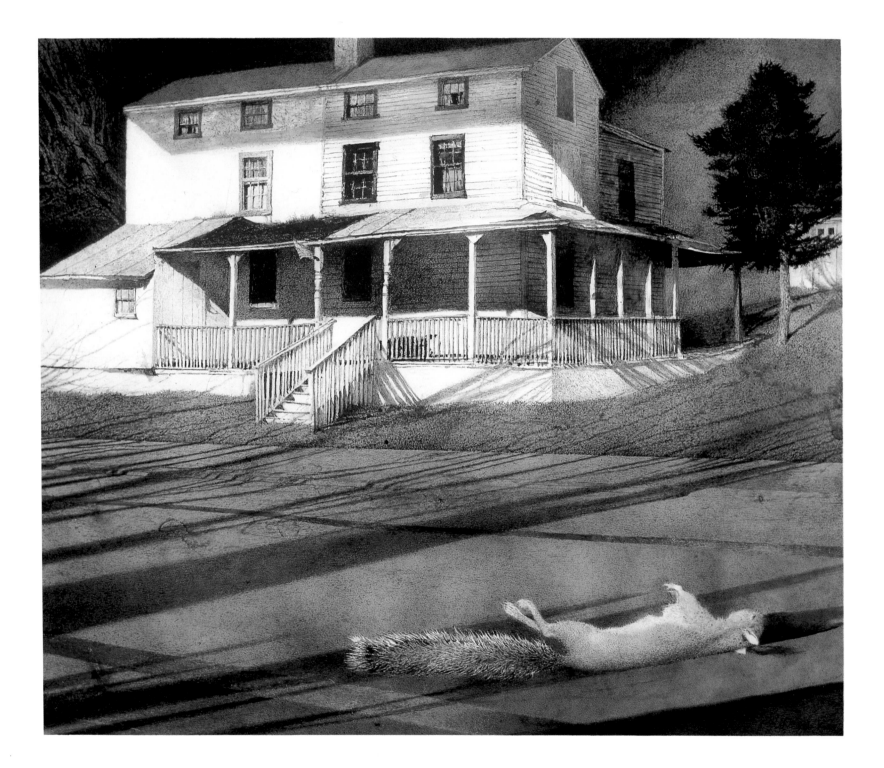

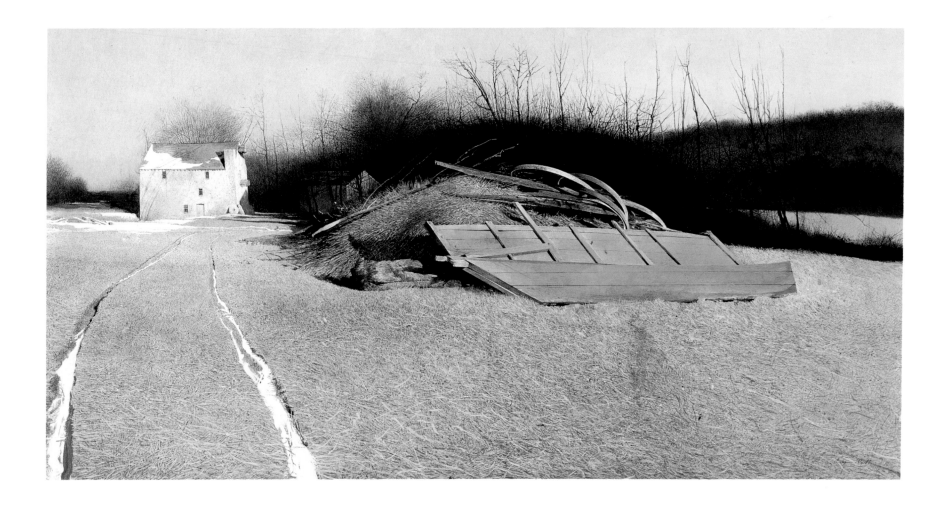

FLOOD PLAIN, 1986
Tempera on panel
24½ × 48 inches (62.2 × 121.9 cm)
Charlton Heston

I wanted to capture the clean-swept character of the beginning of winter after the floods. I looked out and wondered, What's that blue thing? It was the startling blue cover of a wagon. I found the car tracks rushing toward me exciting. The wagon had been in some parade and had been dumped out there near the raceway. The size of this picture is just right.

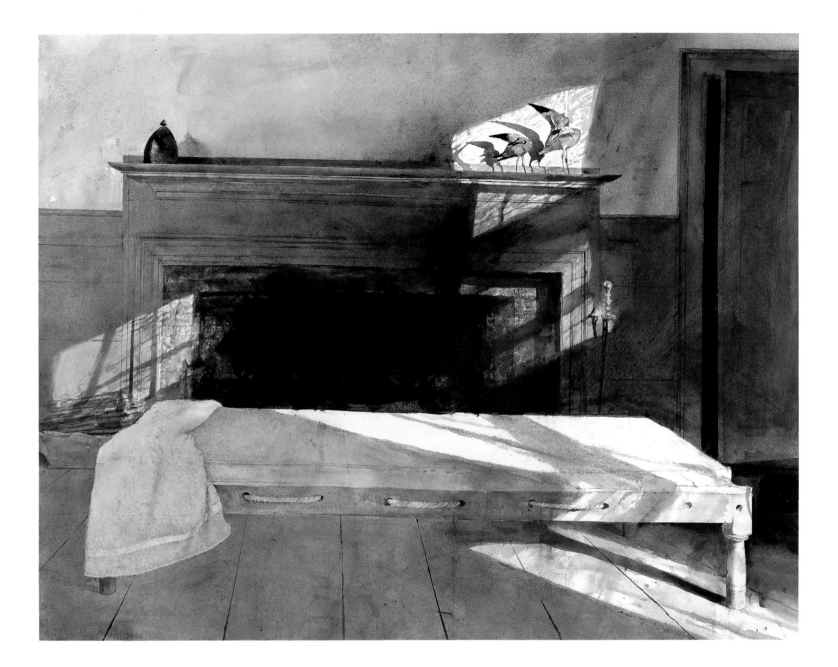

MAINE ROOM, 1991
Watercolor
28 × 35½ inches (71.1 × 90.2 cm)
Private Collection

Early morning with the sun hitting those birds on the mantelpiece.
I wanted an expression of a simple early New England house with its
large mantel and the fire tongs on the right catching the light. They
came from Christina Olson's house. I remember the exact time of day
I painted this—at six-thirty in the morning in the early spring. The
light infuses the whole painting. This light is not pictorial but atmo-
spheric—light not as some effect, but light as light and enduring.

PENTECOST, 1989
Tempera on panel
20¾ × 30⅝ inches (52.7 × 77.8 cm)
Collection of Mr. and Mrs. Andrew Wyeth

This painting is almost entirely different from all my other temperas, be-
ing almost a "pretty" subject matter. I think it *is* beautiful, and I can't
always say that about my paintings. I felt the spirit of something when I
did it, and I believe I managed to communicate that spirit. You see, at that
time—it is, of course, Maine, on Allen Island, one of my wife's two
islands—a young girl was washed out to sea in a storm. They couldn't save
her. In time the body floated by off Pemaquid Point. I was thinking about
that girl's body floating there underwater, and the nets became her spirit.
It's a grisly story, but knowing the depth of my feeling kind of saves this
picture. Those nets are like fog. I tried doing them with a brush but
couldn't get that cold blue, almost silver, cast, and so I went to the pencil
and put them in after I had put on the tempera. But it's that story of the
girl that prevents it from having been painted, say, in Venice. Know what
I mean?

LADY OF THE HOUSE, 1990
Watercolor
27½ × 19½ inches (69.9 × 49.5 cm)
Mr. and Mrs. Frank E. Fowler

Jane Wyeth in Maine. I went up there to her house one morning, and I saw her rushing out the door in that long white dress. I was intrigued and asked her to pose. This watercolor took me three days to complete.

STRAW HAT, 1992
Watercolor
27½ × 17¼ inches (69.9 × 43.2 cm)
Frank E. Fowler Gallery, Lookout Mountain, Tenn.

The hat is Helga's with the blue ribbon, the place is my studio in Chadds Ford, and the date is early spring. It was just the way that ribbon caught the light that was the feeling of spring. She'd put the hat there and was going down into the cellar, and I spotted it and it sparkled. It's one of the most spontaneous pictures I've ever done.

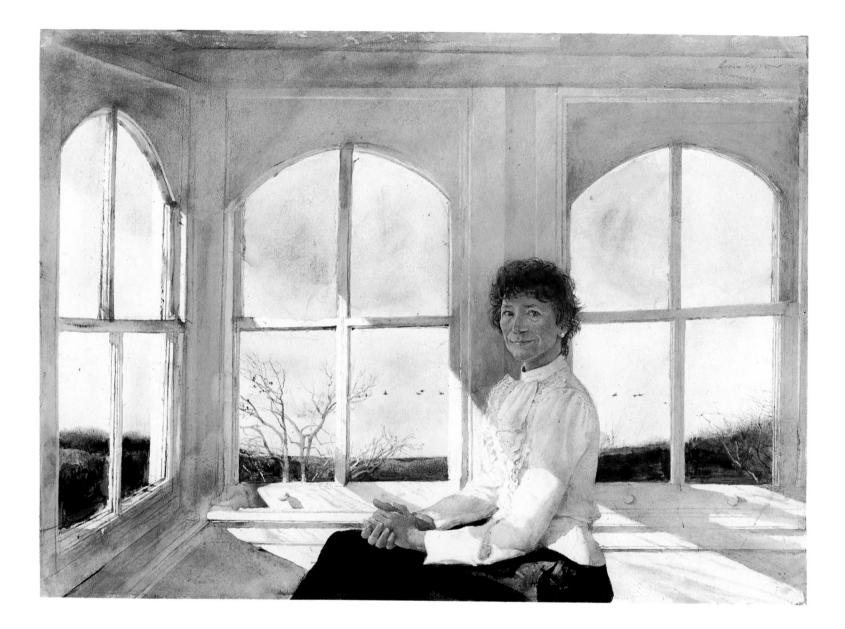

GLASS HOUSE, 1991
Watercolor and drybrush
19⅝ × 27½ inches (50.4 × 69.9 cm)
Private Collection

A portrait of a friend of mine in Chadds Ford, Mrs. Sipala. That glass all around had a fantastic effect on me. It seemed like some kind of fantastic fishbowl, almost surreal. Notice there's a tree outside with the leaves off, and the birds are flying around in a slight, light snowstorm blowing up. I was searching for a feeling of the change of atmosphere. But it's surreal, too. When I see the surreal element in what I observe around me, I keep it understated. When it works almost on its own, it's fine. You have to watch out and not do it too much. It's a fine line. Can't let it become a cliché. I really love painting glass, but you have to be subtle with the reflections. Just enough reflection can make the whole thing read visually. Too much reflection will destroy a picture with glass in it. If you overdo glass and reflections, they become a cartoon. And that gets boring.

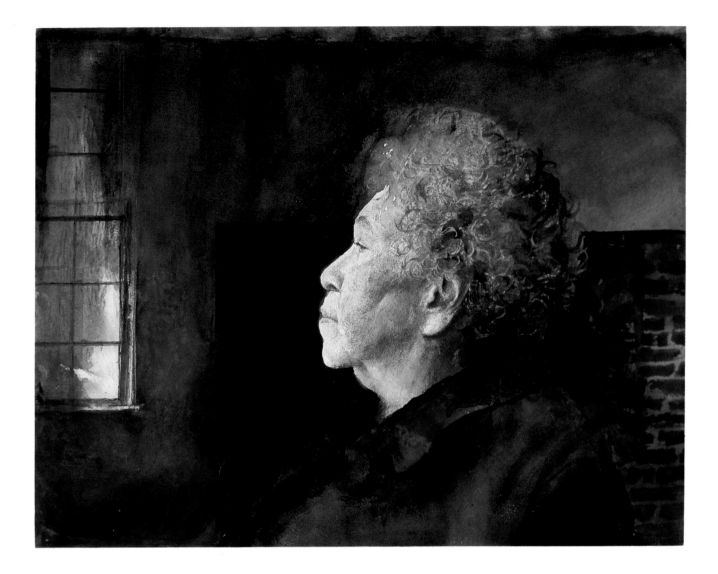

THE CRITIC, 1990
Watercolor and drybrush
25¾ × 29½ inches (65.4 × 74.9 cm)
Collection of the Brandywine River Museum, Chadds Ford, Pa.
See page 168 for list of donors.

My sister Carolyn. I always was interested in the way she'd look up when she was thinking about saying something about a picture. She looked a lot like Father—very vital. Got her here just before her stroke. One of the last things I did of her. I was in the big living room in the middle of winter— you can see some snow through the back. She was very sharp. She was the one who said to me one time, "Too bad Georgia O'Keeffe's painting isn't as good as her looks." Carolyn was a helluva good painter herself. Powerful and primitive. The black painter Horace Pippin liked her work enormously. Carolyn and I were very, very close. She could never shock me, and I could never shock her. We did what we damned pleased. She knew about the Helga pictures from the start and thought the whole idea was terrific.

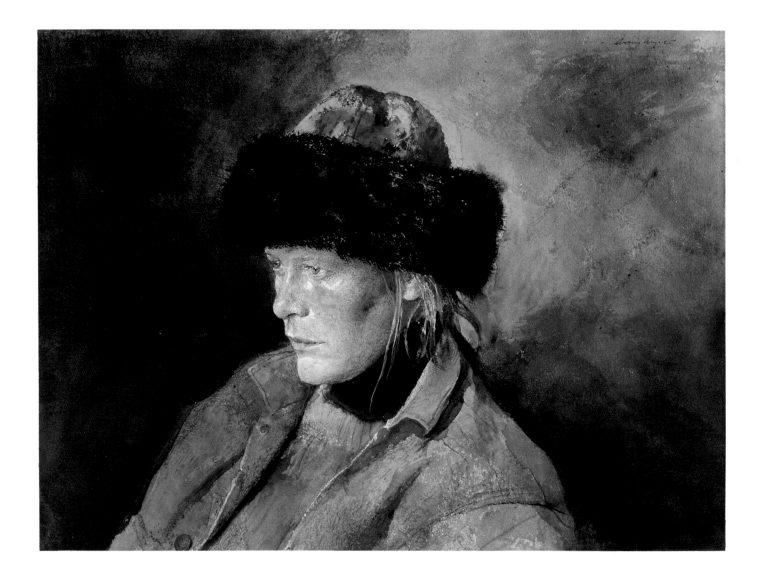

THE LIBERAL, 1993
Drybrush and watercolor
16¾ × 23⅛ inches (42.5 × 58.7 cm)
Private Collection

This is a young lady who works for me at Chadds Ford. Interesting sort. I'm not sure what to make of her. Intelligent. Doesn't miss a trick. Blue eyes. Quick. Will snap right back at you. Her family comes from Washington and was associated, somehow, with the FBI. She's a liberal—politically—and she sat there completely within herself, just like a liberal.

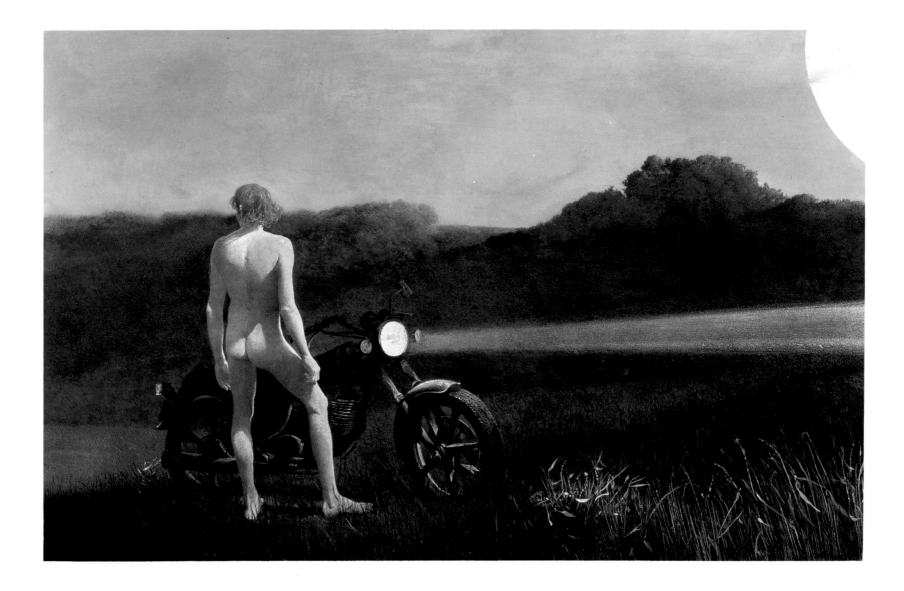

MAN AND THE MOON, 1990
Tempera on panel
30⅛ × 48 inches (76.5 × 121.9 cm)
Collection of Mr. and Mrs. Andrew Wyeth

It's my friend Jimmy Lynch. But there's much more to this painting than Jimmy. When I was young, I used to ride horses and motorcycles at night along with the local farm boys—in the middle of summer, in the middle of the night, all of us naked. I was intrigued by the bodies of those farm kids— their faces so tanned, their bodies, covered up by their work clothes, looking like they were covered with wax. Nude bodies streaking around at night always impressed me. When I was doing this painting, I'd take off my clothes and, together, Jimmy and I would drive around—at two in the morning on his big Harley-Davidson. It wasn't cold, for it was late August. The mist at night was fascinating. It combines the mystery of my youth with the shock of today. I have to laugh, for this one turns most people off.

148

BONFIRE, 1993
Watercolor
39¼ × 27½ inches (99.7 × 69.9 cm)
Private Collection

A woman had died in this house in
Chadds Ford, and they built a huge bon-
fire in her honor, with rail fences
dragged in. It sent sparks shooting into
the high pines. I felt a sense of the pri-
meval, because just such a thing has taken
place over the centuries. I find intense
emotion in fires, and I was deeply moved
by this experience. I don't think there
have been many paintings of fires that
have been done with authority or zip. I
wanted to face this challenge—to cut the
grease off all other paintings of fires. I
had a big piece of paper and laid the pic-
ture down on the spot. They heaped up
the rails and lit the fire several times just
for me. At one point I took a piece of
burned wood from the blaze and chucked
it in the back of the car, because I wanted
something organic from the scene.
Georges Braque used to do that all the
time. I drove back to my studio, and
dammit if the car didn't catch on fire! I
want people to smell this picture. I want
them to be intimidated by it, feel that it's
dangerous.

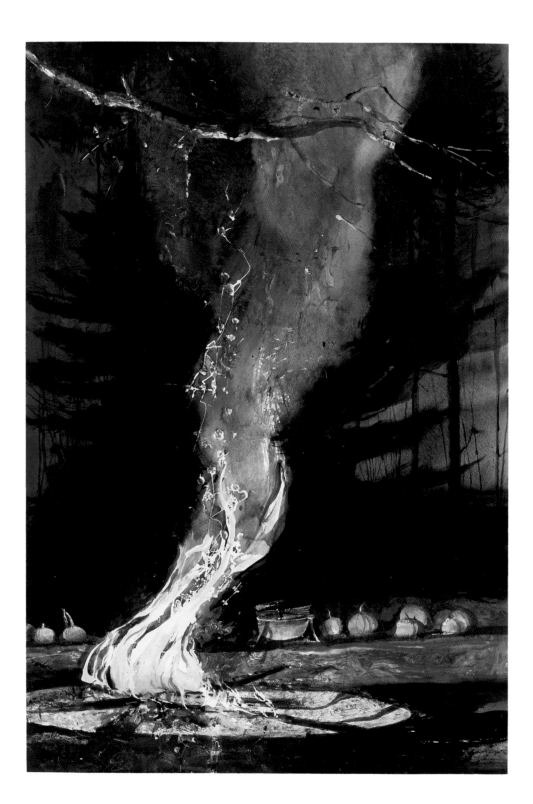

149

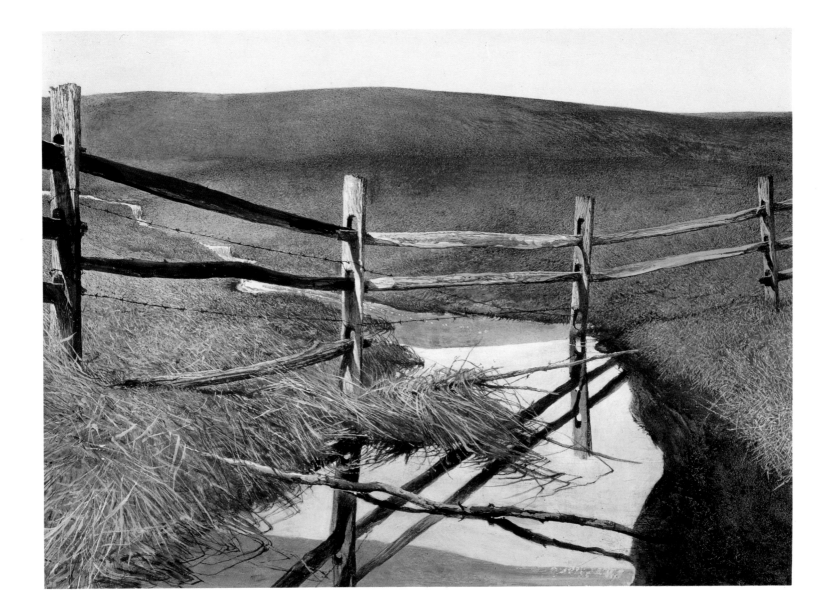

RUN OFF, 1991
Tempera on panel
21½ × 30 inches (54.6 × 76.2 cm)
Collection of Mr. and Mrs. Andrew Wyeth

I've always been compelled by the late winter season and those times, after a spell of wet weather, when the fields are tawny and fence posts are submerged in flooded streams. I wanted the feeling of the power of that stream that surges overhill around a valley. This is based on many, many walks all my life long. In late winter you tend to pass the landscape by, not noticing it, and then you think about it later. I wanted this to be the simplest possible statement of late winter, when everything is matted by the weight of melted snow. I love the way those torrents of water crush everything down. You get the feeling of the force of the water in the way the grasses and weeds are wrapped around that stick. If you really look at sticks at this time of year, they look like braided hair, all bleached and worn. The color of this painting is almost noncolor, which is what saves it from being just a pleasant picture.

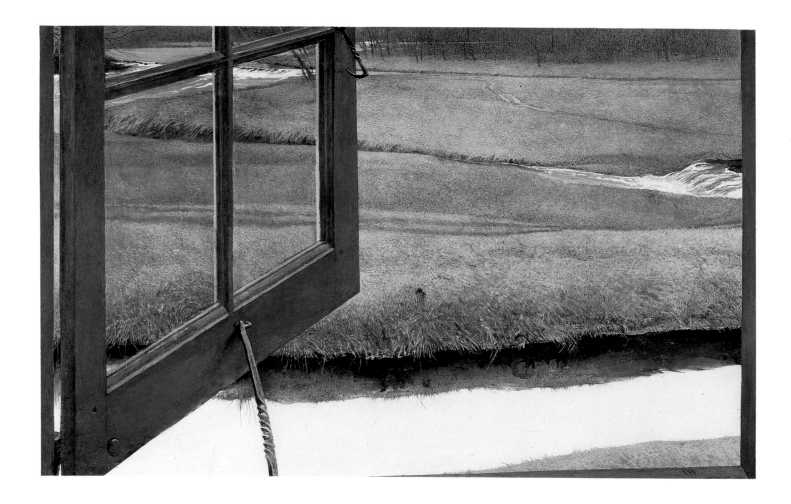

LOVE IN THE AFTERNOON, 1992
Tempera on panel
17⅝ × 28⅝ inches (44.8 × 72.7 cm)
Collection of Mr. and Mrs. Andrew Wyeth

I was looking out the window in the Mill at the bleached ground and the reflections of the race. I go to that window and open it in the morning and close it in the evening. I wanted, again, that tawny feeling of winter and grasses matted in that view up the valley to the falls. I was taken by the feeling of almost falling out of that window. I didn't want a frame around it. I didn't want a feeling of the inside of the room; I wanted the feeling of pushing this windowpane out and letting in the air and that you're just there for a second. You'll recognize it as one of my most mature pictures if you really look at it.

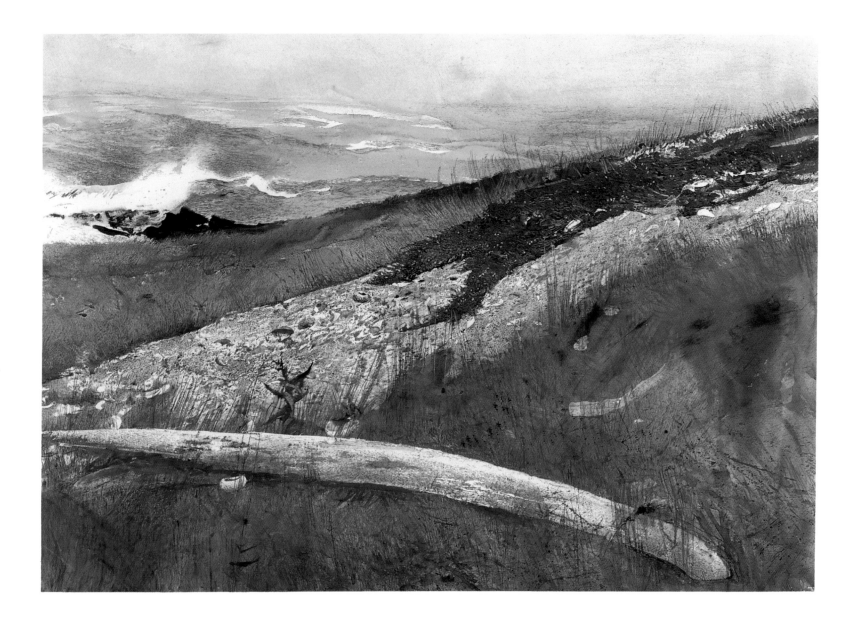

WHALE RIB, 1993
Watercolor
27⅝ × 39½ inches (70.1 × 100.3 cm)
Private Collection

It's Maine on another island my wife owns. I painted this one lying on
my side resting on a trailing yew during a strong northeast gale. I
wanted to capture the power and horror of the raging sea—my God, it
almost overtook the island! The power and the horror of the raging sea.
The whale rib signifies to me the depth of the sea—something thrown
up from so deep down. Frighteningly deep. The whole sea was gray
except for that emerald green when the sun suddenly broke through
and I could see the white spume in that tiny clear spot. Thrilling!

CHAMBERED NAUTILUS, 1956 (see page 2)
Tempera on panel
24¾ × 48¼ inches (62.9 × 122.6 cm)
Wadsworth Athenaeum, Hartford, Conn.
Gift from the Collection of Mr. and Mrs. Robert Montgomery

A portrait of my wife Betsy's mother. She was a remarkable woman and, like Betsy, never had one gray hair in her head. I think I was partly in love with her. She spent a lot of time in bed with her little basket—she was a Christian Scientist. I remember the gold tooth she had, which would flash when she laughed. She had so much vitality, even when getting on in years. That nautilus shell at the edge of her bed, which to me is her symbol, was usually kept on the bureau. When she died, the curtains rose into the air suddenly and I thought, Ah, there's her spirit lifting out the door!

BATTLEGROUND, 1981 (see page 8)
Tempera on panel
49½ × 45⅝ inches (125.7 × 115.9 cm)
The Nelson-Atkins Museum of Art, Kansas City, Mo.
Gift of the Enid and Crosby Kemper Foundation
in memory of Jerome H. Scott, Jr.

This is a portrait of the man who takes care of the Chadds Ford place, George Heebner. The tracks down below look like tank tracks, and George was in the Second World War. I call it *Battleground* because of the Battle of Brandywine, which took place in the valley. George restored the Mill for me. He's highly educated—graduated from the University of Pennsylvania. He's practically a member of the family. I was walking over the hill one day and met him and asked him if he would build a wall around the property. He did that and then restored virtually everything. He is a brilliant jack-of-all-trades. He restored the stones, fixed the electricity, did everything around the place. We've had this relationship for forty years. He's retired now but keeps coming back because he just has to keep busy. That's so Germanic, and that's, of course, what intrigues me. This is precisely where Henry Knox fought at the Battle of Brandywine. I've always been interested in tire tracks with snow lying in them—they look like some sort of hieroglyphics. It's deep winter, freeze time. I love snow; I love Pennsylvania in the winter. It's not pretty. New England is. The Brandywine's sort of ugly, looking like what George Washington must have felt when he camped at Valley Forge. Tough living. I like the difference between New England and this tough place.

© 1983 Bruce Weber

Personal Chronology

1917 Born July 12 in home of his parents, Chadds Ford, Pa. Mother was Carolyn Brenneman Bockius.

1923–29 Educated at home by tutors.

1932 N. C. Wyeth, Andrew's father and distinguished illustrator, took fifteen-year-old Andrew into his studio as an apprentice.

1937 First one-man exhibition at Macbeth Gallery in New York at age twenty. All paintings sold.

1939 Met his future wife, Betsy, who in turn introduced him to model Christina Olson.

1940 Married Betsy Merle James.

Elected to membership of American Watercolor Society; youngest member ever to be elected (age twenty-three).

1943 Participated in major group exhibition at Museum of Modern Art, New York, entitled "American Realists and Magic Realists."

Son, Nicholas Wyeth, born on September 21.

1945 His father, N. C. Wyeth, and his three-year-old nephew were killed when their car was struck by a train near Chadds Ford, Pa.

1946 Son, James Browning Wyeth, born on July 6.

1947 Received Award of Merit from the American Academy of Arts and Letters and the National Institute of Arts and Letters, New York.

1948 Painted *Christina's World* using Christina Olson as his model; later acquired by the Museum of Modern Art, New York.

1948–79 During this thirty-year period, Anna and Karl Kuerner (who died in 1979) served as models for Wyeth. He continues to paint Anna Kuerner.

1950 Elected to the National Institute of Arts and Letters.

1954 Received first honorary doctorate degree, from Colby College, Waterville, Me. (To date has received twenty honorary degrees from colleges and universities.)

1955 Elected to membership of the American Academy of Arts and Letters. (The American Academy is composed of fifty members, who elect their own members. Andrew Wyeth was the youngest member ever elected.)

Received Honorary Doctor of Fine Arts degree from Harvard University, Cambridge, Mass.

1957 Awarded by the Philadelphia Watercolor Club the George-Walter-Dawson Memorial Medal.

1958 Received Honorary Doctor of Fine Arts degree from Swarthmore College, Swarthmore, Pa.

Received Honorary Doctor of Art degree from Dickinson College, Carlisle, Pa.

1959 Awarded by the Philadelphia Museum of Art the Arts Festival Award and given citation "for bringing dignity to American art."

1960 Awarded by the Fellowship of the Pennsylvania Academy of the Fine Arts, Philadelphia, the Percy M. Owens Memorial Award (2nd Annual Award), given to a distinguished Pennsylvania artist.

Elected to membership of the American Academy of Arts and Sciences, Cambridge, Mass. (Youngest member ever to be elected.)

1962 Awarded by the American Watercolor Society, New York, the Certificate of Merit.

1963 Received the Presidential Medal of Freedom from President John F. Kennedy, which was presented by President Johnson in December following the death of President Kennedy.

Given honorary citizenship to the state of Maine.

Given award by the periodical *Art in America* "for outstanding contribution to American art—1963."

Given award and medal by the Philadelphia Watercolor Club "for advancement of watercolor art—1963."

Received Honorary Doctor of Fine Arts degree from Nasson College, Springvale, Me.

Received Honorary Doctor of Humane Letters degree from Tufts University, Medford, Mass.

1964 Received Honorary Doctor of Fine Arts degree from University of Maryland, College Park.

Received Honorary Doctor of Fine Arts degree from Northeastern University, Boston.

Received Honorary Doctor of Humane Letters degree from University of Delaware, Newark.

Received Honorary Doctor of Fine Arts degree from Temple University, Philadelphia.

1965 Received gold medal "for preeminence in painting" from the American Academy of Arts and Letters and the National Institute of Arts and Letters, New York.

Received Honorary Doctor of Fine Arts degree from Princeton University, Princeton, N.J.

Received Honorary Doctor of Humane Letters degree from Franklin and Marshall College, Lancaster, Pa.

Received award at Honors Convocation, LaSalle College, Philadelphia, "Andrew Wyeth—American Artist."

1966 Awarded by the Governor's Committee of 100,000 Pennsylvanians for the Promotion of Economic Growth the "1st Annual Award for Excellence in the Field of Creative Arts."

Appointed by the United States Post Office Department, Washington, D.C., to the Stamp Advisory Committee.

Given by the Pennsylvania Academy of the Fine Arts, Philadelphia, the Gold Medal of Honor (preceding opening of his major exhibition at the PAFA). Andrew Wyeth was the thirty-sixth recipient of this award.

Received Honorary Doctor of Humane Letters degree from Lincoln University, Pa.

1967 Given by Albert Einstein College of Medicine of Yeshiva University, New York, the Award for "exemplary career as a creative artist."

Elected to membership of the American Philosophical Society, Philadelphia.

Elected as member of the Smithsonian Art Commission, Washington, D.C.

Received Honorary Doctor of Humane Letters degree from Amherst College, Amherst, Mass.

1968 Christina Olson, subject of more than 200 drawings and paintings, died on January 27, at age seventy-four.

Elected to Board of Directors, the Pennsylvania Academy of the Fine Arts, Philadelphia.

1969 Elected to honorary membership of the American Watercolor Society, New York.

1970 Had first major solo exhibition of art ever held in the White House, Washington, D.C.

Named to serve on the committee of the President's Commission for the Observance of the 25th Anniversary of the United Nations, Washington, D.C., by President Richard M. Nixon.

Received Honorary Doctor of Fine Arts degree from Bowdoin College, Brunswick, Me.

1971–85 Painted the major body of work that later became known as the Helga collection. Continues to paint her.

1971 Received Honorary Doctor of Humane Letters degree from Ursinus College, Collegeville, Pa.

1972 Received Honorary Doctor of Fine Arts degree from University of Pennsylvania, Philadelphia.

1973 Maine State Award given to Andrew and Betsy Wyeth by the state of Maine.

Mrs. N. C. Wyeth, Andrew's mother, died on March 15.

1976 Metropolitan Museum of Art held major exhibition "Two Worlds of Andrew Wyeth: Kuerners and Olsons."

1977 Elected Associate Member to the Institut de France Académie des Beaux Arts, Paris.

1978 Elected to membership of the Soviet Academy of the Arts, Leningrad.

1979 Karl Kuerner, subject of many paintings at the Kuerner Farm in Chadds Ford, Pa., died at age eighty on January 6.

1980 First exhibition by a living American artist held at the Royal Academy of Arts, London.

1981 Guest of honor, the Pennsylvania Society, Waldorf Astoria, New York, 83rd Anniversary, and awarded gold medal.

Presented by the Commonwealth of Pennsylvania the Hazlett Memorial Award for Excellence in the Arts.

1984 Given Honorary Doctor of Humane Letters degree by West Chester University, West Chester, Pa.

Given Honorary Doctor of Fine Arts degree by Dartmouth College, Hanover, N.H.

1985 United Nations Postal Administration issued two stamps with paintings by Andrew Wyeth (*Alvaro Raking Hay* and *The Corner*) on the occasion of their fortieth Anniversary.

1986 Inducted as Honorary Member into the Royal Society of Painters and Watercolourists, London.

Presented by the Commonwealth of Pennsylvania the Hazlett Memorial Award for Excellence in the Arts.

1987 Given Honorary Doctor of Fine Arts degree by Bates College, Lewiston, Me.

Walt Anderson, whom Andrew Wyeth had painted in Maine from the time he was a young man, died on July 31.

1988 By the 100th Congress of the United States of America, Washington, D.C. (2nd Session): "An act to request Presidential Award of a gold medal, signed by speaker of the House and approved and signed by Ronald Reagan, President."

Given Honorary Doctor of Humane Letters degree by University of Vermont, Burlington.

1989 Presented by the Philadelphia Art Alliance the Award for Distinguished Achievement, along with his son, Jamie Wyeth.

1990 Nathaniel Convers Wyeth, brother of Andrew Wyeth, died on July 4.

President Bush awarded Congressional Gold Medal at White House ceremony to Andrew Wyeth (the first artist to receive that honor) on October 24.

1994 Carolyn Wyeth, sister of Andrew Wyeth, died on March 1.

Awarded the Dolphin Medal by the American Watercolor Society on April 29 at the time of the exhibition "One Hundred Twenty-seventh International Exhibition at the Galleries of the Salmagundi Club, New York, in which the painting *Blue Stocking* was on exhibit.

Chronology of Exhibitions

1936 Art Alliance, Philadelphia
Exhibition of thirty watercolors by
Andrew Wyeth.

1937 Macbeth Gallery, New York
"First Exhibition of Water Colors by
Andrew Wyeth"
October 19–November 1

1938 Currier Gallery of Art, Manchester, N.H.
"Exhibition of Water Colors by Andrew
Wyeth"

Doll & Richards, Boston
"Water Colors by Andrew Wyeth"
October 24–November 5

1939 Delaware Art Center, Wilmington

Macbeth Gallery, New York
"Second Exhibition of Watercolors by
Andrew Wyeth"
October 10–October 30

1940 Doll & Richards, Boston
"Water Colors by Andrew Wyeth"
November 29–December 14

1941 Baldwin Galleries, Wilmington
"Exhibition of Water Colors and Drawings
by Andrew Wyeth"
February 10–February 24

St. Andrew's School, Middletown, Del.
"Exhibition of the Work of Andrew
Wyeth"
April 1–April 22

Art Institute of Chicago
"The Twentieth International Exhibition
of Water Colors"

July 17–October 5
Eighteen Andrew Wyeth watercolors were
shown in a separate room of the
exhibition.

Corcoran Gallery of Art, Washington, D.C.
Joint exhibition of Andrew Wyeth and
Peter Hurd.

Macbeth Gallery, New York
"Third Exhibition of Watercolors by
Andrew Wyeth"
October 7–October 27

1942 Doll & Richards, Boston
"Third Exhibition of Water Colors by
Andrew Wyeth"
December 7–December 26

1943 Museum of Modern Art, New York
"American Realists and Magic Realists"
Eight works by Andrew Wyeth exhibited.

Macbeth Gallery, New York
"Temperas and Water Colors by Andrew
Wyeth"
November 1–November 20

1944 Colby College, Waterville, Me.
"Exhibition of Water Colors and Temperas
by Andrew Wyeth"
October 10–October 23

Doll & Richards, Boston
"Watercolors by Andrew Wyeth"
December 4–December 23

1945 E. B. Crocker Art Gallery, Sacramento,
Calif.
"Andrew Wyeth Water Colors"

July 1–July 28
Organized by the Western Association of
Art Museums. Exhibited also at the Seattle
Art Museum.

Macbeth Gallery, New York
"Temperas and Watercolors by Andrew
Wyeth"
October 29–November 17

1946 Portraits, Inc., New York
"An Exhibition of Portraits, Landscapes
and Figure Compositions by the Painter
Members of the Wyeth Family"
October 22–November 9
A memorial exhibition to N. C. Wyeth.

Doll & Richards, Boston
"Water Colors by Andrew Wyeth"
November 18–December 7

1947 American Academy of Arts and Letters
and National Institute of Arts and Letters,
New York
"Annual Award Exhibition"
May 22–June 30
The artist received the Award of Merit in this
year. He exhibited nine works in the show.

Pennsylvania Academy of the Fine Arts,
Philadelphia
October 13–October 26

1948 Carnegie Institute, Pittsburgh
"Painting in the United States, 1948"
October 14–December 12

Macbeth Gallery, New York
"Andrew Wyeth"
November 15–December 4

Berkshire Museum, Pittsfield, Mass.
"Water Colors by Andrew Wyeth"

1950 Doll & Richards, Boston
"Water Colors by Andrew Wyeth"
April 17–April 29

Institute of Contemporary Arts, London
"Symbolic Realism in American Painting,
1940–1950"
July 18–August 18
Included three Andrew Wyeth temperas.

Macbeth Gallery, New York
"Andrew Wyeth"
November 21–December 9

1951 Delaware Art Center, Wilmington
January 9–January 29
A Wyeth family exhibition; forty-seven
works total, twelve by Andrew Wyeth.

Currier Gallery of Art, Manchester, N.H.,
and William A. Farnsworth Library and
Art Museum, Rockland, Me.
"Paintings and Drawings by Andrew
Wyeth"
July 7–August 4 at the Currier; August
10–September 8 at the Farnsworth
First major museum retrospective; sixty-
eight works included.

The Berlin Cultural Festival, Berlin
"Amerikanische Malerei, Werden und
Gegenwart"
September 20–October 24
Two Wyeth temperas included.

Macbeth Gallery, New York
"Andrew Wyeth"
November 6–November 29

1952 Institute of Contemporary Art, Boston
Summer exhibition of Andrew Wyeth and
Waldo Pierce.

1953 M. Knoedler and Co., New York
"Exhibition of Paintings by Andrew
Wyeth"
October 26–November 14

1954 Contemporary Arts Museum, Houston
"Americans from the Real to the Abstract"
January 10–February 11
Exhibition of Andrew Wyeth, Ben Shahn,
Abraham Rattner, and Robert Motherwell.

1955 Worcester Art Museum, Massachusetts
"Five Painters of America"
February 17–April 3
Andrew Wyeth, Louis Bouché, Edward
Hopper, Ben Shahn, and Charles Sheeler.

Museum of Art of Ogunquit, Me.
"Third Annual Exhibition"
July 1–September 11

1956 M. H. de Young Memorial Museum, San
Francisco
"Andrew Wyeth"
July 12–August 12
Also exhibited at Santa Barbara Museum
of Art, Calif., August 28–September 23

1957 Delaware Art Center, Wilmington
January 8–February 3

1958 M. Knoedler and Co., New York
"Exhibition of Paintings by Andrew
Wyeth"
October 28–November 22

1960 Dallas Museum of Fine Arts
"Famous Families in American Art"
October 8–November 20
Works by ten members of the Wyeth
family were exhibited.

Hayden Gallery, MIT, Cambridge, Mass.
"Andrew Wyeth: A Retrospective
Exhibition of Temperas and Water Colors"
November 9–December 4

1962 Town Hall, Islesboro, Me.
"Exhibition of Dry Brush and Water
Colors by Andrew Wyeth"
July 21–August 6

Albright-Knox Art Gallery, Buffalo
"Andrew Wyeth: Temperas, Water Colors
and Drawings"
November 3–December 9
Large museum retrospective of 143 works.

1963 University of Arizona Art Gallery, Tucson
"Andrew Wyeth"
March 16–April 14

Fogg Art Museum, Harvard University,
Cambridge, Mass.
"Andrew Wyeth: Dry Brush and Pencil
Drawings"
Also exhibited at Pierpont Morgan Library,
New York; Corcoran Gallery of Art,
Washington, D.C.; William A. Farnsworth
Library and Art Museum, Rockland, Me.
Seventy-three works exhibited.

1964 Brandywine Lions Club, Chadds Ford, Pa.
"Andy Wyeth Day"
May 30

Swarthmore College, Swarthmore, Pa.
"Three Generations of Wyeths"

Boardwalk Art Exhibit, Ocean City, N.J.
"Special Wyeth Exhibit"

Wilmington Society of Fine Arts, Del.
"The William and Mary Phelps Collection of
Paintings and Drawings by Andrew Wyeth"
October 14–November 6

1965 Schauffler Memorial Library, Mount
Hermon School, Mount Hermon, Mass.
"Wyeth Exhibit"
May 8–May 23
Exhibition of N. C., Andrew, and James
Wyeth

1966 Parrish Art Museum, Southampton, N.Y.
"Loan Exhibition of Paintings by the
Wyeth Family"
July 30–August 22

Pennsylvania Academy of the Fine Arts,
Philadelphia
"Andrew Wyeth"
October 5–November 27
Also exhibited at the Baltimore Museum
of Art, December 11, 1966–January 22,
1967; Whitney Museum of American Art,
New York, February 6–April 12, 1967;
Art Institute of Chicago, April 21–June 4,
1967
Retrospective of 222 works.

1967 Wichita Art Museum, Kansas
"Wyeth's World"
September 15–November 15

Virginia Museum of Fine Arts, Richmond
"A Wyeth Portrait"
November 13, 1967–January 14, 1968
This exhibition of one tempera and its
fourteen prestudies traveled throughout the
state of Virginia in an Artmobile during
1968.

Oklahoma Museum of Art, Oklahoma
City
"The Wonder of Andrew Wyeth"
December 3–December 24

1968 Los Angeles County Museum of Art
"Eight American Masters of Water Color"
April 23–June 16
Also exhibited at M. H. de Young
Museum, San Francisco, June 28–August
18; Seattle Art Museum, September 5–
October 13

Delaware Art Center, Wilmington
"The Phelps Collection"
May 10–October 20

William A. Farnsworth Library and Art
Museum, Rockland, Me.
Summer exhibition of twenty-five Maine
paintings by the artist.

Chadds Ford Historical Society, Chadds
Ford, Pa.
"The Chadds Ford Art Heritage, 1898–
1968"
Chadds Ford Mill, September 6–
September 15
Exhibition of the Brandywine artists.

1969 Chadds Ford Historical Society, Chadds
Ford, Pa.
"Chadds Ford Reflections of a Culture"
Tri-County Conservancy Mill, July 4–
July 6

Bamberger's, Newark, N.J.
November 17–December 27

1970 Washington County Museum of Fine
Arts, Hagerstown, Md.
"Andrew Wyeth, Temperas, Watercolors
and Drawings"
February 8–March 22

The White House, Washington, D.C.
February 19–March 31

Museum of Fine Arts, Boston
"Andrew Wyeth"
Retrospective of 170 works.

1971 Brandywine River Museum, Chadds
Ford, Pa.
"The Brandywine Heritage"
Exhibition of Howard Pyle, various
Howard Pyle students, N. C., Andrew,
and James Wyeth.

Delaware Art Center, Wilmington
"Brandywine Tradition Artists"
October 1971–October 1972

1973 M. H. de Young Memorial Museum, San
Francisco
"Andrew Wyeth"
June 16–September 3

1974 The National Museum of Modern Art,
Tokyo
"Works of Andrew Wyeth"
April 6–May 19
Also exhibited at The National Museum of
Modern Art, Kyoto, May 25–June 30

Museum of Art, Science & Industry,
Bridgeport, Conn.
"Brandywine Heritage '74: Pyle • Wyeth •
Wyeth • Wyeth," April 20–May 28

Lefevre Gallery, London
"Andrew Wyeth"
May 23–June 22

1976 The Metropolitan Museum of Art, New
York
"The Two Worlds of Andrew Wyeth"
October 16, 1976–February 6, 1977

1977 United Bank of Denver
"Andrew Wyeth in Facsimile"
September 16–October 14

The Art Emporium, Vancouver, B.C.
"Andrew Wyeth: Recent Works"
October 4–October 18

1978 Greenville County Museum of Art,
Greenville, S.C.
"Andrew Wyeth: In Southern Collections"
February 1–March 31

Portland Museum of Art, Portland, Me.
"Andrew Wyeth in Maine"
February 3–March 5

Mitsukoshi Main Store, Nihombashi,
Tokyo
"Andrew Wyeth"
October 24–November 5

Also exhibited at Mitsukoshi Sapporo Branch Store, Sapporo, November 14–November 19; Mitsukoshi Kobe Branch Store, Kobe, November 21–December 3

1979 Greenville County Museum of Art, Greenville, S.C.
"Works by Andrew Wyeth from the Holly and Arthur Magill Collection"
September 12–continuous exhibition

San Jose Museum of Art, San Jose, Calif.
"Paintings by Andrew Wyeth"
November 17, 1979–January 9, 1980

1980 Royal Academy of Arts, London
"Andrew Wyeth"
June 7–August 31

Galerie Claude Bernard, Paris
"Andrew Wyeth: Temperas, Aquarelles, Dry Brush, Dessins"
December 2, 1980–January 31, 1981

1981 Southern Alleghenies Museum of Art, Loretto, Pa.
"The 1981 Hazlett Memorial Awards Exhibition for the Visual Arts"
May 9–June 7
Also exhibited at Pittsburgh Plan for Art, June 20–July 19; Allentown Art Museum, Allentown, Pa., August 1–September 6

Brandywine River Museum, Chadds Ford, Pa.
"Working at Olsons: Watercolors & Drawings by Andrew Wyeth from the Holly & Arthur Magill Collection"
May 30–September 7
Also exhibited at Madison-Morgan Cultural Center, Madison, Ga., November 1, 1981–January 31, 1982; Greenville County Museum of Art, Greenville, S.C., February 18–April 25, 1982

1982 Virginia Art Museum, Richmond
"Collectors of the Year—Works from the Holly & Arthur Magill Collection"
February 16–March 7

1983 The Peck School, Morristown, N.J.
"Three Generations of Wyeth"
May 6 (one-day exhibition)

Museum of Art, Fort Lauderdale, Fla.
"Andrew Wyeth from Public and Private Collections"
January 12–February 28

Memphis Brooks Museum of Art
"Howard Pyle and the Wyeths: Four Generations of American Imagination"
September 1–October 23
Also exhibited at Montgomery Museum of Fine Arts, Ala., November 12, 1983–January 2, 1984; North Carolina Museum of Art, Raleigh, February 4–April 1

Portland Museum of Art, Portland, Me.
"Maine Temperas by Andrew Wyeth"
May 14–September 4

1984 Greenville County Museum of Art, Greenville, S.C.
"Andrew Wyeth: A Trojan Horse Modernist"
March 9–April 15

Funabishi Gallery, Tokyo
"Andrew Wyeth: Tempera, Drawings, Prints"

Brandywine River Museum, Chadds Ford, Pa.
"Andrew Wyeth from the Wyeth Collection"
Opening show of the new wing, September 15–November 18; new shows mounted semiannually since 1984

Gallery Iida, Tokyo
"Andrew Wyeth"
December 1–December 31

1985 Quinlan Art Center and Gainesville Junior College, Gainesville, Ga.
"Works by Andrew Wyeth at the Quinlan"
February 1–March 1

Coe Kerr Gallery, New York
"Andrew Wyeth"
April 8–April 27

The Canton Art Institute, Canton, Ohio
"Andrew Wyeth from Public and Private Collections"
September 15–November 3

Arnot Art Museum, Elmira, N.Y.
"Three Generations of Wyeths"
December 7, 1985–February 23, 1986

1986 Seibu Pisa, Ltd., Tokyo
"Andrew Wyeth"
April 1–May 15

1987 The Brandywine River Museum, Chadds Ford, Pa.
"An American Vision: Three Generations of Wyeth Art"
September 17, 1987–November 22, 1988
Also exhibited at Academy of the Arts of the USSR, Leningrad, March 11–April 12; Academy of the Arts of the USSR, Moscow, April 24–May 31; Corcoran Gallery of Art, Washington, D.C., July 4–August 30; Dallas Museum of Art, Dallas, September 29–November 29; Terra Museum of American Art, Chicago, December 13–February 14, 1988; Setegaya Art Museum, Tokyo, March 10–April 21, 1988; Palazzo Reale, Milan, May 17–June 20, 1988; Fitzwilliam Museum, Cambridge, England, July 12–August 29, 1988

National Gallery of Art, Washington, D.C.
"Andrew Wyeth—The Helga Pictures"
May 24–September 27

Also exhibited at Museum of Fine Arts, Boston, October 28, 1987–January 3, 1988; The Museum of Fine Arts, Houston, January 31, 1988–April 10, 1988; Los Angeles County Museum of Art, April 28, 1988–July 10, 1988; Fine Arts Museum of San Francisco, August 13, 1988–October 16, 1988; Detroit Institute of Arts, November 13, 1988–January 22, 1989

1988 William A. Farnsworth Library and Art Museum, Rockland, Me.
"Something of the Artist"
July 7–October 17

The Arkansas Arts Center, Little Rock, Ark.
"The Next Two Generations: Andrew Wyeth and Jamie Wyeth"
February 4–March 27

Seibu Pisa Ltd., Tokyo
"Andrew Wyeth"

1989 Heckscher Museum, Huntington, N.Y.
"The Wyeth Legacy: A Family of Artists"
January 14–February 19

Portland Museum of Art, Portland, Me.
"Andrew Wyeth in Maine"
July 27–September 24

Thomas Gilcrease Museum, Tulsa
"Andrew Wyeth: Works on Paper"
January 28–April 16

1990 Sezon Museum of Art, Tokyo
"Andrew Wyeth's Helga—Paintings from the Helga Collection (8 venues)"
January 2–December 16

Gallery Nukago, Japan
"Andrew Wyeth"

Marcelle Fine Art, Inc., New York
"Andrew Wyeth—New New England"
November 15–December 31

1991 Takuji Kato Modern Art Museum, Tokyo
"Andrew Wyeth"
May 3–July 25

Millport Museum, Lititz, Pa.
"N. C. Wyeth and His Family—Four Generations of Artists"
May 11–June 2

1992 Brandywine River Museum, Chadds Ford, Pa.
"The Helga Pictures—Then and Now"
September 24, 1992–January 18, 1993
Also exhibited at Portland Museum of Art, Portland, Me., July 1–October 17, 1993

William A. Farnsworth Library and Art Museum, Rockland, Me.
"By Land and Sea: Selections from the Collection of Andrew and Betsy Wyeth"
May 30–September 27

Galleria Forni, Bologna, Italy
"Andrew Wyeth"
March 28–May 12

Jacksonville Art Museum, Jacksonville, Fla.
"Andrew Wyeth: Southeastern Collections"
January 19–May 19

1993 A.C.A. Gallery, New York
"Andrew Wyeth"
January 15–February 27

Finley Gallery, Mountain Brook, Ala.
"A Selection of Works by Andrew and Jamie Wyeth"
November 21–December 18

1994 William A. Farnsworth Library and Art Museum, Rockland, Me.
"Andrew Wyeth: Highlights from the Collections of Andrew and Betsy Wyeth and the Farnsworth Museum"
June 1–September 4

1995 Aichi Prefectural Museum of Art and the Chunichi Shimbun, Nagoya, Japan
"Andrew Wyeth Retrospective"
February 3–April 2
Also exhibited at the Bunkamura Museum of Art, Tokyo, April 15–June 4; Fukushima Prefectural Museum of Art, Fukushima, June 10–July 16; The Nelson-Atkins Museum of Art, Kansas City, September 29–November 26

Selected Bibliography

EXHIBITION CATALOGUES
(in chronological order)

New York, Museum of Modern Art, 1943
American Realists and Magic Realists
Foreword Dorothy C. Miller, introduction Lincoln
Kirstein

London, Institute of Contemporary Arts, 1950
Symbolic Realism in American Painting, 1940–1950
Introduction Lincoln Kirstein

Manchester, N.H., Currier Gallery of Art, and
William A. Farnsworth Library and Art Museum,
Rockland, Me., 1951
Paintings and Drawings by Andrew Wyeth
Introduction Samuel M. Green

New York, M. Knoedler and Co., 1953
Exhibition of Paintings by Andrew Wyeth
Introduction Robert G. McIntyre

New York, Whitney Museum of American Art,
1959
*The Museum and Its Friends: Eighteen Living
American Artists Selected by the Friends of the Whitney
Museum*
Including statement by Andrew Wyeth

Cambridge, Massachusetts Institute of Technology,
Hayden Gallery, 1960
*Andrew Wyeth: A Retrospective Exhibition of
Temperas and Watercolors*

Dallas Museum of Fine Arts, 1960
Famous Families in American Art
Text by J. Bywaters

Buffalo, Fine Arts Academy, Albright-Knox Art
Gallery, 1962

Andrew Wyeth: Temperas, Water Colors and Drawings
Foreword Gordon M. Smith, introduction Joseph
Verner Reed

Cambridge, Harvard University, Fogg Art
Museum, 1963
Andrew Wyeth: Dry Brush and Pencil Drawings
Introduction Agnes Mongan

Tucson, University of Arizona Art Gallery, 1963
Andrew Wyeth: Impressions for a Portrait
Introduction Paul Horgan

Philadelphia, Pennsylvania Academy of the Fine
Arts, 1966
*Andrew Wyeth: Temperas, Watercolors, Dry Brush,
Drawings, 1938 to 1966*
Text by Edward P. Richardson

Oklahoma City, Oklahoma Museum of Art, 1967
The Wonder of Andrew Wyeth

Wichita Art Museum, 1967
Wyeth's World

Los Angeles County Museum of Art, 1968
Eight American Masters of Watercolor
Text by Larry Curry

Boston, Museum of Fine Arts, 1970
Andrew Wyeth
Introduction David McCord

Chadds Ford, Pa., Brandywine River Museum, 1971
*The Brandywine Heritage: Howard Pyle, N. C.
Wyeth, Andrew Wyeth, James Wyeth*
Introduction Richard M. McLanathan

Wilmington, Delaware Art Museum, 1971–72
Brandywine Tradition Artists
Introduction Rowland Elzea

San Francisco, M. H. de Young Memorial Museum
(of the Fine Arts Museums of San Francisco), 1973
The Art of Andrew Wyeth
Wanda M. Corn, with contributions by Brian
O'Doherty, Richard Meryman, E. P. Richardson

London, Lefevre Gallery, 1974
Andrew Wyeth

Greenville County Museum of Art, S.C., 1974
Andrew Wyeth in Southern Collections
Introduction Edwin Ritts, Jr.

Tokyo, National Museum of Modern Art, 1974
Works of Andrew Wyeth
Text in Japanese only

New York, Metropolitan Museum of Art, 1976
Two Worlds of Andrew Wyeth: Kuerners and Olsons
Thomas Hoving

Greenville County Museum of Art, S.C., 1979
*Works by Andrew Wyeth from the Holly and Arthur
Magill Collection*

London, Royal Academy of Arts, 1980
Andrew Wyeth

Paris, Galerie Claude Bernard, 1980
*Andrew Wyeth: Tempéras, Aquarelles, Dry Brush,
Dessins*

Fort Lauderdale, Fla., Museum of Art, 1983
Andrew Wyeth from Public and Private Collections
Introduction John H. Surovek

Memphis Brooks Museum of Art, 1983
*Howard Pyle and the Wyeths: Four Generations of
American Imagination*
Texts by Douglas K. S. Hyland and Howard P.
Brokaw

Chadds Ford, Pennsylvania, Brandywine River Museum, 1987
An American Vision: Three Generations of Wyeth Art
Essays by James H. Duff, Andrew Wyeth, Thomas Hoving, and Lincoln Kirstein

Washington, D.C., National Gallery of Art, 1987
Andrew Wyeth—The Helga Pictures
John Wilmerding

Nagoya, Japan, and Kansas City, 1995
Andrew Wyeth: Autobiography
Thomas Hoving

BOOKS AND ARTICLES IN PERIODICAL PUBLICATIONS
(alphabetically arranged according to author or, in the case of unsigned articles, by name of publication)

Alloway, Lawrence. "Critique: The Other Andy." *Arts Magazine,* vol. 41, no. 6 (Apr. 1967), pp. 20–21.

"Three Generations of the Wyeth Family" (special issue). *American Artist,* vol. 39, Feb. 1975, pp. 70–75, 109–17.

"Artists in Focus: Documenting the Life and Work of Three Painters." *American Artist,* vol. 48, Aug. 1984, p. 71.

Ammons, A. R. "For Andrew Wyeth" [a poem]. *The New York Times Book Review,* Oct. 27, 1968, p. 56.

"Andrew Wyeth, in Debut, Wins Critics' Acclaim." *Art Digest,* vol. 12, no. 3 (Nov. 1937), p. 15.

"Hoving's Wyethworld." *Art in America,* vol. 64, Nov. 1976, p. 160.

"Andrew Wyeth." *Artist Jr.,* vol. 9, no. 5 (March 1968), pp. 1–8.

Ashby, Neal. "Reunion in a Gallery: Three Generations of Wyeths." *The New York Times,* Sept. 19, 1971, sec. 10, p. 3.

Barol, Bill, and Peter McKillop. "Wyeth's Secret Cache" and "Andrew Wyeth's Secret Obsession." *Newsweek,* August 18, 1986, pp. 3, 48–54.

Baur, John I. H. "Andrew Wyeth," in: *New Art in America.* Greenwich, Conn.: New York Graphic Society, 1957, pp. 277–81.

Beaumont, M. R. "Andrew Wyeth: Poetic Realist?" *Art and Artists,* no. 15 (Aug. 1980), pp. 22–25.

Berenson, R. "Sandy and Andy." *National Review,* vol. 28, Dec. 24, 1976, pp. 1409–10.

Bristow, B. "Andrew Wyeth: Oracle of the Ordinary." *Christianity Today,* vol. 21, Feb. 4, 1977, pp. 27–28.

Buckley, W. F. "Betsy and Andrew Wyeth in Maine: A Sea Change for Their Island Lighthouse." *Architectural Digest,* no. 45 (June 1986), pp. 116–25.

Canaday, John. "Natural Wonder." *The New York Times,* Oct. 11, 1959, sec. 2, p. 16.

———. "A Phenomenon of Contradiction: Wyeth's Work to Be Shown in Buffalo." *The New York Times,* Nov. 1, 1962, p. 28.

———. "Kline and Wyeth." *The New York Times,* Nov. 4, 1962, sec. 2, p. 23.

———. "The Wyeth Menace." *The New York Times,* Feb. 12, 1967, sec. 2, p. 17.

———. "Andrew Wyeth Faces First News Conference." *The New York Times,* Feb. 14, 1967, p. 40.

———. "In Boston: Fine Wyeth Retrospective." *The New York Times,* July 16, 1970, p. 38.

———. "Wyeth's Nostalgia for a Vanished America Is Still a Best-Seller." *The New York Times,* July 26, 1970, sec. 2, p. 19.

———. "Homely Virtue Depicted by a Dynasty." *The New York Times,* June 2, 1971, p. 32.

———. "A Doubleheader Down East." *The New York Times,* Aug. 1, 1971, sec. 2, p. 17.

———. "Andrew Wyeth: Rising above the Scorn." *Art Gallery* (USA), vol. 22, pt. 4 (May 1979), pp. 102–14, 126.

Clark, Eliot. "Andrew Wyeth: America's Most Popular Painter." *The Studio,* vol. 160, no. 812 (Dec. 1960), pp. 206–9, 234–35.

Cohen, Hennig. "Wyeth's World." *The Reporter,* vol. 35, no. 10 (Dec. 15, 1966), pp. 56–60.

Contemporary Great Masters: Andrew Wyeth, Kodansha Ltd., Tokyo, 1993. (Text in Japanese.)

Corliss, Richard. "Andrew Wyeth's Stunning Secret." *Time,* August 18, 1986, pp. 48–57.

Corn, Wanda M. *The Art of Andrew Wyeth.* With contributions by Brian O'Doherty, Richard Meryman, E. P. Richardson. Boston: New York Graphic Society, 1973.

Davis, Douglas. "World of Wyeth: Exhibition in Boston." *Newsweek,* vol. 76, Aug. 24, 1970, pp. 54–57.

———. "The Brandywine School." *Newsweek,* vol. 77, no. 26 (June 28, 1971), p. 93.

De Kooning, Elaine. "Andrew Wyeth Paints a Picture." *Art News,* vol. 49, March 1950, pp. 38–41, 54–56.

Donohoe, Victoria. "Besides Eroticism, Scholarly Exoticism." *Art News,* vol. 74, Summer 1975, p. 88.

Duff, James H. *An American Vision: Three Generations of Wyeth Art.* With essays by Andrew

Wyeth, Thomas Hoving, and Lincoln Kirstein. Boston: New York Graphic Society/Little, Brown and Company, 1987.

Goodrich, Lloyd. *The Four Seasons: Paintings and Drawings by Andrew Wyeth*. New York: Art in America, 1962. Most of these plates are reproduced in "The Four Seasons: Dry Brush Drawings by Andrew Wyeth." *Art in America*, vol. 50, March 1962, pp. 32–49.

Hall, Paula. "Andrew Wyeth—Purely a Personal Expression." *Gilcrease Magazine of American History and Art*, January 1989, pp. 1–21.

Hazleton, Lesley. "Betsy's World—It Takes a Genius to Live with a Genius." *Connoisseur*, April 1985, pp. 96–101.

Hines, Diane C. "The Living Legends of American Watercolor: Profiles of Fourteen Celebrated American Artists Who Have Influenced Generations of Watercolorists." *American Artist*, vol. 47, Feb. 1983, pp. 68–76.

"Andrew Wyeth Turns His Attention from Landscapes to Portraits." *Horizon*, vol. 9, no. 2 (Spring 1967), pp. 86–87.

Hoving, Thomas. *Two Worlds of Andrew Wyeth: Kuerners and Olsons*. New York: Metropolitan Museum, 1976. Variant edition: *Two Worlds of Andrew Wyeth: A Conversation with Andrew Wyeth*. Boston: Houghton Mifflin Co., 1978.

———. "The 'Prussian': Andrew Wyeth's Secret Paintings (1972–85)." *Connoisseur*, vol. 216, no. 896 (Sept. 1986), pp. 84–87.

———. "Wyeth since Helga." *Connoisseur*, December 1990, pp. 108–119.

Hughes, Robert. "Fact as Poetry." *Time*, vol. 102, no. 10 (Sept. 3, 1973), pp. 54–55.

———. "Wyeth's Cold Comfort: Exhibition at the Metropolitan Museum." *Time*, vol. 108, no. 18 (Nov. 1, 1976), p. 69.

Ingersoll, Bob. "Wyeth, Giant among Artists, Says He's Never Satisfied." *Evening Journal* (Wilmington, Del.), May 14, 1963.

Jacobs, Jay. "Andrew Wyeth: An Unsentimental Reappraisal." *Art in America*, vol. 55, Jan.–Feb. 1967, pp. 24–31. Letters responding to this article: *Art in America*, vol. 55, May 1967, p. 126.

Janson, Donald. "Wyeth's Art to Open Museum in Mill: New Works by Andrew Wyeth Will Be in Show." *The New York Times*, June 2, 1971, p. 32.

Jodidio, Philip. "Andrew Wyeth." *Connaissance des Arts*, Nov. 1986, pp. 76–77.

Koethe, E. John. "The Wyeth Craze." *Art News*, vol. 69, Oct. 1970, p. 30.

Larson, Kay. "Andrew Wyeth: Monotone in a Minor Key." *Art News*, vol. 75, Dec. 1976, pp. 42–44.

Lehmann-Haupt, Christopher. Review of *Christina's World: Paintings and Pre-studies of Andrew Wyeth*. *The New York Times*, Dec. 6, 1982, p. C22.

"Andrew Wyeth, An American Realist Paints What He Sees." *Life*, vol. 24, no. 20 (May 17, 1948), pp. 102–6.

"Artist Paints a Ghostly House." *Life*, vol. 35, no. 4 (July 27, 1953), pp. 80–83.

Logsdon, Gene. *Wyeth People: A Portrait of Andrew Wyeth as He Is Seen by His Friends and Neighbours*. Garden City, N.Y.: Doubleday & Co., 1971.

Loucheim, Aline B. "Wyeth—Conservative Avant-Gardist." *The New York Times Magazine*, Oct. 25, 1953, sec. 6, pp. 28ff.

McBride, Henry. "Wyeth: Serious Best-Seller." *Art News*, vol. 52, Nov. 1953, pp. 38–67.

Meryman, Richard. "Andrew Wyeth: An Interview." *Life*, vol. 58, no. 19 (May 14, 1965), pp. 92–116, 121–22.

———. *Andrew Wyeth*. Boston: Houghton Mifflin Co., 1968.

———. "The Wyeths' Kind of Christmas Magic." *Life*, vol. 71, no. 25 (Dec. 17, 1971), pp. 122–29.

———. "Wyeth's World—How a Woman Named Helga Came to Haunt the Art of America's Foremost Realist." *Life*, June 1987, pp. 72–84.

———. "American Visions—The Wyeth Family." *National Geographic*, July 1991, pp. 78–109.

———. *First Impressions*. New York: Harry N. Abrams, 1991.

Meyer, Susan E. "Three Generations of the Wyeth Family: N. C. Wyeth, Peter Hurd, Henriette Wyeth, Carolyn Wyeth, John W. McCoy, Andrew Wyeth, George Weymouth, James Wyeth." *American Artist*, vol. 39, Feb. 1975, pp. 37–119.

———. "Editorial Random Thoughts on the Most Famous Painter in America." *American Artist*, vol. 41, Feb. 1977, pp. 6–7.

Mortenson, C. Walter. *The Illustrations of Andrew Wyeth: A Checklist*. West Chester, Pa.: Aralia Press, 1977.

Myers, Fred A. "Thomas Gilcrease and His National Treasure—Andrew Wyeth." *Thomas Gilcrease Museums Association*, Tulsa, 1987, p. 68.

"Wyeth at Work." *Newsweek*, vol. 60, no. 20 (Nov. 12, 1962), p. 94.

"Wyeth's World." *Newsweek*, vol. 69, no. 10 (March 6, 1967), pp. 76–79.

"The World of Wyeth." *Newsweek*, vol. 76, no. 8 (Aug. 24, 1970), pp. 54–57.

O'Connor, John J. "Kline and Wyeth: Disparate Realists." *Wall Street Journal*, Feb. 28, 1967, p. 18.

O'Doherty, Brian. "Andrew Wyeth: Art Loner." *The New York Times*, March 30, 1963, p. 5.

———. "Wyeth Drawings Are Displayed." *The New York Times,* April 1, 1963, p. 55.

———. "Andrew Wyeth." *Show,* vol. 5, no. 4 (May 1965), pp. 46–55, 72–75.

———. "Wyeth and Emerson: Art as Analogy." *Art and Artists* (London), vol. 2, no. 1 (April 1967), pp. 12–15.

———. *American Masters: The Voice and the Myth.* New York: Random House, [1974]. With photographs by Hans Namuth.

Pitz, Henry C. "Andrew Wyeth." *American Artist,* vol. 12, Nov. 1958, pp. 26–33, 65–66.

———. *The Brandywine Tradition.* Boston: Houghton Mifflin Co., 1969.

Plimpton, George, and Donald Stewart. "An Interview with Andrew Wyeth." *Horizon,* vol. 4, no. 1 (Sept. 1961), pp. 88–101.

Porter, Fairfield. "Andrew Wyeth." *Art News,* vol. 57, Dec. 1958, p. 13.

Raoul, Rosine. "Weber and Wyeth: A Study in Opposites." *Apollo,* vol. 78, no. 19 (Sept. 1963), pp. 222–23.

Ratcliff, Carter. "Wyeth, the Art World and Class Unconsciousness." *Art in America,* vol. 65, Jan. 1977, p. 15. Reply with rejoinder by M. R. Wilson: *Art in America,* vol. 65, May 1977, p. 5.

Reed, Judith Kaye. "The Wyeth Family Honors Its Sire." *Art Digest,* vol. 21, no. 1 (Oct. 15, 1946), p. 10.

Reed, Susan. "Leonard Andrews Unveils 240 of Andrew Wyeth's Best-Kept Secrets—The Helga Paintings." *People,* Aug. 25, 1986, pp. 32–37.

Richardson, E. P. "Andrew Wyeth." *Atlantic Monthly,* vol. 208, no. 6 (June 1964), pp. 62–71.

Rodman, Seldon. "Andrew Wyeth," in: *Conversations with Artists.* New York: Capricorn Books, 1961, pp. 211–21.

"Brandywine: A Triumph of Spirit and Strength." *The Saturday Evening Post,* vol. 243, no. 2 (Fall 1971), pp. 68–73.

Schaire, Jeffrey. "The Unknown Andrew Wyeth." *Art & Antiques,* Sept. 1985, pp. 46–57.

———. "Andrew Wyeth's Secret Paintings: An American Treasure Revealed." *Art & Antiques,* Sept. 1986, pp. 68–79.

Schroeder, Fred E. H. "Andrew Wyeth and the Transcendental Tradition." *American Quarterly,* vol. 17, no. 3 (Fall 1965), pp. 559–67.

Seelye, John. "Wyeth and Hopper." *New Republic,* vol. 166, no. 11 (March 11, 1972), pp. 18, 22–24.

Shirey, David. "Brandywine Museum Honors Three Wyeths with Display." *The New York Times,* June 19, 1971, p. 18.

Stewart, Patrick L., Jr. "Andrew Wyeth and the American Descriptivist Tradition." Unpublished master's thesis (Binghamton: State University of New York, 1972).

Talmey, Allene. "Andrew Wyeth." *Vogue,* vol. 140, no. 9 (Nov. 15, 1962), pp. 118–21, 160–61. With photographs by Henri Cartier-Bresson.

"American Realist." *Time,* vol. 58, no. 3 (July 16, 1951), pp. 72–75.

"Andy's World." *Time,* vol. 82, no. 26 (Dec. 27, 1963), cover and pp. 44–52.

"Appalled and Amazed." *Time,* vol. 89, no. 8 (Feb. 24, 1967), p. 68.

Tunley, Raoul. "The Wonderful World of Andrew Wyeth." *Woman's Day,* Aug. 1963, pp. 33–37, 67–68.

Tyler, Parker. "The Dream of Perspective in Andrew Wyeth." *American Artist,* vol. 14, Jan. 1950, pp. 35–38.

Wade, Marcia. "The Wyeth Legacy." *Horizon,* April 1987, pp. 52–57.

Wainwright, Loudon. "The Mass Sport of Wyeth Watching." *Life,* vol. 62, no. 10 (March 10, 1967), p. 27.

Wilmerding, John. *Andrew Wyeth—The Helga Pictures.* National Gallery of Art, Washington, D.C. New York: Harry N. Abrams, 1987.

Wyeth, Andrew. "Note on *The Trodden Weed.*" *Art News,* vol. 51, March 1952, p. 6.

Wyeth, Betsy James. *Wyeth at Kuerners.* Boston: Houghton Mifflin, 1976. Works by Andrew Wyeth at the Kuerner farm, Pennsylvania, covering the years 1936–75. Selected, arranged, and with text by Betsy James Wyeth.

———. *Christina's World: Paintings and Pre-studies of Andrew Wyeth.* Boston: Houghton Mifflin, 1982. Works by Andrew Wyeth at the Olson farm, Maine, with text by Betsy James Wyeth.

Young, Mahonri Sharp. "Wyeth and Manet in Philadelphia." *Apollo,* vol. 84, Nov. 1966, pp. 403–6.

———. "Letter from USA: Sublime and Beauteous Shapes." *Apollo,* vol. 86, July 1967, pp. 65–66.

Index

Additional credits for paintings from the Collection
of the Brandywine Museum are as follows:
Raccoon (page 49)
Museum purchase made possible by David
Rockefeller, Laurance S. Rockefeller, anonymous
donors, and The Pew Memorial Trust, in memory
of Nancy Hanks.
The Virgin (page 83), Siri (page 87), Black Water
(page 93)
Purchased for the museum by John T. Dorrance,
Jr., Mr. and Mrs. Felix du Pont, Mr. and Mrs.
James P. Mills, Mr. and Mrs. Bayard Sharp, two
anonymous donors, and The Pew Memorial Trust.
The Critic (page 146)
Purchased from the Claniel Fund, the Caroline
Gussmann Keller Fund, Museum Volunteers'
Purchase Fund, 1990, and other funds.